For Documentary

For Documentary

Twelve Essays

Dai Vaughan

UNIVERSITY OF CALIFORNIA PRESS

Berkeley Los Angeles London

This book is a print-on-demand volume. It is
manufactured using toner is place of ink. Type and
images may be less sharp than the same material seen in
traditionally printed University of California editions.

University of California Press
Berkeley and Los Angeles, California

University of California Press, Ltd.
London, England

Library of Congress Cataloging-in-Publication Data

Vaughan, Dai.
 For documentary : twelve essays / Dai Vaughan.
 p. cm.
 Includes index.
 ISBN 0-520-21694-6 (alk. paper). — ISBN 0-520-
21695-4 (pbk. : alk. paper)
 1. Documentary films—History and criticism. I. Title.
 PN1995.9.D6V33 1999
 070.1'8—dc21 99-13376
 CIP

Printed in the United States of America

 .

The paper used in this publication meets the minimum
requirements of ANSI/NISO Z39.48 (R 1997) (
Permanence of paper)

*I should like to express my gratitude
to David MacDougall and Lucien Taylor,
who chivvied me into assembling this collection
and submitting it for publication*

CONTENTS

Publication History

ix

Note

xi

Preface

xiii

Let There Be Lumière

I

The Space between Shots

9

Arms and the Absent

29

The Aesthetics of Ambiguity

54

What Do We Mean by "What"?

84

Berlin versus Tokyo

90

Notes on the Ascent of a Fictitious Mountain

111

Rooting for Magoo

137

Competing with Reality

148

Salvatore Giuliano

155

From Today, Cinema Is Dead

181

A Light Not Its Own

193

Index

209

PUBLICATION HISTORY

"Let There Be Lumière": *Sight and Sound* vol. 50 no. 1 (Spring 1981); reprinted in *Early Cinema*, ed. Thomas Elsaesser (BFI 1990).

"The Space between Shots": *Screen* vol. 15 no. 1 (Spring 1974); reprinted in *Movies and Methods II*, ed. Bill Nichols (University of California Press 1985).

"Arms and the Absent": *Sight and Sound* vol. 48 no. 3 (Summer 1979).

"The Aesthetics of Ambiguity": *Film as Ethnography*, ed. Peter Ian Crawford and David Turton (Manchester University Press 1992).

"What Do We Mean by 'What'?": *Cilect Review* vol. 2 no. 1 (November 1986).

"Berlin versus Tokyo": *Sight and Sound* vol. 46 no. 4 (Autumn 1977).

"Notes on the Ascent of a Fictitious Mountain": *Documentary and the Mass Media*, ed. John Corner (Edward Arnold 1986).

"Rooting for Magoo": Précis of lecture delivered at University of Liverpool, April 1988.

"From Today, Cinema Is Dead" (as "The Broken Trust of the Image"): *Vertigo* no. 4 (Winter 1994–95).

(Remainder hitherto unpublished.)

NOTE

It was my initial intention to present these essays in the order in which they were written rather than that of their first publication. Dating them, however, proved to be no simple matter. "Let There Be Lumière," "Arms and the Absent," and "Berlin versus Tokyo," for example, though appearing in 1981, 1979, and 1977 respectively, had their origins in a project on which I was engaged in the early 1970s to explore the way the documentary principle operated in films of different periods and traditions. Having abandoned the idea of trying to persuade a publisher to back me in this venture, I eventually hived off some of the material into separate articles, doubtless revising them somewhat in the process.

An extreme case of tortuous growth is "The Aesthetics of Ambiguity"—perhaps the keystone of the collection. This began as an attempt to knock into shape ideas developed during a period of work with the American Universities Field Staff in 1973 and 1974. The resulting article was rejected by all the appropri-

ate journals. Many of its arguments were cannibalised for other things, in particular a quasi-polemical BFI monograph, *Television Documentary Usage* (1976). Then in 1978 I received a commission from a publisher to provide a 12,000-word essay for a book to be called "Ethnographic Film and Domestic Representation." For this I took the original article as a foundation, adding in the process of redevelopment some otherwise mystifying references to "the domestic realm." The book was to consist of contributions by two academics, an editor, a director, and a producer; but the director and producer failed to deliver their copy, and the project was ditched. "The Aesthetics of Ambiguity" was eventually taken up by David Turton and Peter Ian Crawford for their collection, *Film as Ethnography*. For reasons of length it had to be shortened by some 3,000 words; and I took this opportunity to get rid of some material which had lost its relevance or had in the meantime been used elsewhere.

Likewise, "From Today, Cinema Is Dead" was first written in 1991 and progressively updated until 1995, when it appeared in *Vertigo* under the title "The Broken Trust of the Image." According to my records, the version included here is the eighth. I have resisted the temptation to tinker with the style of the earlier pieces, to eliminate overlapping of ideas from one to another, or to pepper them with footnotes bearing qualifications, elaborations, caveats, or fresh news, and have confined myself mostly to dropping one or two passages which seemed either unnecessarily obscure or simply mistaken.

PREFACE

Why write about documentary? It is simply film about the real world; or it is film using shots of the real world. Its articulations are the same as those used for fiction, and it therefore does not differ in any significant way from fiction; or its articulations are so rudimentary as not to deserve serious scrutiny at all. It presents no interesting problems purely by virtue of being documentary; or such problems as it presents are practical and procedural rather than ideological or aesthetic. Is that not so?

Let me offer in reply an anecdote from my own experience as an editor. A film on which I worked included a female circumcision; and we had covered this, as I recall, with a succession of long-held shots of people waiting outside the hut where the operation was taking place. During the discussion after a rough-cut viewing, three divergent views of this sequence were expressed. One person suggested that, if we were not to see the surgery, we might at least be allowed to hear a scream or two to signal to the viewer the unpleasantness of what was occurring. Someone else

remarked that there had in fact been a scream recorded during this event, and that it would be perfectly legitimate for us to lay it over. But someone else again made the point that the scream had been such an exceptional feature of this ceremony that it would be a misrepresentation of the culture to include it. What is significant about these three views is that they reflect three distinct assumptions about the claim documentary stakes upon the world: in the first case, symbolic (a scream stands for pain); in the second, referential (this is what our equipment actually recorded); in the third, generalisatory (to include the atypical is misleading). This question, about the claim documentaries stake upon the world, is one that confronts us afresh, and in different ways, with every project. No simple answer can serve for all circumstances; and no film editor can avoid fretting about such things.

Since I have stressed the particularities of life in the cutting room, I ought perhaps to allow a brief glimpse into my own background. I cut my first film in 1963, just at the time when the first silent-running cameras and lightweight broadcast-quality tape recorders were becoming available in Britain. By mid-1965, the revolution was complete, and these had become standard equipment in British television. Indeed, the explosion of documentary into television at that time is often associated in people's minds specifically with this equipment, though it would be more true to say that it was consequent upon developments of a slower and less dramatic nature: the gradual improvement in the resolution of film emulsions to the point where 16mm became acceptable as a professional gauge for what was still, in Britain at that time, the old 405-line TV system. As an enthusiast for documentary before entering the industry, my loyalties lay with those traditions that had grown out of the use of 35mm: the work of

Joris Ivens, Georges Franju, Alain Resnais, or—more specifi-
cally, here at home—Humphrey Jennings. These were traditions
reliant upon raising the everyday image to quasi-symbolic sta-
tus through the use of juxtaposition, both of image with image
and of image with sound, to create a rich web of connotation and
nuance.

As it happens, I still have great affection for that sort of film-
making. It shares with later *vérité* and observational methods one
crucial characteristic, namely, an insistence on the priority of the
given: an insistence that meaning should be generated directly
from the organisation of the visual and auditory material, rather
than this material being subordinated to something prior or ex-
trinsic—typically, a pre-scripted schema or a dominant verbal
narration. Perhaps because we had the weight of three decades
of British Documentary behind us, television in this country
was slow to take up the challenge of the groundbreaking *vérité*
work being produced in America. One of the first series to do so
was Roger Graef's *Space between Words*, five films devoted to the
theme of human communication. It was around the same time
that the need was being felt to raise films about other cultures
above the banal level of the travelogue. In 1969 or 1970, Brian
Moser persuaded Granada Television to initiate the *Disappearing
World* series, one of whose defining characteristics was that each
programme should be made in collaboration with an anthropol-
ogist expert in the particular field and, indeed, on close personal
terms with the particular people being filmed. Methods akin to
those pioneered by such filmmakers as Jean Rouch and the
MacDougalls were adapted, albeit hesitantly, in this rapidly de-
veloping and critically successful genre.

Having been fortunate enough to be in the right place at the

right time for *Space between Words*, I gravitated more and more toward anthropological film—which was where all the interesting arguments were then happening—and for some years worked primarily in this and closely related areas. To a significant extent, the essays in this collection map that trajectory and the preoccupations which accompanied it.

It has always seemed to me axiomatic that film works not with a learned and shared symbolic vocabulary but with images whose associations will vary somewhat from viewer to viewer. Thus the meaning attributed to any text—and to documentary in particular—must entrain, and therefore by the same token modify in some degree, the viewer's own experience. This being the case, even the most seemingly innocent response can be the product of complex negotiations between the viewer and the ordering of the imagery.

Hence some of these essays offer analyses of particular films from a viewer's perspective, while others adopt the perspective of the filmmaker in discussing the options available in a working context. There ought surely to be some way for these two perspectives to be reconciled; but it is often far from obvious how this could be done. It was to some extent a recognition of such difficulties which led me, at a certain point, to become dissatisfied with the rigidity of the terms in which I was writing about film, and to ask whether the subject might not be better served by something more allusive, tangential, open even to the risk of self-contradiction.

An outcome of such self-questioning was "Notes on the Ascent of a Fictitious Mountain," a piece which engages with another major preoccupation: the relation of documentary to fiction. Postmodernism has lent new currency to the weary old

argument that, since fiction is narrative, anything which partakes of narrative must be fiction. This glib formulation, which deletes at one stroke our project as documentary filmmakers and theorises our life's work out of existence, has met little opposition from within the critical and scholarly orthodoxies of the past two decades. It has at times seemed important, therefore, to pay attention to the workings of fiction film, especially where, as with *Salvatore Giuliano*, this assumes a certain documentary flavour. There was a time, after all, in the early 1930s, when the terms "documentary" and "realist film" were treated as virtually synonymous.

But to return to the workbench, to television. Since this is where most documentary is now produced and disseminated, we are bound to ask what is the function of this institution in our society. Following the restoration of the British monarchy in 1659, demands were voiced for the curtailment of public literacy in the hope that outbreaks of political thinking on the part of the lower orders might be avoided in the future (and indeed, it was not until after the First World War that the level of general education, as measured by the proportion of the population entering university, recovered to that of the 1640s). At the beginning of the nineteenth century it was argued by leading figures in the Methodist church that, while it was acceptable for their Sunday schools to teach the children of the poor to read—so that they might peruse the Scriptures—teaching them to write was an altogether more hazardous undertaking. In 1957 Richard Hoggart published his seminal book, *The Uses of Literacy*, which analysed the way in which the near-universal adult literacy resulting from the Education Acts of the 1870s and 1880s had been hijacked and trivialised by the purveyors of "popular" culture, in particular the

tabloid press. It may be argued that the institution of television should be looked at against this background. Just as, in the late nineteenth century, industry had reached a point where it could no longer make do with an illiterate workforce, so, from the mid–twentieth century onward, advances in technology demanded workers of ever-increasing intellectual sophistication. The problem was how to achieve such sophistication without sacrificing political docility. Imagine someone conforming to this requirement, and you will have lit upon the stereotypical viewer as defined by today's television: credited with broad interests, but not assumed to act on them; encouraged to think, but only within the parameters allowed by the programme formats—an intelligence self-locked into passivity.

Ideological determinism is seldom the whole story—or seldom a simple one. I mention these things only to make the obvious point that all debate about filmmaking takes place within profound institutional constraints, even where these are so familiar that we scarcely identify them as such. In this country we have been relatively lucky, especially in the five or six years after the launch of Channel 4 in 1982. These years were the high-water mark of British television, when BBC2 also, for whatever reasons, raised its standards and commissioned such remarkable work as the second tranche of documentaries about the Maasai by Melissa Llewelyn-Davies. The phrase commonly used—and which I catch myself trying to avoid—is "quality programming." "Quality" is what legislation in these areas typically pledges itself to preserve; but it is an unhelpful concept, since it presupposes someone competent who may be deputed to judge it. What really matters is that programmes should address the viewer in such a way that the viewer may approach them on his or her own terms

and not on those of television management. And for a while we came close to seeing these criteria fulfilled.

Some may feel that I have given too much time to television. But its merit was that it allowed a diversity of people—playwrights, physicists, coal miners, comedians, filmmakers—to come together before a public which, if never homogeneous, was a good deal less fissile than it appears today. Top executives continue shuffling the syllables—docu-soap, info-tainment, fact-ion—in the hope of stumbling upon something that will look good in their corporate mission statements; but secretly they know the game is up. And it is possible that the game is up not only because they chose to concede it, and not only because of the proliferation of electronic gizmos inside and outside of television, but because of structural changes in postindustrial Western society whereby the former working population (the working and middle classes) have been reduced to the status once imposed upon colonial peoples: that of a reservoir of labour which may be drawn upon when required but to whom no societal responsibilities are acknowledged.

To sum up: for much of the span of my own working life, it has been possible for documentarists in Britain to believe in—or to be seduced by, if you prefer—the ideal of television as a means of disseminating significant work to a mass audience; and it was out of this milieu, this set of assumptions, this particular concatenation of people and circumstances, that the essays in this volume grew. I hope, however, that this does not limit their usefulness, and that the questions they raise may be granted a significance beyond the parochial.

London 1998

Let There Be Lumière

To look critically and sympathetically at the beginnings of cinema—at those programmes of one-minute scenes first publicly exhibited in Paris in December 1895, and in London the following February—is like pondering what happened to the universe in the first few microseconds after the big bang.

We need not doubt that, so far as the genesis of film art is concerned, these early shows mounted by the Lumière brothers represent the nearest we will find to a singularity. Before them, notwithstanding such precedents as the photographic analysis of animal movement by Marey and Muybridge, the public projection of animated drawings in Reynaud's Théatre Optique, or anticipations of film narrative methods in comic strip and lantern slide sequence, cinema did not exist. A story so frequently repeated as to have assumed the status of folklore tells how members of the first audience dodged aside as a train steamed toward them into a station. We cannot seriously imagine, though, that these educated people in Paris and London expected the train to

emerge from the screen and run them down. It must clearly have been a reaction similar to that which prevents us from stepping with unconcern onto a static escalator, no matter how firmly we may assure ourselves that all it requires is a simple stride on an immobile flat surface. What this legend means is that the particular combination of visual signals present in that film had had no previous existence *other* than as signifying a real train pulling into a real station.

Yet already, in this primitive world, we find structures tantalisingly prophetic of some we know today. Compare the *Workers Leaving the Lumière Factory*, very few of whom return our gaze with even a glance from the screen, with the members disembarking from a riverboat for the *Congress of Photographic Societies at Neuville-sur-Saône*, who greet the camera with much waving and doffing of headgear. Do we not see here that distinction, very much a part of our television experience, between those who wield the power of communication and those who do not: between those granted subjectivity and those held in objectivity by the media?

Perhaps, if we wish to infer a state of cinema anterior to this almost instantaneous spawning of connotatory formations—and it is worth bearing in mind, in this regard, that the photographers arriving at Neuville-sur-Saône did not even know they were confronted with a *ciné*-camera—we should perhaps examine more closely the recorded responses of the earliest viewers. A curious example is offered in Stanley Reed's commentary to the BFI's sound version of the first British Lumière programme. This programme ended with *A Boat Leaving Harbour*; and we are told that visitors came forward after the performance to poke at the screen with their walking sticks, convinced that it must be

made of glass and conceal a tank of water. Whilst we may allow this to pass as a measure of the wonderment caused by the first cinematographic projections, it becomes on consideration rather puzzling. How could people have supposed that the screen concealed a tank of water when it would also, by the same supposition, have had to conceal a garden, a railway station, a factory, and various other edifices? Yet I believe that this little story, like the one about the train, is telling us something important.

A Boat Leaving Harbour does, even today, stand out among the early Lumière subjects. (Indeed, an ulterior motive behind this article is my desire to pay tribute to a film I have loved since first encountering it very many years ago.) The action is simple. A rowing boat, with two men at the oars and one at the tiller, is entering boldly from the right foreground; and it proceeds, for fifty-odd seconds, toward the left background. On the tip of the jetty, which juts awkwardly into frame on the right, stand a child or two in frilly white and two portly women in black. Light shimmers on the water, though the sky seems leaden. The swell is not heavy; but as the boat passes beyond the jetty, leaving the protection of the harbour mouth, it is slewed around and caught broadside-on by a succession of waves. The men are in difficulties; and one woman turns her attention from the children to look at them. There it ends. Yet every time I have seen this film I have been overwhelmed by a sense of the *potentiality* of the medium: as if it had just been invented and lay waiting still to be explored.

I do not think it is just the Tennysonian resonances—crossing the bar, and so forth—which invest this episode with nostalgia for cinema's lost beginnings: a nostalgia which one would expect to be prompted equally, if at all, by the other items in the programme. One thing which will be obvious even from the

above brief description is that the subject, with its waves glimmering to a distant horizon, could not possibly have been simulated in an indoor tank. So why were those early visitors poking at the screen with their walking sticks? A superficially similar reaction, this time to Edison's "kinetoscope," is quoted in the first volume of Georges Sadoul's *Histoire générale du cinéma*. The kinetoscope was an individual viewing box which ran continuous bands of film, the subjects being photographed by daylight in a blackened studio which could be revolved to face the sun; and in 1894 Henri de Parville wrote of it in *Les Annales politiques et littéraires:* "Tous les acteurs sont en mouvement. Leurs moindres actes sont si naturellement reproduits qu'on se demande s'il y a illusion." What he presumably meant by "illusion" was some system whereby the images of live actors might have been brought by mirrors under the eyepiece of the machine. But it is clear that the relevance of this lies not in similarity but in contrast: for there was no way that the image of a French harbour could have been reflected by mirrors into the auditorium of the Regent Street Polytechnic. The gentlemen with their walking sticks were not trying to discover how the trick worked. Their concern was not that they might have been the victims of an illusion, but that they had experienced something which transcended the cosy world of illusionism altogether.

We need look no further than Sadoul's standard *Histoire générale* for ample evidence of the fact that what most impressed the early audiences were what would now be considered the incidentals of scenes: smoke from a forge, steam from a locomotive, brick dust from a demolished wall. Georges Méliès, a guest at the first Paris performance (who was soon to become a pioneer of trick filming), made particular mention of the rustling of leaves

in the background of *Le Déjeuner de bébé*—a detail which, as Sadoul himself observes, would scarcely be remarked today. It is worth asking why this should be so—and why, by implication, we consider Lumière cinema and Edison not: for surely, it might be argued, what mattered was the photographic rendering of movement, regardless of what moved. Sadoul entitles his chapter on Lumière "La Nature même prise sur le fait"; and Stanley Reed points out that audiences had hitherto been familiar only with the painted backdrops of the theatre. But to put it this way round is to understate the most revealing aspect of it: that people were startled not so much by the phenomenon of the moving photograph, which its inventors had struggled long to achieve, as by the ability of this to portray spontaneities of which the theatre was not capable. The movements of photographed people were accepted without demur because they were perceived as performance, as simply a new mode of self-projection; but that the inanimate should participate in self-projection was astonishing.

Most of the people in the Lumière show either are performing for the camera—whether knocking down walls or feeding babies—or are engaged in such neutral activities as leaving the factory or alighting from a train. What is different about *A Boat Leaving Harbour* is that, when the boat is threatened by the waves, the men must apply their efforts to controlling it; and, by responding to the challenge of the spontaneous moment, they become integrated into its spontaneity. The unpredictable has not only emerged from the background to occupy the greater proportion of the frame; it has also taken sway over the protagonists. Man, no longer the mountebank self-presenter, has become equal with the leaves and the brick dust—and as miraculous.

But such an invasion of the spontaneous into the human arts, being unprecedented, must have assumed the character of a threat not only to the "performers" but to the whole idea of controlled, willed, obedient communication. And conversely, since the idea of communication had in the past been inseparable from the assumption of willed control, this invasion must have seemed a veritable doubling-back of the world into its own imagery, a denial of the order of a coded system: an escape of the represented from the representational act. Thus what the early audiences suspected was not the presence of a water tank but the presence, in some metaphysical sense, of the sea itself: a sea liberated from the laboriousness of painted highlights and the drudgeries of metaphor. And their prodding of the screen was comparable with our own compulsion to reach out and "touch" a hologram.

Yet if this helps to explain why, in 1896, a representation of the sea should have caused greater bemusement than that of a factory or railway station, it does not explain why *A Boat Leaving Harbour* should have retained its fascination for a hundred years. To understand this, we must turn the other way: not toward a notional first moment but towards the future already latent in Lumière. The earliest programme contained an episode, *L'Arroseur arrosé*, which is generally considered to mark the initiation of screen narrative. A man is watering a garden; a boy puts his foot on the hose and stops the jet; the gardener peers into the nozzle; and the boy removes his foot so that the gardener is squirted in the face. But is this a fiction film or simply a filmed fiction?

One answer would be that the fiction film comes into being only when the articulations of camera movement and editing form an inalienable component of the narration. Another, slightly more sophisticated, would be that the distinction is

meaningless at this primitive level of organisation, and that *L'Arroseur arrosé* may be said to be filmed fiction and fiction film at once. But let us consider the question from the point of view of what seemed at the time the essential triumph of Lumière: the harnessing of spontaneity. It is clear how this applies to the men rowing the boat out of the harbour; but it is far from clear how it applies to the *Arroseur* episode.

At first it may seem that there are two simple alternatives: either this was an event observed in passing, perhaps with a concealed camera; or it was a scene staged by the filmmaker with the complicity of both parties. Furthermore, the gaucheness of the performances suffices to resolve any doubt in favour of the latter, thus perhaps leading us—our definition swallowing its tail—to say that what we see is an *attempt* at fiction film which, insofar as it is *perceived* only as an attempt, reverts to the spontaneous. But it is not so easy. Suppose, for example, that the camera had been set up only to record the garden-watering, and that the boy had played his trick unprompted; or that the boy and the cameraman had been in collusion to trick the unsuspecting gardener; or the boy and the gardener in collusion to surprise the cameraman. . . . Spontaneity begins to seem, in human affairs, a matter less of behaviour than of motivations—and of transactions in which the part of the mountebank *behind* the camera cannot long be excluded from question. "Spontaneity," that is to say, comes down to what is not predictable by—and not under the control of—the filmmaker. As for the gaucherie, it is arguable that flawless performances would have given us not true fiction but mendacious actuality.

Fiction film arises at precisely the point where people tire of these riddles. As audiences settle for appearances, according

film's images the status of dream or fantasy whose links with a prior world are assumed to have been severed if they ever existed, film falls into place as a signifying system whose articulations may grow ever more complex. True, the movement of leaves remains unpredictable; but we know that, with the endless possibility of retakes open to the filmmaker, what was unplanned is nevertheless what has been chosen: and the spontaneous is subsumed into the enunciated. Even in documentary, which seeks to respect the provenance of its images, they are bent inexorably to foreign purpose. The "big bang" leaves only a murmur of background radiation, detectable whenever someone decides that a film will gain in realism by being shot on "real" locations or where the verisimilitude of a Western is enhanced, momentarily, by the unscripted whinny of a horse.

A Boat Leaving Harbour begins without purpose and ends without conclusion, its actors drawn into the contingency of events. Successive viewings serve only to stress its pathetic brevity as a fragment of human experience. It survives as a reminder of that moment when the question of spontaneity was posed and not yet found to be insoluble: when cinema seemed free, not only of its proper connotations, but of the threat of its absorption into meanings beyond it. Here is the secret of its beauty. The promise of this film remains untarnished because it is a promise which can never be kept: a promise whose every fulfilment is also its betrayal.

The Space between Shots

For those who bewail its absence, honesty is a moral problem. For those who try to achieve it, it is a technical one. At their first transmission, Roger Graef's *Space between Words* series aroused a good deal of fresh controversy about the relationship between *cinéma vérité* and truth.* But most of the discussion was of a purely moralistic character in that the desiderata of "objectivity" were dissected with scant regard for the realities of the film language in which it was, or was not, held to find expression. What has been lacking is an assessment of the problem by a technician on day-to-day terms with the demands of the medium. My own qualification for hazarding an opinion is that I was film editor on three of the *Space between Words* programmes, and in close touch with colleagues on all five; but there is little in what I shall say that

* The series consisted of five films: *Politics, Work, School, Family,* and *Diplomacy.* Transmission: BBC2, 8 February to 7 March 1972.

is not the stuff of common gossip in the canteens of television companies.

The justification for the concern with apparent trivia is that the answers we give to questions raised by new developments in documentary technique will help determine our views on censorship, access, democracy and control in broadcasting: and our views on these subjects have practical consequences. Policy decisions based upon a shaky understanding of the medium are likely to be bad ones.

Almost simultaneously with the first transmission of the *Space between Words* series, the BBC was circulating to its staff a little green booklet called *Principles and Practice in Documentary Programmes*. This "guide to conduct" received a hostile response from the press; but it did represent a rare attempt to link the ethics of television with its practical procedures. My purpose in referring to it here is not to revive a lapsed polemic but to illustrate the importance of the attempt with an example of practical recommendations based on what seems to me a faulty analysis:

> A producer's ethics are principally concerned with: (1) what he may, or may not, simulate; (2) what he should, or should not, select for showing on the screen. The need for some element of simulation had been explained under II METHOD but the precise extent to which this may be done is clearly a matter of great delicacy, and is frequently the cause of misunderstanding. For example, it is virtually impossible to convey an accurate impression of a board meeting or discussion by filming it as it happens. In real life nobody can predict the order in which various people will speak. The director, cameraman and sound man will find it impossible to follow a rapid and spontaneous interchange. Furthermore, the presence of

the film crew will create in itself an artificial situation which can lead to self-consciousness and exhibitionism. Therefore the producer must to some extent prepare such a discussion. So long as the result on the screen gives a true picture of the real type of discussion (which the producer witnessed during his research), and so long as it is an accurate impression of the personalities involved, such preparation is not only ethically permissible, but necessary. (p. 20)

And II METHOD offers the following:

He [the producer on research] sees what *really* happens when people go about their daily lives without the knowledge that a television audience is watching. He sees how a man *really* behaves when he is not putting on a show for the camera. . . . (p. 8)

Recent developments in cameras, microphones and film stocks have reduced technical preparation to a minimum, and made it increasingly possible to shoot things at the first attempt and with little pre-arrangement. But even the purest piece of "ciné vérité" can never be—and indeed should never be—totally free of the day-to-day business of directing. (p. 11)

The above will be seen to contain some surprising assumptions:

1. A shot of someone speaking is more truthful than a shot of someone listening.
2. Someone who is aware of the camera is aware of the television audience.
3. People's considered adaptation to the camera is more real than their spontaneous response.

4. What the director sees when the camera is absent is what would be happening if he himself were absent.

5. The director can judge the reality of what happens this time by reference to what happened last time.

6. The purpose is to portray a "type" of incident, not to record a particular one.

7. To ask for an "accurate impression" does not beg all the important questions.

It is only fair to point out that the context from which these quotations come is not an encouragement to unbridled simulation but a warning to producers not to go too far—though anyone who stepped beyond these recommendations would surely be engaged in pure fiction. But the underlying assumptions which the quotations reveal form part of a consistent attitude toward the medium which can best be understood in a historical perspective.

In 1955, documentary films looked much as they had looked for the previous twenty years. They were shot on 35mm, budget permitting, with any synch sound recorded directly onto optical track or, latterly, transferred to optical from quarter-inch tape. People were rehearsed in their everyday activities so that they could perform them convincingly in front of the crowd of technicians with their forbidding mass of equipment, cables, and lights. The finished film usually had a commentary and, frequently, music. I cannot recall what television documentaries were like at the time, but I know that few people in the short-film world saw television as a potential outlet for their talents.

Then, in the late '50s and early '60s, there came a succession of technical developments each of which, being seized upon by filmmakers tired of the old formulae, gave birth to an element of what

was soon to become a new style. The first was the general introduction of magnetic sound stock, which can be cut into pieces and endlessly rearranged in a way that optical cannot, and which opened up the possibilities for disjunctive editing of sound and picture—for doing with ease what must have cost Jennings considerable effort. Denis Mitchell and John Read were able to pioneer the technique of "voice-over," in which people's recorded comments are laid—and usually hacked around a bit—to fit whatever visuals the filmmaker chooses. Already the participants in a film are one step farther away from knowing what is being done to them.

The second development was a by-product of the first. Magnetic sound cannot be put together with a cement joiner (or rather it can, but the joins click). After about three years of trial and error, someone invented a satisfactory device for joining magnetic sound with ordinary clear sticky tape; and it was quickly realised that this could equally be used for joining picture. With it came a new freedom. The cement joiner made an overlapping join, so that every time we changed a cut we lost two frames, and every time we put something back we had to replace the loss with black spacing, and could no longer see how the cut worked. There was therefore an inhibition against making alterations. But with the tape joiner, which makes a butt join, we could try out any idea, however unpromising, knowing that if we did not like it we could try something else. With the invention of the tape joiner, documentary became truly an editor's medium.

The next two developments came simultaneously in 1963, with the appearance of a silent-running 16mm camera (the Eclair) and a professional-quality lightweight tape recorder (the Nagra). Almost overnight it became possible to shoot synch with

portable equipment; and this, combined with the gradually improved resolution of film emulsions, swung the balance in favour of 16mm as a professional gauge. This in turn meant less expensive film stock, with the result that higher shooting ratios were considered acceptable. The script finally became obsolete. The new type of documentary, shot with small crews, which was relatively cheap and could be made in a hurry, was ideally suited to the needs of television, where the difference in definition between 16mm and 35mm was least important. Had the technical innovations happened in a different order, it is quite possible that what we know as the Mitchell style would not have been the one to develop from a challenge to a language, and ultimately to an orthodoxy, in the space of ten years: but they didn't, and it did.

Yet it was an orthodoxy ill suited to the orthodox. It was a style in which nothing could safely be judged in advance—by the participants, by the executives, or even by the filmmakers; a style in which responsibility was indeterminately distributed (a thing administrators never like) between a director who did not know what the cameraman was seeing, a cameraman who did not know what was going to happen next, and an editor with more permutations to choose from than he could try out in a lifetime. Moreover, it was a style which drew upon a formal vocabulary—of vox-pop, voice-over, montage, talking head, musical interlude, significant juxtapositions of any and all elements—so vast and flexible as to make the expression of attitude through the very form of the film not merely possible but inevitable. Yet there was no knowing whose attitude it was. It might have been the director's. It might have been the editor's. It might conceivably have been nobody's. Films have their own logic.

The public always distrusted the style, suspecting it of wilful distortion. The usual complaint was that things were taken out of context: to which the only reply is, "How much context does a quotation require—a paragraph, a volume, a lifetime's experience?" Behind the inanities of tabloid opinion and the fulminations of "Disgusted" lay very real ethical problems; but they were problems which presented themselves with every choice of camera angle, with each cut, with each decision to put something in or leave something out. Such problems are not amenable to blanket legislation.

Recognising this, the BBC drew up its code of practice not as a table of requirements but as a set of guidelines to the individual conscience of the director. (The failure to recognise other technicians as creative contributors derives not from aesthetic theory but from institutional predisposition.) However, in facing the moral ambiguities of a style in which the elements are more life-like than ever before, yet the overall result bears less resemblance than ever to simple actuality—as if poetry had been achieved by collage from a company report—the BBC group seem to have clutched for reassurance at straws of the earlier tradition, evincing an apparent nostalgia for the well-made British documentary left behind with the waning of the Grierson impetus: all polish and no boots.

It further appears that, in attempting to draw general guidelines from specific examples, they have, in a most curious fashion, transferred the requirement for generality back upon the particular instance. Thus in their example of a boardroom meeting they seem to be saying that what is required is an "impression" of a "type" of event rather than a record of an actual

one. But the way of generality is treacherous. When, say, an Education Authority complain that one of their schools has been portrayed in an untypical or abnormal light, they understand by typical and normal not an intuitive statistical average of what actually goes on in that school, but an adherence to the type or norm laid down for it, from which the confusion of daily troubles is seen as ephemeral deviation. In other words, authorities' idea of what is typical is what they like to imagine happens. And this is precisely what you get if you allow the board to rehearse their meeting. Perhaps the BBC's inclination toward this conception of the typical can be explained as one bureaucracy understanding the needs of others. (It was not for nothing that the Grierson style—the style of optical sound and cement joiner—recommended itself to the agencies of government and the managements of industry.) But perhaps it would be kinder to explain it as a gentlemanly hankering for a tradition in which, even if the filmmakers had to be taken on trust, the participants had at least some control over the image of reality they projected.

But while the BBC looks in one direction for its lost certitudes, documentary has been moving in another. This time the technical innovations have been less dramatic. While continued improvements in film emulsion have made it possible to shoot a high proportion of subjects with available light—or, at worst, with the replacement of ordinary lightbulbs by photofloods—cameramen and sound recordists, freed by the crystal pulse from the necessity of being roped together like mountaineers, have developed incredible virtuosity in working in unison to follow, steadily and continuously, the most confused discussion or complicated action. Meanwhile editors, feeling their language has be-

come stale with overuse, having seen the innovations of Godard and Ichikawa absorbed and exploited to the point of gimmickry, uneasy with the morality of subordinating real people's experiences to a paramusical structure, and bored with being able to sit at home watching the box and snap their fingers to cue in the voice-over, have become fascinated by the experience of "real time" which present-day rushes, in their continuity, frequently offer.

The result is the style, exemplified by the *Space between Words* series, which has been labelled "objective." My own belief is that the subjective/objective duality is one of those which, like classic/romantic or intellectual/emotional, is useful only where it is too crude to be interesting: but since the word is with us, it may be worth our while to ask whether this series can legitimately be described as objective in some sense in which other documentaries cannot, and to discuss the bearing of this style upon the ethical problems of filmmaking.

Before the films were embarked upon, a number of assurances were given to those whose participation was required, in return for which the unit were granted freedom to shoot whatever, and wherever, they wished:

1. The unit would never intentionally influence the course of events (for example, by revealing to one participant information gained from another).
2. The unit would shoot only what was relevant to the specified theme of each film, and nothing, however interesting, that was not. (This could scarcely withstand legal scrutiny; but it was not meant to. The spirit was clear.)

3. No one would be asked to do anything, or to repeat anything, for the benefit of the camera. (If we missed something, it stayed missed.)

4. The finished films would have no commentary beyond a brief, explanatory introduction (i.e., people's actions would not be subjected to verbal interpretation).

5. There would be no interviews. (This assurance was not given for all the films, but it was fundamental in winning the cooperation of the trade unionists—a group particularly sensitive to the way their statements are used on television.)

6. If there were objections on grounds of "security" to the use of anything which had been filmed, such as classified diplomatic information, it would not be included; and if necessary the record would be erased or exposed to light immediately. (Such destruction of material was never requested; and I recall only three remarks, out of 105 hours of rushes, which I was asked to omit from the films.)

These assurances, in addition to merely gaining the necessary consent to film, enabled the work to proceed in an atmosphere of relative trust. As a further preparation, the crew made a point of being on location, with their equipment, for anything up to a fortnight before the start of shooting so that their presence, being familiar, would cause the minimum distraction.

Indeed, one remarkable feature of the *Space between Words* series is their success in conveying the impression that the protagonists were wholly unaffected by the presence of the camera—or at least, were indifferent to it. Indifference, it must be clearly said, is not the same as unawareness: in fact the impres-

sion of normality owes a great deal to those occasional moments in which someone glances uninterestedly toward the camera, acknowledging its presence, then continues with what he is doing. On the other hand, it is easier to be indifferent to something if it is relatively inconspicuous: and the fact that the series was shot almost entirely with available light, so that people did not find themselves plunged into an extraordinary environment of glaring and shifting lamps, was paramount in permitting them to behave naturally.

But again, it is disarmingly easy to equate "naturally" with "normally"—to allow ourselves to believe that because people seem relaxed in the presence of the camera they are behaving exactly as they would if it were not there. These distinctions, though crucial, are rarely made. It needs only one extra person to enter a room—let alone a whole film crew—for the pattern of behaviour to be completely altered. The extent of this alteration will vary from one situation to another; but in all situations it can only be estimated by guesswork. Of course, it can be argued that what happens in the presence of a camera is as much a fact of life as what happens in its absence, and that one's only responsibility to truth is to ensure that the viewer knows the people know they are being filmed. (In case anyone is inclined to say that this can be taken as obvious, I should point out that some viewers have already asked whether the *Space between Words* series was not shot with concealed cameras, despite the evidence that the cameraman is clearly moving around among the desks of a classroom and filming from eye level.) It was in recognition of this argument that the American wing of the *cinéma vérité* movement sometimes went to great lengths to ensure the accidental presence of technicians and mike booms in picture; but the fact that this technique

rapidly degenerated into cliché is proof enough that it was alien to the nature of documentary. Even those occasional glances at the camera—a more discreet way of making the same point— are scarcely an integral element of film style. They may never happen to occur, or may all happen to be cut out in an editing process dictated by other requirements: and this will neither enhance nor diminish the truthfulness of what we are seeing.

If this sort of shooting can be called objective, it is only in the trivial sense that it is less predetermined than ever by the intentions of an individual—the director. But the cameraman cannot be looking everywhere at once; and his choice of angle will reflect his moment-to-moment judgment of what is important. A sound recordist, faced with an unruly classroom, must choose between using a wide-angle mike to pick up the ambient noise or a narrow-angle mike to pick up what people are saying. Alternatively, he can choose to mix between several mikes, thus either sacrificing his mobility or increasing the number of technicians required to carry booms. At one noisy moment in the *School* film the teacher leaned forward to say to a boy, "I can't hear you. I can't hear you." The cameraman zoomed in, but the recordist was not able to adjust his position quickly enough. The result was that, although the teacher was in close-up, her words were almost drowned out: and the effect, in the finished film, was to throw emphasis upon her difficulties. Our professional "honesty" would have deterred us from simulating such an effect in the dubbing theatre. Yet was it truth or falsehood?

Most people, if pressed for their definition of the "objective" view of an event, might define it as that view which would be obtained by an invisible observer with no preconceptions. But what qualities are we to attribute to our hypothetical observer? Can he

watch from all directions? Can he perceive the overall pattern of the action together with the minute, telltale gestures, simultaneously and with equal attention? If he has no preconceptions, can he have any criteria of relevance or even of interest? And if he were to transfer all his observations to film, how long would it take us to look at it? Eternity would not exhaust it. The objective observer is a chimera.

Criteria of relevance are, of course, central to the editing process. I was recently obliged to look through some material which had been omitted from the very first assemblies of the *Space between Words* films. It was an acutely boring experience: not because there was nothing happening on the screen (there is never nothing happening); but because the camera was failing at these moments to reveal anything interesting about it. Despite his infatuation with the "real-time" experience—and hence with the eventual extinction of his office—the editor finds himself, willy-nilly, making cuts: firstly to overcome camera run-outs and wobbles; then to eliminate longueurs and repetitions; next to clarify points of confusion created by earlier cuts; and finally, with resignation, to allow the film to take on that form to which it seems to aspire. And if at times he begins to feel that editing is less a creative act than a mutilation visited upon some defenceless simulacrum of life, he is nevertheless forced by the logic of his craft to acknowledge the distinction between film and reality: that film is about something, whereas reality is not. (Andy Warhol's twenty-four-hour look at the Empire State Building has the purely philosophic value of defining a limit. Like Duchamp's urinal, it needs not to be seen but only to have been done.)

The way in which a "slice of life" takes on the quality of being "about" something can be illustrated by another example from

School. The last two days of shooting afforded us two conversation sequences (neither, incidentally, used in the transmitted programme): in the one, the teacher on whom we had mainly concentrated said that the course of seminars conducted by an American educationist had greatly enlarged her understanding and increased her confidence; in the other, she said that the course seemed to have undermined her previous technique without putting anything better in its place. There was nothing particularly surprising about this. People's moods change, and they appear to contradict themselves. But for us the problem was how to end the film: and behind our jokes about using the happy ending for the American version lay an awareness that the note on which we chose to end would reverberate back through the programme and would express a view of the teacher's experience, whilst to juxtapose both possible endings would merely express confusion.

A further point emerges from this example: that, for all the differences of approach and method, the way cinematic elements function in these films is not dissimilar from the way they function in other films. In *Family* there is a sequence in which, after a gradual increase in emotional stress between the mother and the son, the father is shown withdrawn in concentration upon mending a child's toy. This shot is perfectly genuine, in the sense that it happened at the point which it occupies in the film. Yet it owes its remarkably moving effect not to its genuineness but to its poetic appropriateness. A shot of a father mending a toy could be taken in any family, at practically any time, with or without marital tension. And a Pudovkin could have perceived the possibilities of the shot and used it in just this way.

People have an eye for reality. In the films on which I worked there are one or two cutaways—as opposed to synchronous listening shots—which strike a false note for me, and which seem to do so for others. Yet the fact remains that a "genuine" shot works not because it is genuine but because it feels genuine. The *Space between Words* films can be analysed with much the same critical vocabulary as can other films. The differences quarantine themselves in the area where moral uncertainty resides—that of the filmmakers' subjectivity. The problems are in one respect worse than those which the BBC's booklet evades, for the Mitchell style left no one in doubt that what they were seeing was poetry. It is we, not the audience, who must take responsibility if dubious conclusions about the real world are based upon the false premises of our errors.

Cinéma vérité is not an elixir of truth. A film based upon no criteria of significance would be an amorphous mess; and criteria presuppose attitudes and judgments. How are these judgments made? In practice, on the *Space between Words* series, they were made over the course of lengthy discussions between the technicians involved: the camera and sound crew, who could assess the relationship of what they had shot to the event as a whole; the director and researcher, who were frequently not present during shooting (since they wished to keep distraction to a minimum, and were in some cases fully employed in trying to discover what would happen next) but whose many conversations with those concerned gave them an overall understanding of the situation; and the editor, who could judge the potential of the rushes unprejudiced by prior knowledge of what they were supposed to reveal. In addition, the films were frequently checked for com-

prehensibility and apparent implication with projectionists, office staff, and a random assortment of cutting room personnel, each of whose criticisms revealed the vantage point of his own philosophy.

But this was merely an extension, based upon conscious recognition, of that dispersal of responsibility brought about by the handheld camera and the enlarged shooting ratio. (The convergence between methods of procedure evolved to suit new equipment and insights into human communication gained from the subject matter of these films would almost merit a study in itself.) What we must ask is not only how, but on what basis, decisions were made: what were the guiding considerations; and did they differ from those governing the making of other documentaries?

Our overriding concern was that, just as the process of filmmaking should be as open-ended as was consistent with the need to produce finished programmes, the finished programmes should, so far as possible, reflect this open-endedness. We did not set out to prove anything, but simply to explore communication in several contexts with the aid of film. We did not assume from the start that communication between people was generally good or generally bad; and even the assumption that good communication was better than bad communication came under scrutiny. Though each of us, inevitably, had preoccupations (or values) which influenced his interpretation of events, we tried not to allow the structure of the films to be a mere expression of any one interpretation. For example, though some of us were struck by a parallelism between the manner adopted by management toward workers and that adopted by shop stewards toward members, we resisted using cinematic juxtaposition to make this a "point."

There can be few film editors who have not been disturbed by the ability of their medium to suggest that a subject has been exhausted. The mere act of cutting a sequence into coherent shape, the craftsman's compulsion to resolve irresolution and tidy up mess, contributes to a tradition whereby the viewer sails under sealed orders: and the very structure of the film conspires with the well-turned commentary to rob it of that penumbra of incomprehensibility which would preserve its link with reality and encourage the viewer to grant it further thought. (Comprehensibility has a way of implying comprehensiveness.) In the *Space between Words* series we tried to curb the encroachment of craftsmanship upon significance. We wished to leave people free to draw conclusions from the films as nearly as possible in the way one draws them from life, and hoped to avoid setting the familiar pattern of expectations within which the alert viewer watches for a clue to the stance of the *auteur*.

Some critics have seen in this an abrogation of responsibility. The *Socialist Worker* condemned the *Work* film for not condemning capitalism (apparently doubting capitalism's ability to condemn itself). But for anyone not committed to propaganda—which I would define as the conscious suppression of facts which might sustain a point of view other than one's own—our approach was a natural concomitant of that respect for "real time" engendered by the style of shooting which present-day equipment permits. It has its dangers. On the one hand, we cannot boast of leaving our films open-ended and at the same time complain if people draw from them conclusions we dislike. (Some reviewers have not merely drawn nasty meanings from our films, but have attributed those meanings to us and have proceeded to attack us for them.) On the other hand, in our anxiety to avoid

using film language to communicate a closed message, we risk forgetting that without this language a film communicates nothing at all. A further danger is that of being carried away by our enthusiasm into believing that we have achieved some sort of transcendental impartiality. Throughout the series we were concerned to avert misconception of one sort and another. In *School*, for instance, we had to give adequate account of the disruptive potential of thirty recalcitrant children without implying that the teacher was simply unable to control the class. But to seek to avert misconception presupposes a judgment of what constitutes a true conception: and this judgment must be exercised by fallible and prejudiced human beings. The notion of objectivity does not help.

We crave the security of absolute distinctions, and tend to argue as if a difference in degree were no sort of difference at all. But if the *Space between Words* series shares its syntax with *Rescued by Rover*, and if its distinctiveness appears at times to boil down to no more than the reinstatement of the unities of time, place, and action, and if we seem to have difficulty in defining its characteristics by other than negative statements, perhaps some measure of its success can be found in the extent to which those who have seen it discuss the subject matter rather than the films, and the extent to which they find in the films implications beyond those of which we ourselves were conscious.

The question which remains to be asked is whether this series indicates a direction in which television might usefully develop. The style is expensive, requiring as it does a high shooting ratio (so that the unforeseeable moments of real revelation may be captured) and a superlatively skilled camera and sound team (who will be in the right place when they happen): and, in a system

where merit must bargain with money in the accountant's language, the cost barrier may frequently prove insurmountable. But this problem may soon be overcome by the development of high-quality portable videotape units.

A more serious difficulty is that of overall length. Overtly poetic films in the tradition of the last ten years can accommodate themselves with relative ease to slot lengths fixed for the convenience of programme planners: their constituent elements can, if sometimes with resentment, be dismantled and reassembled in a different form. But a film in the style of *Space between Words* requires a finite time to reveal the significance of its subject: and what we lose by shortening is not just the significance of what is cut out, but the enhanced comprehension which this shed on what is left in: so that the film is not merely shortened but impoverished. Each film has its optimum length, defined by the point at which the increasing enrichment of cross-reference is overtaken by the repetitiousness of diminishing returns.

However, if we set aside these practical considerations, we may allow ourselves the fantasy of a television service in which every aspect of our social lives would be reflected in a public mirror less distorting than any to which we have been accustomed, and in which the sheer volume of such programmes would do a good deal to cancel out the lingering effects of prejudice in any one filmmaker. Indeed, it is not impossible that the portable video unit might eliminate entirely the ethical problems which currently beset the BBC. New problems would of course arise. The pessimistic side of this fantasy is the vision of a world in which people would be held to account for their unguarded utterances and the element of performance would therefore invade all our activities and relationships, with spontaneity retreating into the

hermetic isolation of the inner life. But which would then be the artifice and which the reality? And is this or is it not an inevitable consequence of a more open society—whatever its technical detail—in which matters of public significance would be released from the confinement of private grudge? To put it at its simplest, would not many people rather act out their predicament before a ciné-camera than state their case at a public meeting?

This brings me to my final point, which I deliberately side-stepped at an earlier stage. Among the people who were not consulted in the shaping of the films were the participants. This conforms with time-hallowed practice, which is usually defended on the grounds that the judgment of those who appear in a film would be vitiated by pride, vanity, modesty, or embarrassment. Perhaps it would; and perhaps to argue our way beyond such impediments would take longer than current production schedules allow; and perhaps the attempt, through open discussion with the crew, to reach agreement with conflicting parties on what constituted a truthful account of a given event would bear more resemblance to a psychiatric encounter session than to a civilised chat between colleagues, and the film would end in ribbons. But perhaps that is a better use for some films than transmission, and perhaps our budgets should allow for it. There is something to be said for an art which is grounded, as therapy, in a real situation; and since television is a collaborative art, it may as well be a collaborative therapy. The results might in fact be impressive.

Arms and the Absent

Two attitudes toward documentary are frequently met. One, to be found among filmmakers in such fields as anthropology and current affairs, is that documentary is a form to which aesthetic considerations are of little or no relevance. Truth remains truth regardless of how you tell it. The other, more in sympathy with the critical temper, is that all film involves manipulation of images, and that to accord documentary a privileged relationship with "the real" is therefore nonsensical. Film remains fabrication regardless of what it is saying.

In using the word "fabrication" I deliberately imply a sort of gradient where the idea of an artifact may be allowed to slide effortlessly into that of a falsehood. But still, it is by no means clear what manner of truth we might grant to statements which, expressed in what is not an abstract symbolic system, do not lend themselves to verification. Most of us would feel that the word "documentary" had not justified its place in the dictionary if the films so called did not manifest some relationship with the world

not shared by others. A documentary makes—implicitly—two claims: on the one hand, to present us with images referring unashamedly to their sources; on the other, to articulate a statement of which those sources will be the object. But can these two claims be reconciled?

One way of approaching the question might be to concentrate upon films whose interest seemed to lie entirely in their subject matter and to examine the artifices by which such "subject matter" was filmically constructed. This has, indeed, been the emphasis of much recent criticism, which has applied itself to the refutation of the position—rarely argued and scarcely arguable, but none the less potent for that—which treats documentary reality as an unmediated view of the world. But this leads ultimately to an impasse. If documentary reality is a filmic construct, yet is not a verifiable statement and certainly does not wish to be taken for a fiction, what exactly is it? Does it inhabit a purely autistic universe, having circumscribed its means of expression only to find its links with its sources severed regardless? I have preferred to approach the question from the opposite direction: to choose films whose linguistic complexities are extreme and obvious, and to ask whether or not such complexities render meaningless any claim to privileged relationship with the events or objects filmed.

The revolution in documentary filmmaking initiated by the introduction of portable equipment in the early '60s may be perceived in two ways: either as having renewed its innocence, by obviating the need for preplanning of shots, or as having destroyed its innocence by raising unprecedented doubts about the nature of its images. For this reason I have selected one film from the earlier and one from the later period: Georges Franju's *Hôtel des*

*Invalides** and Adrian Cowell's *The Tribe That Hides from Man.*** These two films seem to me to represent high points of sophistication in, respectively, the classical and modern phases of documentary: "classical" in the sense that the status of the linguistic elements—the source material—is not treated as shifting or problematical; "modern" in the sense that it is.

The Hôtel des Invalides in Paris, which houses Napoleon's tomb, combines the functions of the Chelsea Hospital and the Imperial War Museum. Franju's film concentrates on the Musée de l'Armée, though the old soldiers make one or two important appearances. The film is shot in a chill, Novemberish light. *Hôtel des Invalides* in high summer is almost unthinkable. Yet this can hardly mean that such truth as the film entails will fluctuate with the seasons. It is here, straightaway, that we encounter the paradox we hope to elucidate: for our primary response is to a mood; yet what has a mood to do with a museum?

The film, which follows the simple plan of a tour around the galleries, is composed and cut with that formal precision which one is inclined to call "military." (A characteristic pattern is the strict alternation of diagonal forward tracking shots with static close-ups of items of particular interest.) A few "other" visitors go the rounds with us; and the commentary, after an initial introduction, is carried by the voices of the guides.

On a superficial view, *Hôtel des Invalides* is a study in the horrors of warfare; and there is no lack of material for such an inter-

* Prod: Forces et Voix de France (1952).
** ATV Network Production. First transmission: 17 February 1970.

pretation. Early on, we see a pair of youngsters laughing at the dumpy shape of an old mortar. There is a starburst wipe from a close-up of the girl to a newsreel shot of an A-bomb cloud, and the commentator says, "Some of these engines of war amuse the visitors by their strange appearance; but, when we consider the dangerous growth of an industry which is shooting up like a poisoned mushroom, we must agree that it is no laughing matter." A double wipe, from the edges to the centre of the screen, takes us to a close shot of a shut door, which opens to admit us to the museum.

But other interpretations are available: interpretations which mainly support, but sometimes clash with, this primary one. Shortly before the scene just mentioned is the most notorious moment in the film. Out in the courtyard, the camera pans down from a low-angle shot of a statue of Napoleon on the facade of the building. As the pan ends, a squeaky little wheel enters from the right—a bath chair in which a nurse is pushing a wounded veteran. Over the pan the commentary says, "Legend has its heroes. War has its victims." The nurse pauses, and we have a close-up of the vacant, paralysed face of the old soldier apparently gazing up at the statue. (If we assume that he can see the statue, we read pained inscrutability into his expression; if we assume that he cannot, we read irony into the juxtaposition.) Then the soldier is wheeled out of picture in a shot whose foreground is dominated by the heavy barrel of a gun. Clearly the pan from the statue to the soldier supports the antithesis between hero and victim, between the glory of legend chronicled by the conqueror and the sufferings of those who achieve the conquest. But the visual metaphor in which this antithesis is couched—the contrast between mineral (whether stone or metal) and human flesh—is to weave

an independent course through the film. Finally, at a more abstract level of response, we are offered a third antithesis: between petrified past and mortified present.

The opposition between mineral and flesh is picked up almost immediately, with bronze lovers on the lugs of an artillery piece, and is then pursued in the room devoted to suits of armour. The early examples have the presence and menace of primitive masks. The gentle tracking past these "figures" seems not so much to invest them with movement as to draw attention to their lack of it. Yet in the gloom of the gallery we peer for eyes in the depths behind the visors, and half believe we see them. As the sequence progresses, the metal skins become more realistic: armour with noses; armour with moustaches; totally enclosed armour ("very rare"); a child's armour suspended from the ceiling like an aborted foetus in a pickling jar. Later, when we come upon the head from the bronze statue of General Mangin, which seems to have been hit in the ear by a cannonball, this obvious symbol of human decapitation is enriched, through the persistence of the mineral/flesh metaphor, with the suggestion that the more closely metal resembles flesh the more vulnerable it becomes. The theme is rounded off at the end of the film, where we cut with a smart "Eyes right!" from the tomb of Marshal Foch to a line of children leaving the museum, grouped as tightly as the bronze bearers of Foch's bier and singing the trench song "Auprès de ma blonde."

To appreciate the pervasive influence of the "third level" of antithesis—an interdependence between the past as hypostasis and the present as vacancy—we must look at what is perhaps the oddest sequence in the film: where a girl peers into a trench periscope and "sees" newsreel images of soldiers going over the top. The lead-up to this deserves scrutiny. In the final shot of the pre-

vious sequence, the white coat of the girl, whom we have not yet seen, is reflected like a passing ghost in the slanting glass of a case of rumpled tunics; and this suggestion of the visitors as revenants has been anticipated in a still earlier shot where their shadows, passing out of frame in the same direction, are cast against a panoramic painting of a battlefield—the last of the group, whom again we have not seen, being a limping man supported on the arm of his companion. Whether the past is haunting the present or the present the past, the two realms seem to exclude each other.

When we cut to the periscope, in long shot, the girl enters and moves toward it while her boyfriend stations himself immediately behind it with his back to us. On the practical level, this serves to demonstrate that the periscope has nothing up its sleeve —that it is not rigged to project images. On the metaphoric level it frames the boyfriend within the supports of the device in which the girl will watch young men facing death for the honour of France. In midshot the girl swivels the periscope, which its label identifies as from the Chemin-des-Dames sector. (The irony of such a name in the context of trench warfare is emphasised by a hint of the tune "Auprès de ma blonde" on the music track, which anticipates its use at the end of the film.) Next we see a reflection in the periscope of the plaster head of an officer, which we may have noticed in the background of a previous shot (and which somewhat resembles General Mangin, whose severed bronze head we have recently been shown). This shot introduces a sense of spatial disorientation; and it may be considered, with its ghostly white reflection juxtaposed against the tangible presence of the girl, the converse of the shot in which her reflected white coat flitted across the display of uniforms. There follows a close-up of the girl's own reflection as she uses the mirror to adjust her hair;

then, with a flick of the controls, we are into the newsreel foot-
age. The sound track cuts from music to battle effects.

What, however, is the status of this newsreel sequence? Our
initial response may well be that it "doesn't quite work"; and I
think this is because we are inclined to seek in it the obvious con-
trast between the living horror of warfare and the mute witness
of relics. But in which of these two categories are we to perceive
the newsreel as falling? The sequence might have supported the
"obvious" interpretation in either of two cases: if the newsreel
footage had been cut directly against shots of museum exhibits;
or if it had been presented as being seen by the girl in a what-the-
butler-saw viewing contraption. In the former event there would
have been merit in using clean, undamaged film, as similar as
possible in quality to the surrounding footage, in order to em-
phasise that the contrast was to be drawn simply between the
"content" of the images, i.e., between war and museum. In the
latter, where we would have identified our perception with that
of the girl, the scratched, sparkly and jump-cut quality of the
newsreel (as actually used) would have marked it as itself an ex-
hibit, occupying the same status as all the other exhibits shown,
and would therefore not have impeded our response to *its* images
as betokening reality—at secondhand, as it were. But where does
the sequence stand in relation to these alternatives?

There is indeed, despite the fact that we know the periscope is
not projecting film, a hint that the newsreel is being somehow
"viewed" in it. The early shots are masked at the edges as if
being reflected in the mirrors. Perhaps, then, we should read this
as an "as if" construction: it is *as if* the girl were observing a
battle through the periscope at Chemin-des-Dames. But in this
case too, surely, we would expect the images to be clean and un-

scathed, enabling us to assign to the battle the same level of reality as to her actual surroundings. Alternatively, we may understand that the girl is stimulated by looking in the periscope to *imagine* a battle in the only way she has seen one—in the scratched and grainy idiom of war footage. But in that case why are the initial shots masked exactly as is the reflection shot of the plaster general?

Despite the careful setting up of the girl's involvement with the periscope, there are perhaps equally persuasive reasons for not reading the battle footage as in any sense perceived by the girl. Firstly, although this footage is accompanied by sound effects which would seem to set it on the level of naturalism, these effects are curiously thin. Very similar effects—token sound, almost—have already been used over a shot of a naval aircraft apparently aiming its guns at some people seen distantly in the courtyard: and in that instance the effects are clearly established as part of a disjunctive sound track rich in comment and association. Secondly, the only other newsreel section in the film—the shot of the A-bomb—is closely parallel in that it is introduced by the only other close-up of a girl; yet it is firmly didactic in its relation to commentary and firmly artificial in opening and closing with wipes, which are not used elsewhere.

If we deny the relationship of the newsreel to the girl's perceptions, do we not thereby dispute its relationship to the periscope into which she is looking, and hence make nonsense of the elaborate construction of the sequence? One way out might be to suggest that the damaged battle film represents the periscope's own memory, stored in the reticulated quicksilver of an aging mirror. But we are now being driven into using an outlandish metaphor—not as a tentative verbal equivalent for the

metaphoric potential of a film image but to describe the mode in which an interaction of images is to be understood. The fact of the matter, as this must suggest, is that the conventions are methodically contradicting one another and are conspiring to present the newsreel not as shots of battle but as shots *of shots* of battle—or, if we prefer, as the image of something which was once an image of battle but whose potency has evaporated or may be denied. Neither of the simple conventions—direct juxtapositions or the what-the-butler-saw device—would have demanded this rupture in our cognitive response whereby the truth is held at one remove from our apprehension.

Once identified, the cognitive rift spreads through the film like a molecular realignment in a crystal lattice. Consider, for example, the use of the guides' voices for commentary. The guides are occasionally seen in picture; and their voices are laid over their shadows, their backs, and their presumed presence just off-screen. No doubt this method was dictated by budgetary limitations upon synchronous shooting: but the consequence is to establish the voices as comment both within the film and upon it. If "This way, ladies and gentlemen" and "Here we see such-and-such" are addressed to us as well as to the visitors, then so is, "Take your hats off, gentlemen, before the colours." And what are we to make of the moment, already mentioned, where the picture itself cuts to the command "Eyes right!"? By normal convention, if a commentator says, "He lives in a grey house," and we cut to a grey house, this is to be read as a direct statement in film language, whereas if a character says, "I live in a grey house," and we cut to a grey house, it is to be read as an image of what the character is seeing or visualising. There can, of course, be mutation—even within a single shot—from one mode to the other,

as when commentary picks up from voice-over. But in *Hôtel des Invalides* the ambivalence is present from the beginning and is never resolved: so that the epistemic status of the images is always in doubt. Moreover, the guides themselves are old soldiers—in a sense, exhibits.

Once again, then, we find a movement patterned upon the spiralling down from protective metal to metallic representation of unprotected flesh. The ambivalence in the treatment of the newsreel footage opens up a gap through which *Hôtel des In-valides*, since it is itself film footage, may be perpetually repositioned within its own perspectives: not in the sense that it would demand to be seen as "shots of shots" (our very need to attribute meaning effects a rapid recuperation on that level), but in the sense that the assimilated photographic images are denied a primary eloquence—or that such eloquence should always drain into its negation. Had the newsreel been intercut for direct contrast with the museum, the armaments might have taken on the quality of having just cooled, as in those paintings of game which are redolent of cordite because the carcases are obviously fresh. But the gun barrels stacked upright as exhausted smokestacks in the Courtyard of Victory are images not of guns but of things which were once guns—and yet perhaps are still guns (as the spiral turns) to the guide, to the visitors, to us. The tank is both awesome in its blackness and innocuous as an old boiler. The stone which is an image of the man who was Napoleon faces the man who is an image of what was once a soldier, yet is still a man. And the metaphor of vulnerability in the head of General Mangin receives an added undertone: that when armour-become-flesh is split open, there is nothing inside.

Perhaps the most bizarre object we encounter is the glass case containing, stuffed, Napoleon's horse and dog. As with most works of taxidermy, we are caught in the fascination of an irresoluble paradox which resembles that of the newsreel footage. As we look at the close-up of the horse, with its globular glass eye and its fixed, stitched grin, we try to tell ourselves that Napoleon sat astride this object, patted its neck, and gave it lumps of sugar; yet there is less horse in it than in a few swift lines from Hokusai or Gaudier-Brzeska. It is flesh made statue by the passing of years —a horse which is an inadequate image of the horse it once was. Similarly, when the composition of a shot and its overlaid sound seem to tell us that an aircraft is firing at a group in the courtyard, our response is: "See it as a fighter strafing those people. . . . No, it's no use. I can't." It is a stuffed aeroplane. Neither of these examples, I think, would assume its full effect without our predisposition to doubt the face value of the film's vocabulary. As it is, they contribute to it. One way or another, intrinsically or by their context, we are repeatedly presented with images which seem to strive for an heroic stature—or even merely to strive for a meaningful symbolic existence—to which they cannot attain. The museum is seen as the locus of something which, for all its obsessive concreteness, remains elusive.

History may remind us that *Hôtel des Invalides* was made at a time when French intellectuals were disillusioned by the failure of the Resistance to sustain its revolutionary impetus into postwar society; and when the military establishment, on the other hand, had probably not recovered from the shock of 1940: but this, while it may help to explain the emergence of such a film at this particular juncture, cannot account for our response to it

now. Since film speaks not with signs but with images, and since these images draw their primary force from the viewer's own experience, film syntax cannot easily lead us to a conclusion at variance with the value we assign to its elements. What is it in our perception of the subject matter—the contents of an army museum—which enables us to see the syntactical breakdown in the periscope sequence as implying a rift in the epistemic status of the images (rather than just as a maladroit handling of the medium) and, conversely, to see this rift as contributing to this perception?

If we visit a museum of art, we are presented in a direct way with the significances of the exhibits—in the sense that the artists' purpose was to make these objects for scrutiny. In a museum of science we see gadgets which, though obsolete, have added their contribution to the present corpus of knowledge. The only place where we experience a melancholy comparable with that induced by a show of military hardware is a museum of the theatre devoted to old posters, playbills, moth-eaten costumes, and snapshots autographed by forgotten matinée idols—the paraphernalia of the ephemeral. Here, because the significance to which the objects point is vanished and irretrievable, we can respond only in that mood of sentimentality to which the theatrical profession is understandably prone. But even plays are revived. Battles are not.

It is from this standpoint that we may interpret the grey light which suffuses *Hôtel des Invalides*. Whereas other seasons might have assumed symbolic potential—spring suggesting reconciliation, summer forgetfulness, or midwinter a stoic fortitude—the November light permits no patina of regret, hope, or nostalgia.

It presents us objects with complete neutrality. But it is precisely neutrality which renders an army meaningless. The "mood" of *Hôtel des Invalides* lies not just in our response to its grisaille tonal range but in our accepting its contradictory use of film conventions as an articulation of the view that threadbare regimental colours, the insignia of victories rendered null by the shifts and reversals of subsequent history, are the equivalent of rave notices for productions no one remembers. If we really believed its "victories" were our victories, the film would probably not work for us.

The old comrades attend a service at their Church of St. Louis, a baroque edifice which has clearly survived the "decapitation of the monarchy" and where the priest, performing his offices across an acre of chancel, makes the sign of the cross with a gesture verging upon the dismissive. The soldiers, jittery with shell shock, boasting their medals and their mutilations, proudly raise a banner with the motto, "Le Paradis est à l'Ombre des Sabres." The sentiment is not only monstrous: it is out of date. As with the symbols of war which are no longer instruments of war, their presence serves only to assert their loss of significance. To present the army museum among leafless trees, against a sunless sky, is to withhold the promise of fresh emotional engagements and to focus attention upon the exhibits simply as the detritus of lapsed passion.

As I have already suggested, *Hôtel des Invalides* is a "classical" documentary in that the status of the images with respect to the objects portrayed is, with the arguable exception of the newsreel footage, unvarying and certainly unquestioned. The cognitive

gap which we have examined, manifesting itself as "mood" and requiring for its closure the viewer's commitment to a specific understanding, consists in the refusal of the film's grammar to articulate those symbolisms latent in the objects—flags, statuary, engines of war—before they were filmed. With *The Tribe That Hides from Man*, however, there is a constant questioning of the images by the grammar in a way that unsettles our assumptions both about the relation of the apparent event to the event filmed and about the relation of the event filmed to the wider context. But to what purpose? The film caused something of a stir at the time of its appearance, and is one of the few television programmes to have lodged in the public psyche for many years after its transmission. We must surely assume that its vision derived some profound benefit from the deconstructions practised upon its language.

The Tribe That Hides from Man concerns the attempt of Claudio Villas Boas to establish contact with the remote Kreen-Akrore tribe in the Amazon jungle and to introduce them to the Xingu reserve—a sort of buffer zone between the Stone Age and the twentieth century—before they are steamrollered by the inexorabilities of "progress." At first glance, it is little more than a current affairs–style account of the expedition. The anthropological insights of Villas Boas, though expressed with that unflinching humanity which, in its realism, stands strangely close to arrogance, are scarcely revelatory. His somewhat ornate Portuguese phrasing, translated and delivered in the impeccable English of Michael Flanders, is oddly reminiscent of Jules Verne. But to say this is already to hint at the pattern of prismatic refractions into which the film's meanings seem broken. It is the

equivalent of the "mood" which we sought to explicate in *Hôtel des Invalides.*

If, however, we seek a point of entry to discussion of the film's structure, comparable to that offered by the bronze/flesh polarisation, we need look no further than the very opening. A pair of eyes, in a paint-smeared face, peers implacably at us through a tangle of branches. The focus blurs, and we mix to a slow zoom-in onto Villas Boas, who reclines in a hammock swinging mechanically, watchful, smoking. "For three months I have hardly left this hammock. I know I am beginning to look strained and nervous." The words of his voice-over establish that he experiences himself as being seen. We mix to a shot of the wall of foliage, which is the edge of the jungle, moving up and down as if viewed from the hammock. But the camera does not adjust to compensate for the swing. It is the gaze of a man who is tired of looking.

Here, announced like a motif in three succinct images, is an intimation not only of the film's theme but also of its manner of address and, by implication, of its stance toward reality. Film convention tells us that the first shot is of an unseen watcher— though this must be a staged shot, since someone who is unseen cannot be photographed. The second shot clearly represents what the watcher sees; and this may perhaps be "genuine" if our viewpoint is to be that of the Indian; but the emergence of the voice-over tells us that it is Villas Boas whose viewpoint we share. The third shot, confirming this, is taken as "subjective," since cameramen do not shoot from hammocks without good reason. Thus the opening sequence, though we assume all the shots to have been filmed on location during Villas Boas's vigil, is put to-

gether in a fictional manner. We might be inclined to call it reconstruction: but reconstruction of what? An incident which is not known to have occurred cannot very well be reconstructed.

Given the fictional treatment of the images, the use of the present tense in the voice-over strikes an almost aggressive note. (In fiction films, if verbal narration is used at all, it is usually set in the past; and we tend to read the fictive use of images similarly.) The remainder of the film is told in flashback (for contact with the Kreen-Akrore is never made): but the present tense is nonetheless retained for the account of the current expedition, the past being reserved for Villas Boas's recollections of earlier experiences. In these instances the use of reconstruction is acknowledged. Yet even here the status of the images is rarely assured. The account of an Indian attack upon an earlier expedition is illustrated by stills: but are they reconstructed stills or true ones? It is as if the filmmakers were saying, "We could lie to you if we wished, but why should we want to? We could lie without your knowing it: so why not trust us?" But there is more to it than this. The constant ambivalence in the status of the images, the introduction into *vérité* footage of elements which lead us to question its authenticity, serves to define our perception of the film's reality—our attribution to it of documentary truth—as entailing the proviso that, on the level of significance on which we are responding to it, such questions of veracity do not arise.

The "manner of address" of *The Tribe That Hides from Man* may be inferred from the sequence in which members of the Txukahamei tribe reenact, for Villas Boas's benefit, a raid recently mounted upon a Kreen-Akrore village. In the opening long shot he sits in the foreground, as if to be entertained by a dramatic spectacle for which the deserted camp beyond will provide the

stage. The "attack" is then filmed from the midst of the action, in the style of a feature film heavily influenced by *vérité* techniques. As the action dies down we see Villas Boas in pensive close-up; and this is intercut with shots of an Indian handling a necklace, captured from a killed Kreen-Akrore, which Villas Boas recalls having once given to a Txukahamei. The natural sounds fade; and the voice-over, by association with the close-up, assumes the quality of interior monologue: so that the other images assume the quality of memory. We see a triumphant Txukahamei maltreating a captured Kreen-Akrore child. "White men can be just as cruel; but they would never let me see." It is therefore both a mental image and a thing observed. Did it occur before or after the performance we have just witnessed? The examination of the necklace and the brandishing of the child do not register as reconstruction. (The anguish of the child is certainly unfaked.) These scenes appear to form the climax both of the reenacted battle and of the real one—a confluence of two continuities and of two levels of signification.

Natural sounds return as we mix to overhead shots of the jungle. Villas Boas and some companions are trying to locate the Kreen-Akrore village from the air with the help of information given by the Txukahamei. As we sight the village there is a quick zoom in, and the frame freezes upon the indistinct image of an Indian looking up at us. The dialogue in the aircraft, subtitled in English, gives way to voice-over: "What right have we to trouble those tiny dots below? They don't want us. . . . But the world has found them; and we already know the price of their discovery." From the frozen frame of the "tiny dots below" we cut to a montage of headlines announcing massacres of the Indians. These, with their murky photographs, are the way our culture presents

to us our "discovery" of the Indian, just as is the frozen image of the film we are looking at. The montage is accompanied by insistent drumming indistinguishable from that parody of tribal music with which the entertainment industry of our society spices its reinterpretations of our acts of slaughter. Our response to this music engages us in an attitude both accusatory and confessional.

The Tribe That Hides from Man addresses us in the equivalent of a colourful colloquial lingo mingling technical jargon with biblical allusion, rhetoric with slang, where each usage sets the others in metaphoric quotes—a sort of cinematic Bloomspiel in which the conventions constantly call each other into question. A way in which our responses may engage with such address can be illustrated with the hunting sequence. The voice track is telling us that the Indian regards death, whether of animals or of Indians outside his tribe, with indifference. Within the group there is gentleness and love; but outside there is only the jungle. The low-angle shot of a bowman is in the classic tradition—the representation of an event as archetypal. But the monkey which falls from the tree, pincushioned with arrows, suffers an individual death. There is some chasing of a tapir, taken in harmless long shot; then we come to a close shot of a frightened monkey that will be killed with clubs. A group of Indians surround the animal, flailing at it. As the activity becomes more frenzied, the camera begins to zoom in and out quickly while panning up and down with the clubs—an orgiastic involvement on the part of the film itself which is at variance with the sentiments of the narration—and this leads into a wholly subjective shot, from the monkey's point of view, of the silhouetted Indians raining blows upon us. It is, we

may suspect, a fate which could befall Villas Boas himself were he to put a foot wrong in his dealings with an unknown tribe.

The treatment of this climax is familiar to us from the world of feature films (there is, for example, something very similar to it in Joseph Losey's *The Damned*); and it is the final subjective shot, above all, which those who disapprove of *The Tribe That Hides from Man* quote as undermining its credibility. It seems to me that we may distinguish a number of levels of response, involving successive degrees of reflective abstraction, on which this sequence may be perceived as saying different things or as working (or not working) in different ways:

1. At an extreme of innocence, of unfamiliarity with feature film conventions as they have grown up over the years, we might expect incomprehension. Why are the Indians attacking the cameraman? (In the context of a *vérité* documentary this would be a perfectly legitimate question.)

2. The conventions may be accepted at their face value, as "saying" that the Indians are vicious people who beat helpless monkeys to death, though the commentary is attempting to excuse them. (This seems to have been the response of most of the press critics, who applied to the film such terms as "An orgy of nudity and violence.")

3. We may react against the implications of this response—while supposing it to have been the intended one—by rejecting the conventions themselves as "artificial."

4. Alternatively, the artifice may be understood as *purely* conventional, as an item of received film syntax, a device worn so thin as to be virtually transparent, the equivalent of a

dead metaphor: just a way of saying, "Then they killed a monkey."

5. The conventions may, however, be seen as called into question by their juxtaposition with those drawn from other traditions—classical documentary, *vérité*, reportage—much as dead metaphors may be brought to life by being mixed. On this level, the feature conventions may be understood as counterposing our European cultural tradition of violence against the attitudes attributed to the Indian.

6. This may be perceived as the "purpose" of the sequence; but the method used may be deemed inappropriate on the grounds that to contrast the Indians' *act* of "violence" with the European manner of *portraying* violence is an untrue antithesis; and that the European tradition might more accurately be represented by the actualities of large-scale war than by the way a beating-up may be sensationalised for the purposes of drama.

7. Despite this, we may be impressed by the fact that our mistrust of the sequence presupposes our comprehension of it; and, further, that mistrust on one level seems a prerequisite of comprehension on another. Our comprehension may therefore be seen as embodying, in the flaw of its required mistrust, a confession that our response to the Indians' behavior must inevitably be marred by ethnocentricity, an ethnocentricity which a more direct technique would have concealed behind the camera.

Our awareness of this scale of possibilities does not in itself determine the level on which we will receive the sequence, which

is likely to be the one which offers the most fruitful interactions with the remainder of the film. Neither does it enable us to infer the construction placed upon it by the filmmakers. But we may note with some interest that those of the above responses which have relied upon the imputing of purpose or intention to the sequence have been, by and large, those which have viewed it with disfavour.

The comparison with *The Damned* might appear fanciful were it not for the fact that such fleeting references, too tenuous to be called quotations, seem frequently to hover over the surface of *The Tribe that Hides from Man.* A purely *vérité* sequence offers us, in the excited discovery of a footprint at the water's edge, a moment straight out of *Robinson Crusoe*—itself one of our earliest myths, telling in its popularity, of encounter between the races. The tapir hunt may recall the portrayal of our primitive ancestors in *2001*. And the meditation from the aircraft upon the "tiny dots below" cannot fail to suggest a parallel with Orson Welles's speech from the Ferris wheel in *The Third Man:* "Would you feel any pity if one of those dots stopped moving—for ever?" Such references mark the complicity of our representations with the totality of our heritage. The humanism of Villas Boas has, as he recognises, one thing in common with the cynicism of Harry Lyme: that it presupposes a position of superiority which we, in our understanding of his story, are doomed to share. The collage of styles with its kaleidoscopic internal reflections of our ambient culture, the hermeticism of a work which imprisons rather than excluding us, is appropriate to the account of a man poised between a society too complex for individual comprehension and one which, in its apparent simplicity, eludes even our speculations.

The story ends where it began. The small circle of the present tense is closed; and, with it, the wider orbits of recollection. So far as the film is concerned, Villas Boas will swing in his hammock till the end of time. It is here that we may seek an explanation for the opening shot. We have caught only brief glimpses of the Kreen-Akrore, seen distantly across the water or from the air—just as, in the best horror movies, we are allowed only a glimpse of the monster. When a human form vanished into the jungle during the long march to the river, our uncertainty as to whether this shot was genuine, or merely a simulation of something one of the party thought he had seen, enhanced our sense of the Kreen-Akrore as absent—as evading not just our overtures but even our modes of representing the world to ourselves. A close-up of a friendly Indian peering at the camera through some leaves, used in a sequence whose artifice was to state a self-contradiction, can only have been an image of the absence of what it purported to be.

But if Villas Boas will never leave his hammock, the Kreen-Akrore will never be contacted—will never emerge into face-to-face human ordinariness from the realm of myth which they share with elves, trolls, and goblins. Villas Boas, marvelling that they do not make the staple bread of the Amerindian, that they kill even the children of their enemies, refers to them as alone in the emptiness of the jungle. This is strange anthropology. The villages are communities, and the jungle is their larder. The Indians are not exiles from anywhere. They are at home. The film's resemblance to the work of Jules Verne goes beyond the flavour of its translations to the memory of a time when nineteenth-century science, concealing its diffidence in bravado, faced the

atavistic symbol, phantasm yet fact, of the "dark continents." It is not a question of racialism, though racialism has bent such imagery to its purposes. It is a reflection of the desire that there should still be a reality outside the grasp of our comprehending languages. By representing the tribe as absent, the film is able to recapture a Victorian amazement at the world without contravening those twentieth-century conventions whose insidious message is that life will always be unsurprising. The "absence" of the Kreen-Akrore is the absence of something whose presence would irrevocably dissolve it as scrutiny destroys dreams. Our response to *The Tribe That Hides from Man* expresses our longing that a thing may become familiar without losing its magic, that our next triumph may confute our expectations by not proving a disappointment, that beyond the next peak may stretch not a vista of more mountains but the plains of heaven on earth.

Whereas the maker of a documentary film is likely to see the status of its constituent images, their "reality," as an elemental contribution to the meaning of the whole, the viewer is more likely to see things from the opposite direction, attributing to the whole a relevance, a quality of being "about" something, which he will then read back into the constituent images. In documentary, as perhaps in film generally, meaning precedes syntax. Film has no "parts of speech"; and only in granting it significance do we freeze its associations into a presumptive grammar. Thus, as has been implied, anyone unwilling to assent to the proposition that glory is military schmaltz may dispute that the bronze/flesh opposition plays a significant part in the structure of *Hôtel des*

Invalides; and anyone unresponsive to the elegiac undertones of *The Tribe That Hides from Man* may find its linguistic acrobatics merely tiresome.

It seems to me evident from discussion of these two films that the complex manipulations to which their images are submitted, far from contradicting, cannot be divorced from the claim of those images to a privileged relationship with the world. If the Hôtel des Invalides were a purely fictitious museum, a montage of architectural details and studio interiors assembled solely for the purposes of the film, then the complex means by which its elements are articulated—the "cognitive rift" by which its prior symbolic values are denied potency—would crumble into the gratuitous. Its functioning as a general statement is conditional upon our confidence in its elements as having an existence anterior to that statement. Likewise the self-questioning narrative of *The Tribe That Hides from Man* could not serve to chronicle a fictitious quest for a fictitious people. Let us not be misled by similarities with devices sometimes employed to deconstruct the false coherences of realism. It is not simply that to posit the nonexistent as absent would be a fatuous exercise, but that the close-up of an Indian may affirm his absence only where the provenance of an image is assumed to be relevant. The Indian is "absent" precisely because the syntax of fiction, with its assumption of narrative omnipotence (which is what omniscience amounts to in film), is being used to articulate material where such an assumption is precluded. The Indian cannot be "there," as a documented Kreen-Akrore, since the film narrative—even without the words—asserts that he has not been seen by "us"; yet he cannot be "there" as a purely narrative construct, since we are com-

mitted to a documentary reading. There is no filmic space for him. What is called in question throughout *The Tribe That Hides from Man* is the relationship of its constituent images to anterior events, whether on the narrowly technical or the broadly cultural level. But this makes no sense unless we assume that the relationship matters.

The Aesthetics
of Ambiguity

> In Plato, art is mystification because there is a heaven
> of ideas; but in the earthly domain all glorification of the
> earth is true as soon as it is realised.
> *Simone de Beauvoir*, The Ethics of Ambiguity*

Recently I cut a film about two women and their suburban London ménage. After the completion of the editing, I came to know these people personally, and visited them in their home. When the film was eventually transmitted on television, I found myself perceiving it in an unnervingly bifocal manner. To the extent that I fed into the images my subsequent knowledge of the characters and location, the film broke down into incoherence. To the extent that it did cohere, it projected a world that repudiated any connection with the people and place as I now knew them.

* Tr. Bernard Frechtman. Citadel Press, New York, 1962.

Such an experience is the subjective correlative of the dual nature of film, which exists both as record and as language; and this duality, a source of paradox, has generated much confusion in the debates surrounding "observational cinema."

The problems we face are not new in principle; but the terms in which they must be resolved have changed radically within the past fifteen years. Beneath the many styles in which documentary has historically manifested itself may be discerned a common purpose: to enable the character of film as record to survive, so far as is possible, its metamorphosis into language. But the development of lightweight cameras and tape recorders, mobile and relatively inconspicuous, has brought documentary to a crisis which is largely one of confrontation with its own being. It is as if, having long watched itself approaching, it were now almost near enough to reach out and shake itself by the hand. Almost, but never quite.

The crisis has been most acutely registered in that realm of subject matter which may be termed the domestic. At a calculated risk of question-begging, I shall offer a filmic rather than an ethnographic definition of the domestic realm as comprising those areas of human activity which are (a) most difficult to shoot without interference, since they are not public, and (b) least susceptible to reenactment, since they are not in any simple way repetitive. The purpose of this somewhat negative phrasing is to denote an area of personal, intimate though not quite clandestine behaviour in explicit contrast with those repeatable or public events which have formed documentary's traditional sources— events on which the paraphernalia of filmmaking has been assumed not to exercise any significant influence. Repetitive actions—such as the operating of a lathe—can be performed in

front of the most cumbersome of cameras once the subject has overcome self-consciousness. With public events—such as political speeches—it is different. We cannot say that the presence of the camera necessarily has no effect, for there is a whole category—once known fashionably but misleadingly as *non*-events—where the attention of the media is held responsible for their very existence. An early example might be the 1934 Nazi Party convention, which, we are told, was organised largely with a view to supplying Leni Riefenstahl with good shots. But it is difficult, in such cases, to charge the camera with "distortion." Rather, it is in the nature of public events to *change* their nature according to expectations of public response.

It was a consequence of the character of these traditional source materials—materials which contained already, in their being rehearsable and/or audience-directed, something of the quality of such events as exist only for the purpose of being filmed and of being wholly assimilated into the fabric of a discourse—that documentary seemed, in its classic period, to be concerned only with general truths of the human situation as opposed to the "individual psychology" of acted fiction: dubious distinction being thus implied between people as individuals and as social creatures. It is not surprising, then, that the prime enticement offered by the new equipment should have been the possibility of opening up domestic behaviour to the record without first translating it into something other than itself (i.e., the scripted behaviour, or at least improvised performance, into which classical documentary had sometimes gingerly ventured in an attempt to transgress its limits); that the problems entailed should have been seen as clustering around the ideas of "influence" or "distortion" within the pro-filmic; and that those immediately exercised by such

problems should have been the fieldworkers—directors, camera operators, and, above all, anthropologists already committed to a notion of academic "objectivity."

While most practitioners would claim to be aware that film is not an open channel to "reality," they have nonetheless tended to see the difficulties as centring on their own attitudes and the fear that these may somehow mar the neutrality of the material. Many of the prescriptions of *ciné*-anthropologists have rested upon an assumption, implicit or explicit, that the inevitable selectivity of shooting may be counteracted—or perhaps merely atoned for—by a refusal of selectivity in the editing: that the minimum of structuring will afford the maximum of truth. But the antithesis of the structured is not the truthful, or even the objective, but quite simply the random. We may, indeed, find it a little puzzling that anthropology should have taken so readily to observational modes of filmmaking at all, when it might, as a science, have been expected to prefer the traditional patterns whose tight organisation of protofictional (or at any rate protodemonstrative) materials promises to raise the general principle above the vagaries of the particular instance. (Flaherty's method, for example, with its heavy use of reconstruction, may be said to have been based on the idea that the better we familiarise ourselves with the lifestyles of our subjects, the more of the elements of those lifestyles will be gathered into the realm of the repeatable —repeatable by virtue of our-the-filmmakers' understanding of what constitutes their essentials.)

All events, at least in human affairs, are *events perceived by* somebody. What may seem to be at stake, from the filmmakers' viewpoint, is to prevent their own perceptions from intervening between the viewer and the pro-filmic. But the filmmakers' in-

tentionality is not within the viewers' ken; and their abdication of it will, conversely, do nothing to prevent the camera from transposing the world into what will function for the viewer as imagery. It is to the nature of this imagery that we must look for clarification.

• • • • •

The photograph is a physical imprint of the world. Like the photograph, film stakes a claim on reality which has nothing to do with "realism" in any literary sense; and it is this claim which documentary aspires to fulfil. If it has proven notoriously difficult to define documentary by reference to its constantly shifting stylistic practices, it is because the term "documentary" properly describes not a style or a method or a genre of filmmaking but a mode of response to film material: a mode of response founded upon the acknowledgment that every photograph is a portrait signed by its sitter. Stated at its simplest: the documentary response is one in which the image is perceived as signifying what it appears to record; a documentary film is one which seeks, by whatever means, to elicit this response; and the documentary movement is the history of the strategies which have been adopted to this end.

A crucial fact about the definition of documentary as a mode of response is that it places the attribution of documentary significance squarely within the province of the viewer. Any fiction film can—albeit with difficulty—be perceived as a documentary on its own making. Of course, it is perfectly possible for a film to "be" a documentary in that it will achieve greater coherence on this than on any other interpretation; and it is certainly more than possible for the makers to have intended it in this sense. But

the fact remains that documentary is what we-as-viewers can perceive as referring to the pro-filmic, it being supposed that we can thus construe it as meaningful. However, if we are to treat documentary as so defined by the viewer's perception, we must face up to certain difficulties which this raises concerning the identification of the images.

The photograph—once we are sure that it *is* a photograph—cannot lie. But it can be wrongly labelled. This so-called photograph of King George VI is *in fact* a photograph of someone else. If we accept that documentary is best defined as a way of perceiving images, we cannot evade the implication that it is blind to the falsity of labels. Documentary will be consequent upon what it appears to show, rather than upon what it necessarily does show; and the relationship between the two is a matter for the filmmakers' ethics, inaccessible to the viewer. Yet the assumptions which the viewer makes about this relationship, on the basis of signals intended or unintended, will inform his perception of the film. To make a documentary is therefore to persuade the viewer that what appears to be *is*.

Film is not unique in this demand for a response based upon an ethical assumption which it cannot substantiate. Jazz, for example, may be considered documentary music in that it claims to be predominantly improvised and therefore to represent the actual moment of musical creation. Likewise functional architecture, in its requirement that appearance should express use and structure, is assumed not to cheat. What appears to be a load-bearing pillar must not be simply the outer facing of a ventilation duct. It is possible for documentary to be labelled as such in a bald, extrinsic manner with some caption or billing or publicity which, whilst overtly just requesting us to construe the images in

a documentary sense, carries also the implication that they may be taken on trust. (Here again, Flaherty may offer us an example: for the *myth* of Flaherty, to which he never quite lived up, was taken as an extrinsic tag of "trustworthiness" under whose credentials he felt able to engage in a degree of manipulation of the pro-filmic which most people today would consider a transgression of anthropological ethics.) Most filmmakers, aware of the implicit circularity of this—"Believe me when I say that I'm telling you the truth"—prefer to rely upon intrinsic signals as indications of how the film is to be understood. The labels are swallowed. The ethics become buried in the style.

Documentarists, tracing their genealogy proudly from Lumière, like to believe that documentary is the "natural" form of cinema. But fiction film, like painting and literature, rests no special claims upon the provenance of its linguistic elements. It must surely be clear that it is documentary which is the paradoxical, even aberrant, form. True, the first films were of a "factual" nature; but the medium was not out of its immobile, one-shot infancy when someone saw the possibility that it might be employed to signify something *other* than that which it recorded —this step being taken by Méliès, a prestidigitator. From now on, it was nonfiction films which were to be distinguished by a special name: actualities.

The problems latent in the idea of actuality become compounded at precisely the point where this name becomes inadequate and must be replaced by the more evasive one, "documentary": the point at which the primordial image becomes articulated as language. (It is interesting, though futile, to speculate on how differently the syntax of film might have developed

had Méliès's irreversible step—the original sin of cinema—not been taken.) The difficulties are twofold. Firstly, this is the point at which it becomes possible for the articulations to be used—and perhaps inevitable for them to be perceived—as implicit indications of the nature and status of the component images. Secondly, there is clearly no sense in which the one-to-one relation of shot to prior event may be said to hold good for a structured sequence, let alone for an entire film. The activity of an editor is in this respect more akin to that of a painter than to that of a photographer, whose apparatus may be held to ensure a certain "objectivity" even when it does not produce a good—or even a recognisable—likeness. In what sense, then, is it meaningful to claim any privilege at all for such structures?

These two difficulties—the status imputed by structures to their elements and the status claimed for the structures themselves—may be seen as the "vertical" and "horizontal" aspects of the problem. They are not entirely separable, as one example will suffice to demonstrate. Consider a group of synchronous shots taken from various distances, with or without simultaneous cameras, at a cricket match. An essential factor in this record, as indeed of the "atmosphere" of the occasion, will be the delay between sound and vision as the ball makes contact with the bat. This delay will vary in proportion to our distance from the batsman. If, then, we wish to cut from midshot to long shot immediately after the batsman's stroke, in order to show where the ball goes, the sound on the former shot will be almost instantaneous with the image, whilst the sound on the latter will be noticeably retarded. Thus the sound on the former may occur before the cut, whilst that on the latter may occur after it: in which case we

should hear the impact twice. Conversely, if we cut from long shot to midshot to follow the subsequent movement of the batsman, we ought not to hear it at all. What an editor will in fact do is to iron out these anomalies by laying all the sounds in apparently simultaneous synch with the pictures. In doing so, however, he is allowing a syntactic relation between two elements— a relation whose claim to documentary privilege might properly be discussed in the context of alternative "horizontal" strategies —to determine a shift in the actual relation of the image to the pro-filmic. (It need hardly be added that the problem becomes more vexed when we are dealing not with true variations in camera position but with variations in the setting of a zoom lens from a static viewpoint.)

With this proviso in mind, however, let us examine first the "vertical" question. To face it directly: when, in our watching of a film, do we "know" that it is a documentary—i.e., that its constituent images are to be read in a documentary sense—and how? What is the nature of those buried stylistic signals to which we are responding? The answer to this question will vary from film to film and also, perhaps, from person to person; but what is probable is that these signals, in fact no more than reading instructions preferred to extrinsic labels for their very inexplicitness, will take on, through our-the-viewers' acquiescence in them, the misleading and contentious character of guarantees of the film's veracity. The reasons for this lie in the nature of the documentary idiom.

Just as jazz and functional architecture are identified by certain characteristics consequent upon their mode of manufacture, so most of what one might designate the stylistic indices of doc-

umentary have always been the product of practical constraints: the physical difficulties of filming, the demands of a theme not wholly tailored to the pregiven technology, or simply the usual inadequacy of the budget. These find their objective expression in: a predominance of location shooting; a graininess due to the absence of studio light; a customary linking of diverse images through verbal narration; a woodenness in rehearsed performances due to the use of nonactors, and a consequent tendency for rehearsed material to be broken up into short units; a wobbliness in spontaneous material due to hand-holding of the camera, and a toleration in such material for temporary lapses of focus or framing and for imperfect continuity in the cutting of supposedly matching actions; and a tendency to define complementarity of shots (in a crosscut conversation, for example) according to the framings obtained by panning the camera from a fixed position.

In fiction film, by contrast, the stylistic characteristics are not directly determined by the exigencies of production. Thus, for example, a crosscut conversation will typically be constructed from an alternation of over-the-shoulder shots involving a relocation of the camera, as often as not in midsentence. Generally speaking, classic fiction style wilfully avoids the construction of its space from what might be thought credible positions for one casual observer. It is as if the very arbitrariness of the conventions were itself an index of the fictive disposition of the elements—a signal that what actually happened during filming had no priority over the *fact* of filming, and need not concern us.

But if the idioms of documentary are not arbitrary, that certainly does not mean that they are trustworthy. There is scarcely

one of them (the only obvious exception being the unactorly performance) which has not at some time been appropriated by the fiction film, in which context it becomes an *arbitrary* signifier of real*ism*. Indeed, it is difficult to think of a style of realism in fiction which does *not* call upon some quality thrust upon nonfiction by circumstance. It is almost as if verbal realism were to find it necessary to sport the misspellings, erasures, and shaky grammar of a hastily jotted dispatch. But the traffic has, of course, been two-way. Documentary has usually sought, in its more premeditated sequences, to approximate to the arbitrary conventions of fiction, since these constitute, after all, our received and shared film language for the articulation of time and space. The strangest transactions, however, are documentary's borrowings from itself. We have all seen the shot where a reporter knocks on a door and is admitted, camera atilt, mike in picture, and handheld lights slewing drunkenly, to a house whose occupants show not the slightest surprise at this invasion. At this point the documentary ethic is buried in more senses than one. (No doubt this sort of thing happens less in academic filmmaking than in television; but only in the most Utopian of fantasies can we neglect entirely the possibility of fraud.) What this amounts to is an attempt to invest documentary realism with literary realism: a superimposition of idioms which, ethics aside, can lead only to a blurring of perception.

What we have seen in recent years has been a narrowing of the gap between the languages of documentary and fiction. On the documentary side, this convergence has resulted from precisely those technical developments which have been hailed as opening up the domestic realm to scrutiny, and from the skills developed

by technicians in response to their challenge. Those same light-weight, silent-running cameras and recorders, plus film emulsions whose sensitivity obviates the need for extra lighting in most situations, have led to the production of films whose fluency of camerawork and naturalness of "performances" rival the most polished of studio achievements; and the high shooting ratios now frequently available for such filmmaking have opened up an unprecedented range of stylistic choice for the editor.

What "observational" technology in fact offers us, when we turn our attention from its mere data-gathering aspects, is a film grammar almost free of such technical limitations as have in the past characterised documentary, and have indeed virtually defined it in contradistinction to fiction. If documentary is a form fractured by paradox, what are we to think of a fulfilment whereby it divests itself of what have hitherto been, for the viewer, its definitive and delimiting features? There have, after all, been earlier casualties of the discovery that a stylistic label guarantees nothing: witness that "immediacy" which, as a cant word in the formative years of television, carried an implication that the quality of being immediate, rather than simply of looking spontaneous, might magically be conveyed across the airwaves. This concept did not survive the introduction of videotape recording. Does documentary face a similar dissolution?

Some people would argue that any distinction between documentary and fiction diminishes rapidly toward zero as a film increases in complexity, and that such problems of language and labelling as have been seemingly posed or exacerbated by recent technical advances are no more than the reaffirming of this underlying contradiction. If they are right, then documentary is in-

deed a false calling. It is here that we shift from the "vertical" to the "horizontal" dimension: from the question of the labelling of elements to that of the relation of a broad text (and, by implication, of the elements considered as subdivisions of that text) to the pro-filmic. For to make documentaries is to engage with precisely this paradox: to seek structures in which the aspect of film-as-record may retain (or perhaps reassume?) its significance.

· · · · ·

The definition of documentary in terms of the viewer's perception—i.e., as material perceived as signifying what it appears to record—avoids some of the wilder consequences of attempted definitions in terms of productive method, which, with their stress upon the status of the pro-filmic, inevitably end up in disputes about whether this or that reality is as real as it might be. It is in this light that we may understand why the appropriation of the domestic realm—the conquest of an area hitherto "accessible" only to fiction—should constitute both a fulfilment and a crisis for documentary. The crisis, unfathomable from either of the extreme viewpoints grounded in the conception of film as either purely language or purely record, is one not primarily of field ethics—of how to register behaviour with the minimum of intrusion—but of how to structure material so that whatever it may become as experienced language may in some sense keep faith with its character as pro-filmic fact: for, whilst the attempt to ensure that things are what they seem will present itself to the location crew as an ethical problem, the implications will be present to the viewer only insofar as they manifest themselves in terms of the aesthetic. In the sense that the crisis is located in the

transition from the filmmakers' terms of reference to the viewer's it is a crisis of editing, for it is at this interface that the editor works.

If, as has been suggested, the repetitiveness and public nature of the elements of classical documentary may be said to mark the outset of their own self-symbolism, it is clear that the reality contrived upon such elements must take on the character either of a generalisation from a multitude of possibilities, superimposed and scarcely distinguishable, or of a symbolic entity toward which the pro-filmic was already in incipient project. Even when individual behaviour was essayed, these guidelines were usually respected. The stilted speech of the ground crew awaiting the safe return of F for Freddie was a clear signal (an "intrinsic label") that these were to be construed not as characters (acted) but as people (act*ing*): that this record of their actions, though structured according to the familiar canons of realism, was to be seen as articulating a *demonstration* in the Brechtian sense—a generalised statement about their own lives. Now, deprived of the support of those conventions which no doubt at the time seemed the most grievous of limitations, condemned to a treacherous fluidity by the spontaneities of observed behaviour, documentary must ask itself what may be the structures which will arrest the settling of this fluidity into the ever-accommodating moulds of rhetoric.

Seen in this "horizontal" perspective, however, the prospect is not encouraging. A mere juxtaposition of two shots will demonstrate the proliferation of the difficulties. In an American Senate committee hearing, a senior public official faces accusations of misconduct. As he listens to the development of a hostile line

of questioning, we cut to his hands playing nervously with a paper clip, the voice of his interrogator continuing offscreen. This simple cut opens up a range of possibilities:

1. The sound continuity is genuine, and the second shot is also genuinely synchronous—i.e., it was taken with another camera.
2. The sound continuity is genuine, but the second shot is a "cutaway" taken from a similar context elsewhere in the rushes.
3. Both shots are synchronous, but taken with one camera; and there is a concealed cut (perhaps not *exactly* matching the picture cut) in the sound.
4. The second shot is a cutaway designed to conceal the fact that the sound is discontinuous.
5. The cutaway is taken from a *dis*similar context elsewhere in the rushes.
6. The cutaway was reenacted after the event by the character in the film.
7. The cutaway was set up with an actor.

And so forth. These may be said to represent varying levels of ethical probity—assuming, that is, that some ethical claim has been implicitly made—or, alternatively, to represent a range of statements whose verbal equivalent would be somewhat as follows:

a. This man is made nervous by this question.
b. This man is made nervous by this type of question.
c. This type of man is made nervous by this type of question.

But the implicit signals whereby we-as-viewers evaluate the ma-

terial will, even if we consent to trust them, be too coarse to enable us to discriminate between such alternatives. Not only will we be unable to judge the truth of the film's statement; we will be unable even to determine with any precision what sort of statement it is. However carefully the filmmakers may have matched the nature of the cut to the nature of the statement they wished to be seen as making, however scrupulously they may, under the banner of *vérité*, have selected their options only from the upper reaches of the above lists, neither the sincerities nor the choices made in sincerity will be truly legible in the product. From the standpoint of the viewer, the practices of "observational" cinema cannot be legitimised by the ethics of fieldwork. Yet it is only from the standpoint of the viewer that documentary can be understood.

How, then, are we-as-viewers to take such a sequence? If we perceive it as a transparency (selecting, that is, from the upper parts of the above lists), we stand in danger of being cheated; if we perceive it as an argument (i.e., selecting from the lower parts), then the aspect of film as record, with its implication of uniqueness and contingency, dwindles into insignificance and the particular becomes only the exemplar of the abstraction it articulates. The latter option leaves us little better off than we were in the days of classical, 35mm documentary.

This problem can only be compounded by the use of film as a mode of disquisition (and I am not convinced that retreat into the idea of film as mere research tool is any more than an evasion of it) in anthropology, whose whole bias is to regard the pro-filmic —in the form of ritual, kinship, mythic representation, everyday behaviour—as itself a structure for the articulation of social meanings. If an event is itself an element in a linguistic structure,

what is the status of a film which linguifies it into an element of an altogether different discourse—and, worse still, tries to make this discourse accessible to those who do not speak the original "tongue"?

Consider another example of what occurs in the editing process: an example taken, for simplicity's sake, from our own culture. The event is an argument between two people in a small office. The argument lasts for an hour and a half, out of which the camera is running for approximately fifty minutes, panning between the two people and occasionally shifting position to favour one or the other. The attitudes of the characters emerge only slowly, with much repetition of key points, though with a gradual overall rise in the emotional temperature. The relevance of this sequence to the theme of the film does not justify allowing it more than about twelve minutes of screen time: but this, irksome though it may be, does no more than stress the inherent selectivity of cutting. The problems confronted by the editor therefore present themselves in the form of such questions as: Does this sequence, whilst avoiding undue repetition, reproduce the spiral nature of the interaction? Does it do justice to both positions whilst also conveying the subtleties of the psychological tactics in use on both sides? Does it respect the integrity of each participant, in the sense of not allowing a change of emotional state to appear unmotivated (so that anger, for example, might come across as mere petulance), or of presenting someone's line of argument in a form less rational—or even more rational—than that which it took in the actual debate? And beneath these, of course, lie more fundamental questions. Are we trying to be fair to the people as individuals or to their strategies, or to the institution of whose ethos they are the temporary embodiment?

Are we seeking to demonstrate the arguments used or to clarify the actual intellectual positions which these partly express but partly mask? Is the tedium of the event's repetitiousness—a quality it may possess only for the observer uncommitted to either viewpoint—something which should be retained or avoided? Such things need to be asked not just in a liberal spirit of impartiality, but in an attempt to ground the film's putative meanings—even, where appropriate, its polemic—in a correct apprehension of the world. Throughout the process, the editor is engaged in a curious mental exercise: to attempt, from the rushes and from the testimony of those present, to form an intuitive impression of the event as if it were firsthand experience (granted that all such experience is itself partial and selective); and then, in settling upon the presumptive happening "behind" the material, to use that material to *say* it.

The difficulty with all this lies not in the fact that it is a matter of personal judgment (as of course it is), nor that people are having scripts written for them out of their own words, and performances drawn from the repository of their own unguarded gestures (for it cannot be otherwise), nor even that, in the process of compression, certain "themes" may have to be sacrificed to the coherence of others (the given becoming the data); but in something less obvious. In our anxiety to keep faith with the event as we have understood it, in our careful attention to the mutual respect of the two characters and the behaviour appropriate to their relative status, in our assessment of the degree of eye-to-eye contact which may be permitted across a given cut, the alacrity with which one party may press home an advantage or the pause to be allowed before the other climbs down or gives way to fury, how much interruption is permissible, how much

non sequitur will be tolerated—in all these judgments we are re-sorting to a multiplicity of social behavioural codes: and we are resorting to them not in the sense of requiring to encode them as pro-filmic matter to be demonstrated, but in the sense of recruiting them for use *as filmic codes* in the articulation of the sequence.

The dangers of such a procedure in the portrayal of unfamiliar societies, whose codes of body language, etiquette, and protocol lie outside the competence of editor and viewer, need scarcely be emphasised. I have myself required expert help in the editing of a conversation between two Tuareg, where the constant microscopic adjustments to the height of the veil carry a great weight of social significance. But it is not simply a question of "getting it right." What was in effect happening here was that we were allowing the known conventions of dialogue cutting to feed significance back, as it were, into the gestures which had cued the cuts, so that these gestures might be understood retrospectively by the untutored viewer. And the deeper danger lies precisely in the elision of such known conventions—concerning matching of eyelines, continuity of dialogue over cuts, and so forth—with the capacity of film to swallow the world into its own syntax, since these conventions have been developed specifically for the articulation of the world as realist fiction.

A more extreme example may be taken from a film about a video-dating service. Here, in a sequence where a man watches a videotape of a potential girlfriend, I found myself able to impart an emotional coherence and momentum to the action by employing intuitively understood conventions of eye contact and its avoidance; but in this case the interaction thus narrated from the documentary elements bore a purely illusory relevance to those elements, since the glances of the man were directed not at the

girl herself but at a television screen, whilst those of the girl had been directed not at the man, nor even at her unseen interviewer, but at a video camera. What was happening in this sequence, then, was the deliberate narrative prefiguring of a relationship which was to develop later in the story—an excursion into that treacherous terrain between documentary and fiction which it was our conscious intention in this film to explore. But, whilst one might hesitate to use such methods in a film claiming strictly observational status, we must face the fact that the alternative to using these social codes to imply a relationship might have been to allow them, by default, to deny one.

To put it crudely: we have learned that, when a midshot of someone lowering a cup is followed by a close-up of a cup being placed on a saucer, this is to be construed as signifying not two separate actions but one continuous one. Such a convention— some twenty years younger than the cinematograph itself—functions to efface the pro-filmic (where there actually were two actions) in the projection of a hermetic reality, a closed diegetic world defined only by the narrative which calls it into being to inhabit it and, though masquerading as everybody's world, intelligible only from the standpoint of its narrator.

Furthermore, it is arguable that recourse to such conventions serves not only to define a quasi-literary realism but to inhibit the documentary response altogether: for it is difficult to see what, other than their cumulative presence, may be said to alert the viewer to the fact that material is to be construed in a fictional mode—that we are to see not Christopher Lee mounting some plaster steps in a low-key-lit studio but Count Dracula returning to his castle. Just as, in the documentary response, failure to construe an element as signifying what it appears to record leads to

a breakdown of meaning, so, in the fictive response, perception of an element as recording other than what it appears to signify is consigned to irrelevance. In other words, it is not merely incidental to but definitive of fiction that its nature as record should be negated; and one of the functions of received film syntax is precisely to ensure such negation.

In our case, however, the fiction is not a true fiction, acknowledged by the viewer as such, but the insinuation of a demonstrative position—a pseudo-narrative omniscience achieved by the elision of filmic and pro-filmic languages—into the viewer's construction of the film's meaning: a replacement of documentary's once frank demonstrativeness by a demonstrativeness covert and shifty: an attempt to pass off a metareality as a reality of some transcendent make. The viewer will refer the film back to the events filmed; but such return will constitute not the fleshing out of understanding from the fund of his experience but the superimposition of fictive representation upon the disorder of the pro-filmic. One might posit a form of cryptofiction: a mode in which, though the relation of the material to a prior world is intellectually acknowledged, such relationship remains marginal or irrelevant to the meaning we-as-viewers attribute to the whole. Conversely, it is possible that such meaning may be reinvested in the world in ways the material does not warrant: that an argument may be concealed within the structure of the diegesis such that our construction of the latter will entail endorsement of the former.

Ought we then to regret the invention of the equipment which, erasing the signatures of documentary's previous (if limited) credibility, have enabled us to weave our dubious assertions into the semblance of unanswerable reality? Perhaps. But the

problem as we have stated it offers at least a clue to its own solution, hinting at strategies which must be adopted if documentary is to escape its former demonstrative limitations, its confinement to the general, without being willy-nilly sold into realism. What are needed, broadly speaking, are methods whereby the various strands of discourse—the referential nature of the images, their demonstrative disposition, the construction of narrative continuities in time and space, the filmic and extrafilmic codings—may be denied elision and offered as separable to the viewer's scrutiny. Many approaches are possible. Indeed, the creativity of future documentary must consist largely in exploring them. One—perhaps not too promising—might consist in pushing the received conventions to the point of parody so that, whilst still functioning to articulate the material, they would be perceived in their arbitrariness. Another would be to employ methods of selective jump-cutting whereby one theme—the logic of an argument, perhaps, or the local narrative of one character's actions—would be articulated as a continuity whilst the remainder respected the discontinuity of the pro-filmic. Where commentary must be used, it might take the form of two voices disagreeing with each other as to the proper interpretation of the evidence. If cutaways are needed, perhaps they should be graded differently or wear different clothing from synchronous shots of people listening, as a mark of their different grammatical status. (I once heard an anthropologist-filmmaker being taken to task by a colleague for having constructed a bargaining sequence by intercutting material of a stallholder and customer shot on different days. A distinction in grading between the two components might have satisfied the requirements of both differentiation and synthesis.)

An interesting pendant to these considerations is that even the received conventions of fiction are not immutable, and do not always retain their significance when the responsive context is changed. This fact may act against us or in our favour. On the one hand, I have made the mistake of trying to use a dissolve in a documentary for its classical fiction purpose of indicating a telescoping of narrated time (which in documentary means a telescoping of pro-filmic time), only to find that viewers simply failed to read it in this sense — or even to notice it at all. On the other hand, it seems likely, once the documentary response is firmly established, that a continuity cut which in fiction would certainly signify a single action may take on the force of a jump cut signifying two.

Some of the above suggestions may, I confess, have their origin in the editor's preference for the scratched, unmatched picture and nonequalised sound of the cutting copy over the harmonious fluency of a finished print. However, I am not here trying to outline all the possibilities but merely to suggest that the puritanical caution advocated by many anthropologists as an appropriate attitude to their records is unnecessary. There are certain jokes which we assume to be true stories because there would be no point in telling them if they were not. Perhaps filmmakers should aim toward forms of construction which, in achieving this sort of credibility, would circumvent the need for stylistic labels. Back in the early 1950s I saw a television programme about George Bernard Shaw, doubtless shot with the full panoply of 35mm equipment and its attendant hordes of technicians. A midshot of Shaw sitting down at his typewriter was followed, in classic fashion, by an over-the-shoulder shot as he began to type. What he typed was, "I don't normally behave like this at all."

We have only to look at some of the best in ethnographic film to see both the meaninglessness of claims to supralinguistic objectivity and the subtlety of the methods whereby documentary may yet insist upon the pro-filmic. In a film such as *Lorang's Way*, by David and Judith MacDougall, we may perhaps respond first to its formal discipline and to the sureness of its control. We may be inclined to point out that the long-sustained shots, whose exclusion of offscreen activity becomes at times almost oppressive, constitute as much the imposition of a filmic rhythm as would constant cutting to the objects of the characters' gaze. Yet it is also true, not only that the presence of the camera is acknowledged in each sequence, but that it is acknowledged by successive sequences in contrasting ways—as companion during a walking track, as interlocutor during a formal interview, as casual nuisance in an occasional verbal jibe, as maintaining-a-respectful-distance in a long telephoto hold—and that the juxtaposition of these modes of acknowledgment sustains a constant interrogation of the status of the film unit, both technical/aesthetic and social, which inhibits the semantic closure to which realism constantly tends. And it does this, furthermore, in a way which can have no precise equivalent in fiction.

In short, then, we must beware of treating film from an Olympian standpoint as if, solely by declaring ourselves outside the process, we were able to span that dichotomy between filmmakers' perspective and viewer's perspective which is the concrete presence of film. We may ask ourselves only what options face the filmmakers for the structuring of their perceptions as recorded, and what options face the viewer for the deciphering of this structure as a text. Indeed, as an extreme statement of this position one might suggest that the filmmakers' responsibility is

fulfilled in an attempt to reverse the polarity of the filmic signs so that their sense is toward their material sources—their object matter understood as their subject matter. Certainly it is the case that, since documentary reality is the viewer's construction, any suggestion of interpretations being "forced on us" represents an abdication of responsibility by the viewer. Wilfully or by oversight, some materials may be wrongly labelled. Some things may have been less rehearsed or more rehearsed, less spontaneous, less calculated, less uninfluenced by the camera's presence than we-as-viewers suppose them to have been. But there is no sharp demarcation between the misunderstandings of documentary and the misunderstandings of life. And the documentary stance is essentially one of interrogation.

· · · · ·

We have suggested ways in which complex structures may draw upon, rather than efface, the aspect of film as record; but we have not yet found a justification, within the viewer's perspective, for those "observational" practices which, in the filmmakers' perspective, represent themselves as exploring the potential of the new technology in the appropriation of the domestic realm. (By "observational practices" I mean the extreme precautions frequently taken to minimise the crew's influence upon the profilmic and/or, within the acknowledged fallibility of the medium, to signal the degree of such influence to the viewer: such practices as lengthy acquaintance with the subjects before the start of shooting and/or the inclusion of crew members or camera gear in the shots.) Anthropologists have been mistaken in imagining that *vérité* might herald a return to the prelapsarian innocence of

the actuality. But have they been altogether wrong in the methods they have evolved in this belief?

Let us look again at the dichotomy film-as-record/film-as-language with whose subjective aspect we began. If documentary were merely record, then editors would not be needed to order it, since to grant significance to the order in which records are presented is to impute to it a linguistic nature; yet if documentary were language pure and simple, editors would not be needed to manipulate it, since there would be no meanings generated other than those commonly available—to film crew and viewers alike. Clearly these twin aspects of the medium are not to be understood as alternatives: for, quite apart from its possible articulations as fiction, the record can function as record only to the extent that it is *legible* as such. Of course, there may be mementos so poignant and personal that the linguistic element scarcely rises even to the rudimentary; and we may well, at the other extreme, care to ask exactly what "record" can mean to someone who was not present at the original event. Whether at the cellular level of the photograph or the complex one of structured communication, whether in one-to-one relationship with the pro-filmic or otherwise, an act of decipherment is what is called for. As viewers, in electing to perceive a film as documentary, we do not reject a fictive option for a known nonfiction, but rather select a mode of apprehension in full knowledge of our own ignorance.

There are in *The Battleship Potemkin* sequences in which minimal human activity—sailors asleep in hammocks, others on watch—is intercut with details of the ship and with seascape material such as buoys, gulls, other vessels, and views ashore. At our present distance in time we may construe such material as a por-

trayal of Odessa harbour either in 1905, when the story is set, or in 1925, when the film was made. This distinction, between the fictive and the documentary construction, is subtle but absolute: and it would remain absolute even if the action of the fiction had been set in 1925 also. It depends not upon our prior knowledge of the look of Odessa at these dates but upon the mode of our interrogation of the images. A reality, like a fiction, must be articulated. But the difference between an account and a narrative lies, for us-as-recipients, in the relationship we posit between the linguistic elements and the total discourse. In fiction, the elements are exhausted in the production of the overall meaning of the text; and anything which cannot be read as contributing to this meaning is consigned to a limbo of insignificance. In documentary, by contrast, the elements are seen as always exceeding their contribution to any given meaning; and they remain always open to scrutiny either for their own sakes or for their potential in the generation of new meanings oblique, peripheral, or even antagonistic to the text as understood.

As will be recognised, the analogy of an "account" is inadequate beyond a certain point: for in a verbal account of something—a piece of journalism, say—the excess by which we interpret the prior world as outspanning its description is present to the reader only as a subjective coloration to the words, a sense of their striving after what they cannot wholly comprehend; whereas in documentary that excess is present in the images, in their potential always to reveal—under different interrogations—aspects of the pro-filmic hitherto unremarked. In this respect, then, the verbal affinities of documentary are with poetry, since the resistance of its elements to total absorption in the discourse represents a resistance against the drift toward pure sym-

bolism. Verbal poetry seeks to dissolve the symbolic fixity of the word by undermining the rules of syntax—either relaxing them, as in free, surreal, or rhapsodic verse, or subordinating them to other and more arbitrary structures (alliterative, metrical, quantitative, syllabic . . .) which, whilst preserving, mock them. Freed of the absolute grip of those grammars with which its symbolic precision is held in mutual support, the word offers the full range of its ambiguities and connotations for the generation of a flux of meaning which will be set in resonance by the reader's experience. All film aspires toward the poetic in that it has neither a wholly predetermined syntax nor a precise, delimited symbolic vocabulary. But to grant a film documentary sense is to respect in its images the density, the plenitude of the pro-filmic: a plenitude which defies its reduction toward the symbolic and thus defies also, by implication, its articulation into a simple, linear statement approximating to the condition of prose. Documentary faces us with the paradox that, whilst in its elements it is capable of falsehood, since its labels are swallowed, in its totality it is not capable of falsehood, since its articulations are those of poetry. Thus whilst its elements may be misread though not miswritten, its totality—conceived as prose but perceived as poetry—may be miswritten but not misread.

Very well, perhaps this formulation is a little exaggerated. I do not wish to suggest that there is *no* sense in which documentary may be read as prose. To the extent that it uses unambiguous constructions to make statements capable of falsehood, clearly it may. By editing, I could show the "wrong" side carrying a vote or winning a battle; and even those who insist that there is no absolute—or at least absolutely knowable—"real" event against which its "representations" can be judged would surely agree in

finding such editing reprehensible. But today's lie, differently re-
garded, may be tomorrow's evidence. A notorious film of Pyg-
mies building rope bridges becomes, when we are told that they
do not build such bridges and had to be taught to do so by the
filmmakers, a film about Pygmy adaptability and helpfulness.
Old documentaries are constantly being ransacked for new com-
pilations; yet such recycling seems always to enrich rather than
diminish them. Documentary, unlike fiction, welcomes its own
displacement.

Another way of putting this would be to say that documentary
always exceeds its makers' prescriptions. (If it did not, ethno-
graphic films might as well be made in the studio with actors.)
It is such a recognition which lies behind the wish expressed
by many anthropologists that every last frame of ethnographic
rushes should be catalogued and preserved in a gargantuan
Monde Imaginaire for the benefit of researchers yet unborn—an
idea which at first may seem as crazy as making a collection of
good sentences in the hope that somebody will one day shuffle
them into a book. Resistance to this recognition, on the other
hand, is frequently encountered in the form of politically reac-
tionary claims of privilege for the source of discourse, whether
personal or (by surreptitious proxy) institutional. Superficially
reasonable demands that our films be comprehensible are often
in effect demands that the viewer be browbeaten into shar-
ing *our* understanding of them. Documentary's images are, ide-
ally, not illustrative but constitutive. They are constitutive of the
viewer's meanings, since it is the viewer who constitutes them as
documentary.

It has always been so. Of course, in the post-Méliès era, the
documentary impulse had to satisfy itself with what amounted to

an act of retrenchment, sustaining the Lumière actuality-values in this limited area and that—the locations, "real" people, confinement to the "facts" of known incidents—all of which became, as it were, tokens of a fidelity to be rewarded at some later consummation, endlessly deferred.

But if the technical developments of the past decade-and-a-half have announced that consummation, the announcement has been widely misunderstood. What the new equipment can recover of actuality is not its innocence but its plenitude: or rather, it can extend to most realms that plenitude which was previously available only in those of public or of nonspontaneous behaviour. "Observational" practices increase the margin of "excess" whereby the film outstrips its makers' intentions: and it is by this argument—by this argument alone—that they may be justified within the viewer's frame of reference. In our example of the hands fiddling with the paper clip: once the viewer has accepted our assurance of its significance, it is its significance, not our assurance of it, that will be effective. The plenitude of the image, its polyvalency, is experienced by the viewer as a play of connotations. Just as the ethics of filmmakers are experienced as aesthetics by the viewer, so the anthropologist's objectivity translates into ambiguity: and the "real-life" density commonly attributed by viewers to such film is our experience of active engagement in the generation of meaning. All film is a trace of the world: and, whilst it may be true that the very articulations whereby we are enabled to perceive it as such commit us to ethnocentricity, this truth may at least arguably be suspended in that zone of flux at the leading edge of communication where poetry is forever congealing into prose, insight into dogma. If not, documentary is unjustified.

What Do We Mean
by "What"?

The television series *Hollywood* included in its episode on comedy a substantial extract from a Laurel and Hardy two-reeler. It was the one in which Stan and Ollie, as door-to-door salesmen, get into an argument with a householder which results, after a steady escalation of polite violence, in the near-demolition of the property. Unfortunately, as the programme informed us, an error had been made: and the house at which the filming took place was not the one whose owner had given permission. This simple statement was all that was needed for the film clip to be transmuted from comedy-fiction into documentary: a documentary about a film unit visiting unintended vandalism upon some unwitting person's home.

What makes a film "documentary" is the way we look at it; and the history of documentary has been the succession of strategies by which filmmakers have tried to make viewers look at films this way. To see a film as documentary is to see its meaning as perti-

nent to the events and objects which passed before the camera: to see it, in a word, as signifying what it appears to record. Such a definition may run into theoretical difficulties. The objection may be made that record and signification are not facts of the same order, and are not directly comparable. All the same, it does enable us to avoid the labyrinth of rules and exceptions, and exceptions to the exceptions, which awaits anyone who tries to identify documentary by generic or stylistic criteria.

Where fiction uses film in much the same way as it had already used words or marionettes or the bodies of live actors, documentary represents a mode of cognition which may scarcely be said to have existed before 1895. The only precedent which suggests itself is that of a hunter who, without laborious inference, reads into the spoor the passage of the beast. And even this spoor does not lend itself to being raised to a higher power of articulation through the practice of editing. If documentarists tend to behave as if they were the custodians of some sacred trust, it is because this uniqueness weighs heavily upon them.

The ferocious rows which break out in cutting rooms over questions of authenticity—a relatively new word in our vocabulary—are testimony to this weight. A recent TV programme on Jewish history, so I am told, included a sequence on the rising in the Warsaw ghetto in April 1943. No ciné record exists of this event; and footage of the Warsaw rising of August–October 1944 had been used instead. How ought we to designate such a sequence? If no indication was given of the true provenance of the material, then we must surely say that its use was documentary but mendacious. If, however, the provenance was in some way acknowledged, then I would defend it as a legitimate fictive usage—film fiction being that which signifies something *other*

than what it has recorded. In such a case, one might even argue that certain elements of the fiction—the fact of being shot in genuine Warsaw streets, the use of nonactors—made tenable a partial, residual documentary reading, a sort of ghost documentary presence. It is fascination with such presence that has motivated those feature directors who have felt that realist fiction should be made in "real" locations: in classic terms, De Sica as against Pabst.

There is a type of film which seems to strain our categories: that in which—as, for example, in some works produced in East Germany during the 1950s—material from features and from news sources is blended without distinction. It is doubtful whether the makers of these films see themselves as engaged in deception. More probably they believe that dramatic reconstruction and newsreel are all grist to the mill: all equally valid and ultimately indistinguishable means for reaching back into history. But implicit in this is the idea that the statement—and I do not necessarily mean just the verbal formulation—has absolute priority over its means of expression. It is not that these films blend documentary and fiction, or succeed in staking out some middle ground, but that they are *indifferent* to the way their material will be perceived; and the authoritarianism of the statement, whether pedagogical or political, is inseparable from the handling of its visuals.

That most documentarists today would consider such practices intolerable is a consequence of developments not in historical compilation but in the apparently remote field of anthropology. The boom in ethnographic filmmaking in the late '60s and early '70s, with its "scientific" concern for accuracy in the presentation of data, provoked a good deal of thought about

the nature of documentary reality and its relation to the prior event. The pleasure of *Camera at War*—a British TV series in which news cameramen reminisce about their work—lies in seeing newsreel stories, often very familiar newsreel stories, transformed into *cinéma vérité* by a simple switch of context.

This bears a similarity to our opening Laurel and Hardy example which is, when one thinks about it, a little disturbing. The newsreels are in no sense fictions; and if a comparable shift of perspective can occur within the terms of a documentary reading, then we may reasonably conclude that no documentary reading can claim ultimate, absolute privilege. All true documentarists have known this from the start. Documentary reality is a construction; and some of the viewer's blood goes into it.

If we believe that to construe a film as documentary is an inherently libertarian act (and I shall not attempt to argue the point here, but the above comments on 1950s propaganda may hint at why), then we must believe, with its pioneers, that the form deserves to be defended. In Britain during the war, when full studio facilities became available for the production of feature-length, narrative films by the Crown Film Unit, many practitioners worried that the documentary essence might be diluted beyond recognition. Today the danger to documentary is not its assimilation into fiction but rather a listlessness, a sapping of the will and weakening of the fibre, such as afflicts people who have lived a long time under the supposedly benign discipline of caring or corrective institutions.

If we accept the definition of documentary as signifying what it appears to record—with the consequent ethical imperative, for the film*maker*, that it should have recorded what it appears to signify—then sooner or later we will be faced with the question

What do we mean by "what"? This question, which was brought into prominence by debates about observational and *vérité* filming, is the practical outcropping of that mismatch between "signification" and "recording" which we noted earlier. After all, on a certain level of generalisation—that of "an insurrection in Warsaw in the mid-1940s"—even the use of the Warsaw Rising for the Ghetto Rising might be said to recover its documentary status. The moment you demand that a film should represent an event exactly as it occurred, you are confronted not just with the practical difficulty but with the theoretical absurdity of such a requirement.

This absurdity, however, is not documentary's weakness but its strength. The space opened up by the mismatch between record and signification is precisely the space in which the viewer's choice operates. Every hunter reads the spoor in his own way. The danger to documentary lies in anything which restricts the film within a set of institutionalised norms and erodes that power which the image takes from the viewer's sense of its contingency.

The industry is now full of people who have come from the universities via research or journalism, who talk in terms of "noddies" and "pretties" and "drearies" and have no understanding of the past struggles of the documentary movement: people who have been taught about "signposting," and that camera movements must be linked by dissolves; who know that talking heads must be captioned, so that the viewer can tell "where they are coming from"; who know that—as a young BBC producer recently explained to me—the optimum length for a shot is four seconds, and no shot should exceed ten; who know that what is not current affairs is history, and that what is neither can only be

an Art film . . . The upshot of all this is the equation of truth with banality.

We cannot (and should not wish to) determine how a new generation will address the contradictions of documentary; but the least we can ask is that they should be aware the contradictions exist. Perhaps the question What do we mean by "what"? should be offered them as if it were a Zen koan; and they should be banged on the head with bricks until they have grasped it.

Berlin versus Tokyo

Documentary appears to express attitudes toward the world by appearing to allow the world to speak for itself. A purpose of this article will be to shed some light, albeit indirect and perhaps diffuse, upon this paradox.

I have chosen to compare the use of slow motion in two films of the Olympic Games: those of Leni Riefenstahl (Berlin 1936)* and Kon Ichikawa (Tokyo 1964)**—to which, for convenience of contrast, I shall refer simply as *Berlin* and *Tokyo*. Films about sporting events clearly lie at the "actuality" end of the documentary spectrum, where there is least risk of our confusing their aesthetics with those of narrative fiction or theatre. Slow motion, on the other hand, is a device which might be held to entail manipulation verging upon "distortion."

Since both films are long and inevitably episodic, I shall cen-

* *Olympische Spiele*. Released 1938. English version 218 mins.
** *Tokyo Orinpikku*. Toho. Released 1965. English version 130 mins.

tre discussion upon the treatment of those events which, it may be agreed, afford the most successful sequences in *Berlin* and *Tokyo*, respectively: the pole vault and the marathon.

The pole vault in *Berlin* begins impressionistically. Music accompanies a series of shots from various angles—low shots, shadow shots, shots from above in which the vaulter rises to top the bar at camera level—leading gently into slow motion. Contestants are not identified; and the emphasis is upon the grace of the movement, the surprising height which a pole-vaulter can achieve, and our cumulative compulsion to watch such an act endlessly repeated. The athletes are silhouetted as the light fades. The sun dispenses its parting rays from behind a biblical cloud. The Olympic fire smokes ominously; and the sun—or perhaps it is the moon—glides into blackness. It is night. The music ends; and we are told that the last five men, fighting it out for the first three places, have been vaulting nonstop for five hours. Now we are close to the competitors. The camera squints along the pole as they poise themselves for the run. Their adversaries, huddled in blankets against the chill air, watch with unease and admiration.

In this, the climactic segment of the sequence, the run-up and the vault are taken in slow motion; but the reaction shots occur at normal speed. Since sport is a social ritual, itself arguably the vehicle of meanings prior to those claimed by the medium in which it is represented, the relationship established between spectators and events is of some significance. And here we encounter a striking difference between the two films: for whereas the treatment of the spectators in *Tokyo* is individual to the point of quirkiness (witness the release of the doves at the opening cer-

emony, where someone is shown protecting her head with a transistor radio), a remarkable proportion of the reaction shots in *Berlin* are of claques responding to their cheerleaders. Even enthusiasm, it seems, must be subject to properly constituted authority and respect the appropriate national boundaries.

The pole vault offers an extreme example. The spectators are integrated into the texture of the sequence with impeccable editing, their breath bated for the exertion of liftoff and their sigh of disappointment completing the cadence of a failed attempt; and the cheerleaders, glancing over their shoulders at the athletes as a conductor will glance at the soloist in a concerto, contribute so fully to the play of dramatic tensions that they sometimes appear to be orchestrating not only the responses of the supporters but the progress of the action itself. Moreover, this integration is bonded by an extraordinary congruence between the overall dramatic curve of the sequence and the actual movement of the vaulter through space. Some preparatory shots represent his pause before action. The musical segment corresponds to his run-up. The transition to night is the spring of the pole as it strikes into the box. And the vaulter's ascent is the rising curve of tension to the climax of the contest. The release and fall are then represented by the shots following the announcement of the winner. (There is a high-angle wide shot encompassing the Olympic flame, massed arms aslant in the Nazi salute like the quills of a ruffled porcupine; then we see the winner, Meadows, also saluting, though not in the Hitler fashion; and finally there is a slow dissolve to the American flag.) This overall rhythmic correspondence gives the sequence a look of having been built to last.

By contrast, the treatment of the pole vault in *Tokyo* is either cursory or deft, according to our predisposition. The early shots

are abstract in treatment; and night falls quickly in a series of three cuts from similar setups. Thus far, the sequence parallels that of *Berlin*, even to the use of slow motion and of the flame to introduce darkness. But, once impressionistic graces are relinquished, *Tokyo* takes a very different course. The event is shot, from a distance, in a flat-on manner which denies it the quality of the spectacular; and the ungainly landing of the athletes in a pastel bath of foam-rubber chippings (in 1936 they landed on their feet in sand) deters us from attributing to it potential martial utility. For the final stage of the contest, slow motion is abruptly dropped. Thus the graphlike schema proposed for *Berlin*, fanciful though it may at first sight appear, would certainly not fit *Tokyo*, since here the rhythmic climax (marked by subsequent relaxation into normal speed) has been shifted from the dramatic climax of the winning vault: and the suggestion that the contingency of action may be redeemed or sanctified by the immutability of aesthetic form is simply not present. When the event is over, the camera lingers, despite the darkness, upon the faces of the departing contestants as they vanish into the crawling grain of the film's emulsion.

Partly because of the height involved, the treatment of the pole vault in *Berlin* exemplifies very clearly a technique which is used repeatedly throughout this film, but almost never in *Tokyo:* the combination of slow motion with a low camera position. It is precisely this combination which a studio special-effects department would employ to create the impression that a model was life-size—or that a person was a giant. As things get larger, their mass increases as the cube of their linear dimensions; but the power available to move them (whether external or internal) does not—as we instinctively recognise from a comparison of the mo-

tions of waves and ripples, or of the performances of mice and elephants. To shoot slow motion from a low angle, then, is to encourage an interpretation in this sense. It is not my contention that we perceive the athletes in *Berlin* as actual giants, for we know they are not; but merely that we are asked to constitute their image in the mode of the gigantic, the superhuman, the larger-than-life.

But there is another aspect to the use of slow motion in events where, as is partly true of the pole vault, the athlete is raising his own weight against gravity by sustained muscular control. (The pole-vaulter is both jumping and lifting himself with his arms.) Here the effect, without the low angle and its hint of gigantism, is to suggest a preternatural strength, since the slow motion minimises the apparent contribution of momentum; and even with the low angle, such implication of enhanced strength is available to precisely the extent that we reject the implication of enhanced size. *Berlin* offers many examples of this: two pole vaults (the second occurring in the decathlon) and gymnastic displays on rings, horizontal bars, and horse—in fact, so far as I can see, every event that would fit the category. These events, with the partial exception of the pole vault already discussed, are all presented at normal speed in *Tokyo*. Indeed, a tentative contrast may be found in *Tokyo*'s use of slow motion for the women's shot put, where, since it is a question of imparting momentum to another object, the effect is to make the effort seem disproportionate to the results obtained.

The moulding of slow-motion images into the rhythm of the surrounding action, which we have already observed in the *Berlin* pole vault, diverts attention from their nature as "trick" photography—as requiring to be construed in a sense distinct from

that of the normal-speed material. This quasi-illusionism is further abetted by the use of sound. In *Tokyo* practically every occurrence of slow motion is signalled by an immediate change in sound quality: either the introduction of music or, more often, a sudden eerie hush in which only a few selected and distorted noises reach us—for example, the sonorous clang of mallet on starting blocks in the very first event of the film. But in *Berlin*, if music is not used, the natural effects are continued without change of quality or pitch. The assumption that the pitch of a sound will vary with its speed may well be a recent addition to our perceptual apparatus, since it did not hold good for the steam organ, the pianola, or the musical box; but it was surely well enough established by 1936—and is certainly so today—for the lack of such variation to be read as implying that the action we are watching is being replayed at the speed of its occurrence.

It may be objected that I am making heavy weather of this: that no one is misled, and that we perceive slow motion merely as a slow representation of a quick event in which we are permitted to see more than we otherwise would. I do not deny that this is our primary perception, or that for some people—a PT instructor, perhaps, approaching the film only in a spirit of analytical curiosity—it may exhaust the matter. But film affords an inflexion of experience; and even analysis of movement does not constitute a realm of pure inquiry from which emotion, value, and the darker passions of the intellect are excluded. I once met a child who, at the age of seven, had suffered nightmares for a week after seeing a time-lapse film of a flower opening. A seven-year-old would not be likely to imagine she had been confronted with a new strain of sentient orchid. Such an interpretation might be quite proper in a fiction film; but to perceive a film as

documentary is to assume that what is signified is what happened. The child's nightmares resulted from her discovery that, when brought within the timescale of human perception, this was how plant life really behaved.

Slow motion, like most other elements of film language, is capable of being invested, by its function within a given text, with meaning (or, as I would prefer to say, the potential of meaning) peculiar to that text: meaning which is otherwise arbitrary, unmotivated, and at times even contradictory to the more "naturalistic" meanings discussed above. In the TV series *Six Million Dollar Man*, slow motion was used to signify extreme speed—the difficulty being, presumably, that speeded-up action would have tended to look comical, either intrinsically or by association with Mack Sennett.

Berlin devotes an entire reel of prologue to an attempt to attach a symbolic value to its use of slow motion. The brooding progress of a sub-Wagnerian melody introduces the ruins of classical temples. Heavy filtering blackens the skies, so that buildings and sculpture are isolated from the dazzle of Grecian light. These are dissolved slowly through accelerated shots of clouds which serve not only to shroud them in Norse gloom but also to suggest the telescoping of timescale, the moil and ferment of history against which the masonry and statuary may stand as ideals unchallengeable and eternal. Camera movements of funereal pomp merge into the slow-motion gestures of nude athletes posed to match antique carvings. The Olympic torch (a Nazi invention, incidentally) is carried across Europe in a journey through space and also, by implication, through time; and the black-sky motif, which persists throughout the interminable

travelling map shot—so that the flame will return to life only in the present, and in Germany—makes it uneasily prophetic of a night bombing run. There is an undeniable frisson in the moment when the fire is ignited in the Berlin stadium. If we endorse the symbolism toward which the sequence has been striving, this may entail a surge of vicarious pride. If not, it is more likely to express our horror at the recognition that such pathological kitsch could blossom into political reality. The merciless heroes have returned from a Valhalla thinly disguised as Mount Olympus.

But political reality is relevant to these films not only insofar as our historical awareness influences the way we will attribute mood to an interplay of connotations—a procedure to which my use of such words as "brooding" and "funereal" testifies—but also in that it informs the nature of the event filmed. Let us now, with a view to drawing together the ideas already mooted, return to the social meanings of sport as ritual.

The social idea most obviously enshrined in sport is competition. "Competition," in its capitalist use, is a mystificatory concept, since it elides the idea of competitiveness between businesses, which is supposed to stimulate efficiency and investment and to keep prices low, with that of competitiveness between individuals for advancement within the system. But it is also a blurred concept, since few businesses could prosper without a certain minimum of cooperation on the part of their workforce. What is required, then, if the ideal of competition is not to prove totally destructive, is a countervailing idea of collaboration; but a collaboration which will not challenge the credibility of competition as the sovereign value of the system. Such a collabora-

tion finds its perfect expression in the idea of the team. When, in the tradition of Dr. Arnold, team sports are extolled for their character-building qualities, we must understand what quality of character is in question. The distinctive feature of a sports team is that it is defined not by a task to be accomplished but merely by its opposition to other teams. It thus expresses a collaboration by nature subordinate to competition—a collaboration circumscribed and empty of content.

Team sports as such are given short shrift in *Berlin*—perhaps simply because they are not central to the Olympic tradition, perhaps because their extension in time and space makes them difficult to encompass on film. The treatment of football, for example, is perfunctory. Cutaways are used which are clearly trims from shots occurring, presumably in their proper contexts, elsewhere; and the commentary, at least in the English version, even lapses wearily into the past tense. But in a sequence such as the pole vault, with its flawless integration between the reaction of the claques and the action of their champions—a piece of rhythmic modelling which would be remarkable enough even if slow motion were not employed—it is difficult not to see the recovery of the concept of team at the level of nationhood: a team which leaves free scope for the chosen individual as Romantic hero: a team whose collaboration not only is empty of true content but is indeed purely mythic. Vicarious identification with a group defined solely by its exclusion of other groups is a necessary (though of course not sufficient) condition of fascism.

The finalists in the pole vault happened to be American and Japanese. But it is worth remarking the number of instances in Berlin where the introduction of slow motion coincides with the

appearance of the German contestant—regardless of whether he or she eventually wins. If we eliminate cases where the contestant is not identified (as in certain purely lyrical sequences), or where no German is participating, or where slow motion is used (as in the steeplechase) for the purpose of ridicule, the proportion is close to 65 percent. And even if we include all these questionable cases, the figure still reaches 30 percent—which, with fifty nations competing, is high enough to be considered significant. The pious internationalism of the commentary notwithstanding, it is preponderantly upon the German athletes that the cultural blessings gathered up by slow motion in its measured tread through history are seen to fall: custodians of a mythic heroism which their victories may confirm but their defeats not diminish and in which their compatriots, merely by applauding it, may share.

Since film works not with chains of consecutive logic but with connotations, ambiguities, valencies which interlock at the viewer's discretion, its meanings are difficult to set out in linear form: but somewhere within this web of associations—the use of slow motion with low angle and with normal sound, the intercutting with normal-speed footage to confirm an implication of gigantism, the further investing of slow motion with the values of classical antiquity conceived as suprahistorical, the seamless welding of athletes' action with supporters' reaction so that they are perceived as participating in the same act, the discharging of the accumulated potential of slow motion upon nationality in general and upon German nationality in particular, the conferring of timeless legitimacy upon an event by the duplication of its structure in the architecture of the sequence—we may surely see a

significance whose intellectual correlative lies somewhere at the junction of the concepts Essence, Nation, and Destiny.

I have heard it suggested that *Tokyo* is "not really about sport at all," since "Ichikawa doesn't seem to care who's winning." The idea of "winning," however, is not immune to social inflexion. The unique winner, the world's best who attains his status through a phased succession of eliminatory contests, serves, in sport as we know it, to posit competition as entailing that one person's success be bought with another's failure. Other conceptions are possible. Judo, for example, whose origins are feudal, was organised from the start upon a system of "grades" reflecting degrees of accomplishment against which adepts could be measured. The contestants in a judo bout are, of course, competing. The distinction lies in the fact that they are not competing to *deprive* each other of anything.

Having observed, then, that *Tokyo* avoids such uses of slow motion as would confer superhumanity upon the athletes, we should perhaps, in seeking out its more positive strategies, take our cue from the above adverse criticisms and pay special heed to the ways in which it may be seen as encouraging or discouraging certain inflexions of the competitive idea.

Of a total of twelve uses of slow motion in *Tokyo*, five occur in races (and of the six significant uses, four). This compares with only one, and that only in a qualifying heat, out of twenty or so slow-motion passages in *Berlin*. One obvious point to be made about the presentation of a race in slow motion is that it negates the main objective of running: the attainment of speed (for it is not as if, as with *Six Million Dollar Man*, some contrary local convention had been established). But the impression of speed as

conveyed by film depends not simply on duration but on lens and camera position: and we may understand the use of slow motion for a race as implying a recognition that the "reality" of speed—as experienced either by the runner or by an observer who shares the runner's temporal coordinates—is inaccessible to the film medium. With this in mind we may perceive the slow-motion race either as a surreal dream, in which our capacities for escape are inexplicably paralysed, or as an analysis either of muscular action or of tactics: and in this last instance it is at least arguable that slow motion represents the runners' subjective timescale more accurately than would the hurly-burly of normal pace. It is not clear that any of these interpretations has a special claim to legitimacy; but each of them entails a critique not only of the actual event but also of the relation of film convention to it.

It is characteristic of *Tokyo*, in contrast to *Berlin*, that slow motion is used not only for an event itself but also for its anticipation and aftermath. In the women's 800 metres it constitutes what would now be called an "action replay" in which we are permitted to observe the seraphic smile of Ann Packer as she breasts the tape. In the men's 100 metres—which, being the first event shown, sets the style for our response to the film's coverage—slow motion is sustained throughout the fixing of the starting blocks, the wait for the pistol, the race itself, and the rundown and relaxation. The runners are seen in isolation both before and after the race: and the slow motion, spacing out the temporal congestion, enables us to preserve a sense of their individuality during the run. Furthermore, where a rendering at normal speed would present us with a contrast between people poised for action (i.e., behaving more slowly than usual) and people sprinting (i.e., behaving more quickly than usual), the use of slow motion

diminishes this contrast by presenting both components at a slower-than-usual tempo. The breaking of the tape does not register as a climax, since it does not provoke an immediate falloff in the degree of our concentration. Thus the sprint emerges less as a laboratory experiment, in which competitors are subordinate to the numerical abstractions of their times and positions, than as a moment in the flux of experience where a number of individuals meet, intermingle, and part again.

When we turn to the treatment of the marathon in the two films, we first notice, as with the pole vault, an overall similarity which will throw the significant differences into sharp relief. Both take us to the halfway turnabout very quickly. Both show us the refreshment stands, spectators lining the route, and runners dropping out from exhaustion. Both focus attention on the eventual winner during the last stretch before reentry into the stadium; and in both versions this concentration of attention is accompanied by a transition from natural sound to music. Both end with harrowing images of blistered feet and hollow faces as competitors collapse on crossing the finishing line. *Tokyo* pokes some fun at officialdom which is not permitted in *Berlin;* and *Berlin* makes use of the roadside field radio stations as a device for keeping us informed as to the relative positions of the contestants: but these differences are of little account.

What really distinguishes these two marathons is the way the winners are treated in the home stretch. In *Berlin*, as the initial front-runner drops out and Kitei Son, hitherto sharing second place, pulls ahead of his British companion, a shot of Son passing a Japanese flag leads into a succession of close views of his legs, his arms, his face, his shadow. These are intercut, and later interdissolved, with shots of passing trees and hedgerows from what

can only be interpreted as the point of view, if not of Son himself, at least of a runner following this route. (It is somewhat ironical that a shot of the flag should, in a manner characteristic of *Berlin*, be used to cue a focus of attention upon Son, since he was in fact a Korean competing, very much against his will, under the Imperial Japanese colours.) The climax is reached when a very close shot of Son's pumping elbows, seen from alongside, is followed by a shot of his feet seen unambiguously from his own viewpoint. Let us be clear about what is involved here. It is conceivable—though I think unlikely—that what we are seeing is 'genuine' in the sense that the feet are those of Kitei Son and that the shot was actually taken during the 1936 marathon. Such a shot could have been achieved by rigging the camera upside down on a cantilevered boom travelling just ahead of, and above, the runner. What matters is the function of this shot within its context. The only possible interpretation is that we, the audience, are Kitei Son looking at our own feet. In what sense may this be understood?

Such a device, the "subjective" use of the camera, is familiar in narrative cinema: and we may idly wonder whether it might not have proven acceptable, even in *Berlin*, if Son had somehow been built up as a fictional representative of himself. It is not, after all, a question of truth versus falsehood. Neither is it a question of actuality versus manipulation. All shots are actual in that they are shots of something; and all shots are manipulated in that they have subjected this something to mechanical transformation into an image. But what documentary does is to specify that the image shall not be dissociated from the actuality. Though the label "documentary" may be affixed at whim, its confirmation requires that the viewer interpret the film in this specified sense:

that a shot must retain its "vertical" relation to actuality while functioning "horizontally" as a constituent of a film world. The term "documentary" thus describes, strictly speaking, not the nature of the material but the chosen manner of our response to it. Once we are committed to this response, however, our failure to construe a shot as having recorded what it appears to signify is enough to deny it meaning altogether.

If the shot of Son's feet is to be accorded documentary meaning, then, it must be not simply as "a shot from Son's viewpoint" but as a shot obtained in the contortionate manner already described: a shot used upside down, with feet which should be running toward us facing away. This is not necessarily impossible. It is entirely a question of whether what is signified will, in its context, cohere into something we are prepared to accredit as a reality. We may readily imagine that the shot under discussion would create no problem in, say, a training film for athletes, whose projected reality would be that of muscular dynamics and lung control and where there would be a clear purpose to the inclusion of the shot—*understood* as upside down—from the trainee's viewpoint. But in the *Berlin* marathon no such option is presented. Whereas the "subjective" shots of hedgerows (which may, indeed, have been taken at quite a different time) can be accommodated without difficulty as being "any runner's view of the course," and the sidelong "objective" shots as demonstrating Son's movement—the two sets sparking from each other a poetic statement of the runner's endurance and effort—the shot of Son from his own viewpoint defies interpretation unless we are prepared to read it as recording—not merely signifying, but recording—his individual experience.

A reading which we cannot endorse emotionally can never be more than a speculation upon the possible meaning of the work for others. But it is at least conceivable that, for someone who has been able to endorse the philosophy which has informed *Berlin* up to this crucial passage—someone, that is, whose construction of reality does not exclude the idea of mystical participation in the acts of the hero through the shared essence of nationhood— the shot of Son's feet might attain the meaning to which it seems to aspire. For me, however (and here the logic of my argument obliges me to drop the polite stance of impersonality), the sequence loses coherence at this point and disintegrates into its constituents.

For *Tokyo*, in contrast, the marathon runners embody no ideal which transcends them. The commentary, for example, respects their personality by telling us what each does for a living. Shortly after this, a series of almost abstract close-ups of Abebe Bikela, the Ethiopian who will win the race, leads abruptly into three sustained slow-motion shots: a midshot from three-quarters front, a side shot tilting down to the feet, and a close-up held in profile. The third of these lasts for a minute and a half—and seems much longer. There is an obvious practical advantage in taking this shot in slow motion, since it flattens out the jerkiness which would otherwise make a narrow-angle close-up of a runner impossible to watch. Yet it is not only the camera, but a roadside observer equally, who would be denied this view in real time. The slow motion thus serves to enhance a propensity of the narrow-angle lens which may be remarked elsewhere (for example, in the men's and women's shot put sequences): its suggestion of a far object closely observed; of privacy honoured yet

outwitted. No one was ever so close to an athlete in action — except himself. Yet the proximity underlines the inaccessibility of his experience.

Just as *Berlin* employs a prologue to charge its uses of slow motion with the potential for the generation of specific meanings, so there is strategically placed early in *Tokyo* a shot whose function appears to be, in view of its minimal information content, simply to predispose us to certain responses to its filmic means. A spot of fuzzy red against a black background quivers, swells, and gradually takes shape to reveal itself as a telephoto image of the first glimpse of sunrise. It is cued by the word "Japan" and may be "justified" by the fact that the rising sun is the emblem of the host nation. But to enjoy the joke is to accede to the use of certain elements which will recur frequently throughout the film: the long-focus (i.e., narrow-angle) lens; the sustained hold on a single setup; the shot which begins in a cryptic, puzzling manner. Slow motion soon presents itself as a fourth member of this group. (Indeed, though the sunrise seems not to be in slow motion, one might argue that it represents a comparable estrangement from our day-to-day experience of the sun's movement.) All four are means of separation, of isolation: but whereas narrow angle and slow motion serve to isolate the selected action (the former spatially, the latter temporally) from its context in actuality, so that stress is placed on the image itself and its problematical relation to the world, the cryptic start and the long hold serve to isolate the image (again, the former spatially and the latter temporally) from its context in the structure of the sequence.

A clear example of the functioning of such separative devices is to be seen in the bicycle race sequence, where close-ups of flashing spokes are intercut with massed long shots of cyclists reduced

—not by actual slow motion but simply by the telephoto effect—
to strenuous immobility. This calls into question any idea of "objective" symbolisation of speed. Context is restored only for the
pain of an injured competitor.

Devices which serve synthesis in *Berlin* serve analysis in *Tokyo*.
It is probable that, without the prior example of the sunrise as a
gloss upon its usages, many of us would respond to the long-held,
narrow-angle, slow-motion profile of Abebe Bikela with frustration, baffled by its lack of incident and by its apparent betrayal of
our expectations, perhaps suspecting it of trying to browbeat us
into identification at some emotional level. But, construed as a
linguistic element isolated by sheer duration from its function in
a chain of syntax, it becomes, like a work of beautiful calligraphy,
an object of contemplation in its own right. To be confronted
with this image of Bikela's face, impassive, the beads of sweat
flowing gracefully from his chin with the rhythm of his movement, is to experience the dilation, beyond the normal bounds of
film discourse, of a brief instant in an event to whose gruelling
duration film could scarcely otherwise do justice. The entire race
becomes subsumed into its every moment. The image is that of a
man locked into his own eternity, since only eternity is undiminished by division.

This sequence does not require, then, for its very comprehension, our endorsement of a notion of mystical union with the athlete. Neither does it offer much material for our construction of
the notion of competition in its capitalist sense. Indeed, if we
agree that such a notion is embedded as a meaning in the ritual
of sport as at present understood, we may see in *Tokyo*'s use of
slow motion—as part of the fourfold strategy of separation—a
desire to filter this meaning from the material, to inhibit its re-

construction in our reading, and thus tentatively to posit a world of sport where, whatever the reasons for which a person may be honoured, it will not be for the deprivations he visits upon others. When normal speed resumes, progressing to a wide shot of the stadium, we are somewhat shocked by the renewed perception of the athletes as spectacle—as in some sense public property. Bikela passes the winning post, having paced himself so economically that he is able to indulge in a few loosening-up exercises; and the commentary informs us, in a matter-of-fact way, that he has just undergone an operation for appendicitis and has been running against his doctor's advice. His win is thus presented to us as marking a triumph, primarily, over his own limits. But the heroism is not ours; and we are left to judge it by whatever moral standards our experience makes available.

Whether as a result of selection, camera angle, or an actual change of manners between 1936 and 1964, there is a distinct difference between the ways the medal winners are represented in the two films. Where *Berlin* has them salute, starry-eyed and extravert, *Tokyo* prefers them to weep, smile inwardly, or just look embarrassed. The suggestion that *Tokyo* needs to suppress elements of the Olympic reality in order to expose latent alternative social meanings may account for the oddly ambivalent mood— a sort of reverential mockery—which pervades this film. The dissociative methods employed lie close, of course, to humour. What is clear is that the mode of signification we attribute to a film's primary structures, in our instinctive attempt to assign meaning to it, will invade our perception of "weaker" structures which, in other contexts, might not have seemed significant at all. Thus the onset of night seems, in the *Berlin* pole vault, to supply the pretext for a Manichean opposition of light and darkness, a

play of mutual exclusions, where in *Tokyo* it merely makes things difficult to see. A comparable contrast may be read into the outwardly similar endings of the two marathon sequences. *Tokyo* has some close-ups—intense, bleak, sorrowing. *Berlin* goes into slow motion at this point in a way that seems to overreach, and thus to formalise, the runners' exhausted deceleration. There are some haunting *pietàs* of towel-swathed figures collapsing into the arms of uniformed officials. But where the *Tokyo* athletes suffer in the mortality of the flesh, *Berlin* seems to countenance only the apotheosis of victory or the crucifixion of failure.

It is sometimes averred that, whereas Riefenstahl's *Triumph of the Will* is a piece of explicit Nazi propaganda, her Olympics film may be enjoyed in strictly nonpolitical terms. It seems to me, on the contrary, that whereas *Triumph of the Will* may be construed in an anti-Nazi sense, as exposing the tedium of ceremonial, much of the Olympics film fails to take on full meaning unless we are prepared to invest in our perception of it certain at least near-fascist values. Here, however, we return to the dichotomy stated at the head of this essay: between judgments apparently made upon the film and judgments made, apparently through the film, upon the world.

Where *Berlin* is concerned, my account of the pole vault differs significantly from that of the marathon. The latter records a breakdown of perceived meaning beyond which any further analysis must be purely speculative, while the former records a meaning perceived as rejected. We must ask ourselves, however, whether or not such a perception in some sense commits us to fascist values. One view might be that it does so in a tentative and provisional manner. But it is perhaps relevant to observe that

whereas, before seeing *Tokyo*, I understood *Berlin* as a relatively neutral film about a relatively fascist subject, I came subsequently to understand it as a fascist film about a subject which, though by no means ideologically neutral, offered at least the potential for other constructions. Further, it might be more accurate to say that I came to understand it as a *would-be* fascist film about such a subject, since a concomitant of this change of perspective was that the "success" I had attributed to certain sequences began to ossify into mere expertise—that is, to receive integration at that cruder level at which we customarily characterise a work as "empty" or "meretricious" and where meanings denied to the material are imputed by default to its maker. (Once we start discussing films with reference to their directors' intentions, the chances are that we are trying to disavow our own responsibility for the meanings we read into them.)

The coherence which we impose in rejecting is not identical to that which we impose in accrediting a documentary's meaning. In the former, our perception seems merely to articulate the world of the communication. In the latter, the communication seems to articulate our perception of the world.

In final homage to Ichikawa's *Tokyo* I should like to mention a race in which slow motion is not used. At the end of the 10,000 metres, in which at least one competitor has been seen to drop out, we cut directly from the exultant face of the winner to the arrival of the Sri Lankan who, a whole lap behind, "puts on a burst of speed" to finish last. Like the sound of one hand clapping, he is the victor in an event in which he is the only contestant: and the crowd responds with an ovation. Such a conclusion is, but is not merely, the product of an editor's artifice.

Notes on the Ascent of a Fictitious Mountain

I

A tribe are journeying from their winter to their summer pastures. With goats, sheep, and chickens, they travel for a month: the hale, the toddlers, and the elderly. Cattle serve as pack beasts for all their domestic possessions. Of many obstacles which they encounter, the last is a mountain deep with snow.

Film shot in snow is difficult to edit. The near-uniform whiteness, obscuring the topography, blurs also the conventions. If we cut from the front view of a group approaching to the rear view of a group receding, are we showing the same group from two setups or two groups from the same setup? And confusion of space confuses time: is one group passing several points, are several groups passing the same point, or are several groups passing several points? How far have we progressed?

Since the mountain crossing takes many hours, the entire tribe cannot accomplish it in one day; and the opportunity has been

taken to film it twice, on slightly different routes. One day's rushes emphasise the steepness and treacherousness of the terrain, the other the cold and misery of the people and animals. Partly in order to do justice to both elements, partly to overcome our technical problems, we combine the two sets of material. "We have created," says the director, "a fictitious mountain."

II

It is disturbingly easy to make mistakes—quite serious mistakes —in our recollection of films. Once, for the purposes of an article, I went to see a film four times in one week. After the second viewing, I had isolated a particular succession of shots which I planned to discuss; but on the third viewing I discovered that I had remembered the episode wrongly, and that there were three extra shots between two which I had thought consecutive. On the fourth viewing, just as a final check, I paid special attention at that point. The three intrusive shots had vanished.

We can, of course, watch a film on a Steenbeck with a notepad in front of us, pausing when necessary, and make sure we get it right. Yet if we view it again under normal circumstances after first seeing it on this shot-by-shot basis, we shall still find we have made mistakes: not in our account of detail, but in our construction of overall mood and even of narrated, diegetic action: not in relation of parts to the whole, but in relation of the whole to its parts. Just as the temporal succession of frames is required for the illusion of movement, so the temporal succession of images is necessary to the experience of a film's meaning. Subdivision may demonstrate the process, but cannot authenticate it.

Rather than become irritated with ourselves and others, perhaps we should accept errors of recollection as indicative of the properties of the medium. Since its grammars are only tentative, and its imagery so lacking in cultural delimitation as to allow wide scope for investment by the viewer, there is perhaps more truth for film than for other media in the observation than no two readers will produce the same text. But for each of us this text has the appearance—and carries the conviction—of a metaworld: a world commentative upon the one we live in, yet itself bearing the aspect of "reality."

III

Sometimes it would begin with a general view of a city. Then there would be a few street scenes, busy with black limousines and men in trilby hats. The scope would then narrow to the lobby of an hotel or office building; and finally someone would detach himself from the anonymous populace and hand a card to the receptionist: "Mr. So-and-so's expecting me . . ." Often, I think, the moment would be signalled by a change in the sound: the fading out of music, or simply the transition from location effects to studio dialogue. But always, at this point, I felt a pang of disappointment.

This recurrent experience of filmgoing dates from my teens, or perhaps earlier. Even when I first became aware of it, it seemed to have been with me for a long time. What was the nature of the disappointment? It was not that I did not wish the narrative to start. I had gone for an adventure. But somehow I wanted the narrative to happen without what I might later have called "the-

atricality": without any disruption of that casual, eavesdropping, everywhere-at-once quality which marked the opening establishers. (In the words of the old joke: "There are seven million stories in the Naked City! Why did we have to choose this one?")

I should not care to trust hindsight to the extent of saying that what I was looking for was documentary when I continued to hope, at every visit to the flicks, that the moment of disappointment—the almost imperceptible gap to be bridged before the film could be enjoyed—would for once not occur. It may be that what I sought was unattainable because contradictory: a story composed of uncomposed elements; something which would attain to narrative significance whilst remaining random; a coherence proposed without artifice: that narration itself should share the referential level of its constituents where these had been staked out prior to it. . . . Occasionally a fiction has come close to satisfying my innocent requirements: Olmi's *Tree of Wooden Clogs*, some of Cassavetes's early improvisations—even *Potemkin*. But what have come closest have been certain states of certain *vérité* productions: not the rushes, yet not the fine cuts, and most certainly not the transmitted versions with their cellophane wrap of commentary and captions and studio presentation, but the films as they stood when their narrative structures had just begun to emerge with the patient chipping away of the surrounding substance, yet were still perceptibly of its density and of its mass.

IV

The women are seated in a great circle, facing inward, their legs stretched straight before them. Some men are distributing meat

to the women: thick hunks of beef, roasted on aromatic twigs, which they carry in the aprons of their robes. This sequence—which did not appear in the finished film—showed one stage in a Maasai fertility ceremony. There was one shot in particular which cried out to be used, since it seemed to crystallise the "feeling" of the event: a shot along the line, from the women's eye level, in which a man, working his way toward us, handed meat across the stretched legs in a gesture between a deep bow and a genuflexion.

It was, as I eventually recognised, the reverential overtones of this gesture which made it seem so apt. And in a sense, I was not wrong. An essential feature of the ceremony, for the Maasai themselves, was the reversal of social norms in the according of formal respect by men to women. But the fact remains that the Maasai do not bow. In attempting to signify the spirit of the occasion, I was drawing upon connotations of body language specific to our own culture: and not even our present culture, at that, but rather the recollection, as enshrined in paintings or costume dramas, of a past gestural repertoire: Ralegh laying his cloak down for the Queen. . . .

Of course, this goes for writing too. Anthropologists are not in the habit of insisting that their works be published only in the languages of their subject peoples; and every anthropological paper in English is a contribution to *English* literature. But still, English does not operate by mimicking the appearances of its subjects and recruiting these as language for their own representation (with the consequent tacit suggestion of objectivity). It does not, in quite so direct a fashion as does film, taint the alien with familiarity by encouraging us to read back into the pro-

filmic those qualities which are in fact the connotatory apparatus of its incorporation into symbolism. That an anthropological paper contributes to its own culture may be obvious to the point of triviality. What is less obvious, and proportionately less trivial, is that every anthropological film, insofar as it relies for its comprehension upon the competencies of our own culture yet conceals this fact behind the referential nature of the photographic image, is as much *about* our own society as about that of its subjects. That which is an inflexion of our own experience is inevitably also an interpretation of it. Parallels do not have to be spelled out. They are spelled in.

V

Like many of my generation, I first encountered cinema when taken to see *Snow White* at the age of four; and, like many children of that age, I spent much of the time with my eyes shut, terrified of the witch. Forty-five years later, finding myself at a loose end in a provincial town where *Snow White* was playing at the local picture palace, I decided to go and catch up on what I had missed. The witch, of course, was *meant* to be scary; but I was surprised to discover how much of this quality came from the imperfect register of the early animation: a constant shimmer which you found yourself trying to stabilise by act of will: in the act of reading the image, willing your own fear to be.

A six-year-old returns from a holiday spent in rural Spain. He describes the slaughtering of a sheep: how they skewered it between the ligaments of its hind legs in order to hoist it up to a beam, then cut its throat and slit open its belly and skinned it. "Then they hung me up by my ankles and pretended they were

going to cut my throat too . . ." I know perfectly well that, had these things been shown on television, he would have been unable to watch them.

When animal slaughter occurs in the rushes of an ethnographic film, there is usually some debate along the lines of:

"We'd better tone it down a bit, or it'll upset the viewers."

"But why? It's a normal part of these people's lives. There are no implications of cruelty."

"No, but those still exist for the viewer. You can't wish them away."

"Perhaps if it had been shot differently—not so close . . ." Such debate revolves around distinctions between the "significance" of an event for its participants and the significance of its record as component in the film text; and those, when the film concerns another culture, are likely to be perceived as relating to the problem of ethnocentricity. But something seems to be missing from the argument.

I too have my limits: things I find too horrible to watch. As with the six-year-old, I suspect that some of these are things I could readily cope with in "real life," whilst in other instances I imagine the reverse may be true. But at least in these examples, documentary examples, the horror of the images would be recognised as such by others; and differences in response as between pro-filmic and filmic might be assumed to rest purely upon the differing nature of the demands made upon us: in the one case to take action (whether by helping out or by running away); in the other, to construe as meaningful. With fiction, it is different. I have sometimes found myself forced to leave a cinema, not because anything particularly unpleasant was being shown, but because the very activity of animating images which I was not

also free to stop, the feeding of meanings into a text which had the physical magnitude to overwhelm me with them, the shriek of feedback as I locked into a tight short circuit with activities which raced ahead of me, had become intolerable.

The horror of a documentary can lie in our being required to conceptualise (or—if there were such a word—*per*ceptualise) the world in a certain way and being, at least for the duration of the film, powerless to intervene in it. The horror of a "horror" fiction lies in the fact that the horror to which we are reacting is not in any way pertinent to the pro-filmic but has drawn its compulsion, its power to trap us, wholly out of our own psychic resources.

VI

Magnetic sound can be cut. It would be possible, by excision of a "no" or a "not," to reverse completely the sense of somebody's statement. One's first reaction is that this would be unethical, and that any decent documentary editor would refuse to do it. But suppose the person had made what was obviously, in the light of the original context, a slip of the tongue. Should we then leave it be, on grounds of absolute fidelity to the event, or even on the theory that every slip reveals a hidden motivation; or should we alter it to what was "really" meant?

Even if we believe documentary to be convincingly defined by reference to the viewer's response—the viewer's recognition of the privileged relation between a film image and its pro-filmic source—we are left with difficulties about the nature of the claim documentary makes upon the world.

In the popular press and on television chat shows, *vérité* films are taken to task for their omissions. An implied claim to "objec-

tivity" is disputed by obsessive carping about the process of se-
lection and by knowing references to "the cutting room floor."
But is the truth of a statement proportional to its duration? Most
editors would be insulted at the suggestion that their work con-
sisted essentially of leaving things out. To them, even in *vérité*,
what is important is how things are put together. Most people
who complain about the way they have been represented by film-
makers would surely agree that, in principle, they might find an
edited account of an event in which they had participated more
accurate, in emphasis and interpretation, than the arbitrary to-
tality of the rushes. The question is: does this render the efforts
of *vérité* worthless? Does it demonstrate, for instance, that the re-
lation of *vérité* to the prior event is no different from that of a
skilled reconstruction?

VII

Imagine two stills from a feature film—a Western, let us say.
The first, showing a moment of high drama as the baddies de-
scend upon the stagecoach, bears the caption: "Is this a fictitious
event?" The second, which shows a greasy saddle hanging from
a peg in a stable: "Is this a fictitious object?"

VIII

The Jarrow march lasted for twenty-seven days in October 1936.
For most of the journey there was good weather; and only on the
last day did it rain heavily. Yet the image which has entered our
consciousness is of the marchers in their cloth caps and glisten-
ing black oilskin capes trudging defiantly and stoically through

the downpour. This is partly because the arrival in London was the moment which attracted most newsreel and photographic coverage. But it also reflects our sense of appropriateness: our acknowledgment that a 300-mile slog against deprivation and unemployment was no picnic.

Cinéma vérité was met with detestation by such old documentary hands as Harry Watt; and I think this was because they believed it would leave no room for the sort of selectivity whereby the Jarrow images attain to their proper symbolic potential. They feared the inundation of the medium with *mere* facticity: the reduction of the truth of a moment to the way it *happened* to have been shot. They could yet be proven right. But the most striking thing about early *vérité* films, when we look at them today, is the degree to which they revelled in their rough-and-readiness: the bumps, the jerky zooms, the sudden twitches of focus. The pet name for them in the business was "wobblyscope." The periphera of slapdash shooting were seized upon and, in no time at all, elevated to the function of eliciting audience identification with the camera operator in the urgent search for latent meaning: elevated, that is, to linguistic status. I still remember the excitement of cutting this stuff. The Vietnam War exists for us in this language as surely as does Agincourt in the language of Shakespeare.

Rapid improvements in camera handling made the world of the late 1970s, as reflected in documentary, a far less zap-happy place than that of the late 1960s. What I am saying is that language abhors a vacuum, and that a medium from which connotations have been expelled will reaccumulate them as quickly as a sterile agar dish accumulates germs. This process is expedited by the holistic way in which the ciné-text operates. I once cut a sequence in which two teachers, seated on chairs facing each

other within a circle of their colleagues, engaged in an intense and slightly threatening role-playing exercise. This was in the days when, for cheapness, rushes of colour programmes were still printed in black-and-white; and the sequence had a brooding, Buñuelian atmosphere of Jacobean furniture and faces watching from the shadows as if trying to stare out through the darkened varnish of old portraits. When we saw the print of the finished film, it turned out that the gloom had resulted from the preponderance of yellow in the light: the furniture was new and shoddy-looking; the watchers were not swallowed in semiobscurity; and a garish orange-and-red carpet had materialised out of the nether murk. In consequence, the role-playing had lost its concentration and had become an amusement. Nothing had changed in the behaviour or in the dialogue; but to separate these elements out, and to receive the same "message" as from the sequence in the cutting copy, would have required a conscious act of decrystallisation: a conscious reversal of the act of assigning coherence to film.

IX

It is easy to dislike photographs: not so much when we see them as when we *fore*see them. Glancing through the bus window at the dawn light on the Albert memorial, we can imagine—or imagine we can imagine—exactly what a good colour supplement spread would look like: the dewy grey of the grass, precisely rendered, in muted dissonance with the cuprous stains on the white stone; the figures of the tableaux beckoning and gesticulating to an absent multitude . . . and we resent this reducibility, this predictable accuracy which renders all details equal, denies us the

eye's choice of emphasis and disqualifies such nonvisual components as the chill in the air or the elusive scent of leaf-smoke. In short, we suspect that the photograph, which seems to posit all other visualisations as subjective and hence discreditable, will negate the experience of seeing: will brutalise our perception.

Conversely, we are all familiar with the way in which a glossy picture postcard, which we would normally dismiss as too bland to be expressive of anything, can take on a different quality if it shows a place we are about to visit. We scan the image searchingly. What character of light is represented by this insensitive colour? How would it feel to mingle with that crowd, to sit on that terrace, to look back across those hills? By the shift in focus of our attention, the glazed surface of the convention seems revealed as transparent. When confronted with an old postcard, in hand-tinted monochrome, where the conventions, though still inexpressive, have shed their facile familiarity, we seek both to reinstate that familiarity—to think ourselves back to when the conventions would have been neutral—and yet to penetrate these conventions to the actuality of what is shown. The "fascination" of old postcards lies in our attempt to perform these contrary movements simultaneously. . . .

X

When Princess Anne fell off her horse at some race or other, the newspaper carried a report accompanied by a photograph: a small oblong comprising dotted and dappled areas in two or three degrees of grey. So irresolute was this image that, even with the clue of the news item, one found some difficulty in interpret-

ing it. Needless to say, the photo communicated virtually no information *about* its subject, for its rudimentary resources were scarcely even adequate to the job of making her recognisable to a public already familiar with her appearance. Yet the paper had considered it worth printing. Why? Not to demonstrate the existence of someone called Princess Anne; and not to prove that she had fallen from a horse (for there was no horse in the picture); but simply to confirm, as in a host of less extreme instances, the minimal fact of witness: the simultaneous presence of seer and seen.

It is because every photograph bears such witness that photography is widely supposed to have no fictive disposition. But by "fictive," as often as not, we mean illustrative. (Is a painting by Alma-Tadema in any true sense a *fiction?*) If illustrative photography for fictions has been abandoned by all but the producers of certain picture-romances for the teenage market, there is nonetheless an area in which effacement—or at least attenuation—of the photographic "witness" is commonplace.

I used to have, side by side on the wall of my cutting room, two photographs, each showing a hand poised over a glass. The first was by Jean Mohr, and was in black-and-white. The hand was that of a French peasant: stubby, wearing a wedding ring, with a black mark on the thumbnail that was perhaps a blood blister. The glass, over which the hand hovered as if having just put it down, was empty; but drops of apple spirit still clung to its inner surface. A shaft of sunlight, falling onto the table, illuminated the glass from behind and reflected upward onto the man's palm as if his body were glowing with the warmth of the drink; and it linked the gold wedding band with the rim of the glass, and

the etching of the glass with the floral pattern of the plastic table cover. The second photograph, which was in colour, was a newspaper advertisement for a brand of whisky. The tawny drink, in its immaculate tumbler, with the mandatory three bubbles along the meniscus, seemed to glow from within: for the source of illumination could not be determined. The hand, held a few inches above in a gesture inexplicable unless it was that of a customer saying "When," told us little about its owner except that, since the nails were well manicured and the shirt cuff spotless, he was not impoverished. In fact, of course, he may well have been impoverished. He was almost certainly a model hired solely for the perfection of his hands—a "finger artist." Here, then, was a photograph whose resources were bent to the concealment of its origins. The Mohr might not make us aware of the camera; but it did make us aware of its subject as a moment witnessed, in all the specifics of its detail, by a companion seated at the same table. The advertisement, which on a symbolic level strove toward a similar content (the "warm glow" of a strong drink), so denied its subject's specificities as to present them as witnessed by no one: only ourselves, who looked at the advertisement.

There is a similarity here with the classier forms of pornography, which, seeking to distance the model from the sordor of the photographic session, present her not as the contingent object of voyeuristic attention but as "she who would be desirable *if* she were to enter our world": to present the image not as the record of something seen but as the conjuration of our own wishes. There is, of course, an instability in the concept of "a photograph which is not of something witnessed"; but it is precisely this instability which advertisement and pornography exploit. The

point is not, after all, to posit an ideal; and the purpose of the otherwise puzzling hand in the whisky ad is to ensure that it will not be taken for a painting. Where Mohr gives us a moment aspiring toward universality, the advertisement gives us a universal aspiring toward the momentary: a dream aspiring to materiality through the complicity of our vision. Advertisement is the pornography of all our appetites.

When the photograph assumes a temporal dimension—i.e., becomes cinema—the gravitation of the image to its moment as witness may be cheated in the continuous postponement which is narrative. Indeed, we may wish to argue that it is the very instability of the "nonactuality photograph" that supplies the motive for film fiction. The effacements of actuality in film do not demand the impoverishment of its signs. Since all that is required is that the viewer should suspend enquiry, other means are available: the constitutive grammars of realism. Herzog says of the ship in *Fitzcarraldo*, "You can see it's a real ship. You can see it's not made of plastic . . ."; yet despite this apparent appeal to its materiality, to its pro-filmic properties, it is in no way the same ship as in *Burden of Dreams*, the film on the *making* of *Fitzcarraldo*: and the difference lies in that the narrative, generated by the image of this very ship, defers beyond the "End" title any interest in its circumstances. For all its claims to weight, the universe of film fiction has an ontology similar to that of Bishop Berkeley's tree, which exists only while we are looking at it.

Fiction is film's effacement of the fact of witness. Thus when film is used for advertisement, a problem arises: to prevent the instability latent in the "nonactuality photograph" from being dissipated in the generation of narrative. It is for this reason,

rather than because of any difficulty in otherwise identifying the product, that a pack-shot—in effect, a still—occurs at the end of almost every commercial.

XI

A friend, trying to teach words to her two-year-old, was showing him a book with illustrations of animals and birds. It was not a children's book; and the illustrations were woodcuts, somewhat formalised. The child was unresponsive. Eventually the mother, pointing to one picture, said, "That's an owl, isn't it?" I saw the child's expression change. He turned back to the earlier pages and, as if now armed with a stylistic key, correctly identified most of the previous images.

Film is neither raw world nor a symbolic description of the world. It is a representation of the world which gains the status of a simulacrum from the trust which our culture accords the photograph. This "trust" derives from our recognition of the photograph as a trace, an index, of some prior entity. But the indexal property does not in itself entail anything we would acknowledge as adequate representation, as resemblance. A variable-area optical sound track might be called a photograph of a symphony, for it may certainly be an index of one; but it does not provoke in us the conviction that we are in the presence of an equivalent event.

Some people argue that photography is not a language, a code, and that the photosensitive surface has merely stayed the light waves on their journey from the object to our eyes. But this is no more than is meant by saying that the photograph has an indexal, one-to-one relation with that object. And even if the camera is graphically innocent, our eye is not. The camera is, for example,

a machine for replicating the lordly monocular perspective of Versailles; and we know that schoolbooks using perspective illustrations can be misleading to children in whose visual cultures this is not a tradition.

This lack of innocence, or of neutrality, is even more apparent when we look at the moving photograph. The zoom lens, when first introduced into fiction film (I am thinking in particular of Clouzot's *The Wages of Fear*), seemed to flout our "photographic trust" by its capacity to change the size of an image with no effect of parallax. Despite the fact that the human eye alters focus with a zooming action, this seemed "unnatural." Likewise colour, until we became used to it, seemed to make things less "realistic"—more glamorous—than black-and-white. Our "trust" had been granted not to the indexality per se but to this or that manifestation of it at a particular period in the development of the technology; and a change in that technology was sufficient to disorient us.

The disorientation was, perhaps ironically, less severe in documentary, where anything the camera can do (e.g., night filming by infrared light) is quickly reabsorbed into our reading of the image as actuality, than in fiction, where it is not really supposed to matter how the images were obtained. (Why should we care whether the camera is a neutral observer when what is "observed" exists only to play its part in the narration?) What is clear, however, is that the realism of the film image is not assured either by nature or by linguistic convention, but requires for its warranty the cultural, ideological, and individual contributions of the viewer. And, since this goes for documentary and fiction alike, it is clear too that the problems of documentary and the problems of realism are not the same.

XII

There is nothing in literature strictly comparable to documentary in film. A play made up entirely from the transcripts of a trial might seem to offer an instance of documentary drama. But the fact is that words have no concrete prerequisite. At best, the courtroom drama could attain to a certain paradocumentary status to the extent that we chose to *treat* its dialogue as equivalent to that of the original hearing. But to call this documentary would be to blur a clear and important distinction. The dialogue of the play *could* exist without any prior referend, whereas the point about a film image is that it cannot. Only the radio feature, using location-recorded voices and sounds, may truly be said to straddle this divide.

In literature, fiction is defined in contradistinction to fact; and the grey area between them is not so much a no-man's-land as a whole populous continent. In film, fiction is defined in contradistinction to documentary; and the narrow grey area is one not of intermingling but of indecision—indecision as to how a particular text may best be read. Documentary is "about" the materials of its making; and sufficient of the pro-filmic (or pro-radio) elements must be relevant to the discourse for such a reading to be tenable. Flaherty's films—to take a contentious example— are clearly about the peoples filmed. They may be in some respects lies about them; but that does not prevent their being documentaries. In the case of *Tabu*, however, we may find ourselves switching to the fiction mode: either because we suspect, rightly or wrongly, that the narrative has exceeded any credible relevance to the people performing it; or because we find the narrative closure so hermetic as to render the indexal factor of the im-

ages a matter of indifference. It may still be a film about the South Seas; but it is no longer about the people or the objects or the incidents which passed before the camera.

But if film fiction and literary fiction are defined in contradistinction to different things, this does more than require a slight reallocation of the boundary (so that, for example, "factual fiction" might emerge as a category to embrace such divergent works as *Three Days in Szczecin* and *The Private Life of Henry VIII*): it means that film fiction and literary fiction are radically different in nature, since film fiction inheres in the attempt to disown something which literature does not possess in the first place. To do this, however, is no mechanical matter. Knowing that a panjandrum of ethnographic film was to view one of my rough cuts, I included in it a matching continuity—a cut on an action—between two shots taken on different days. To my delight, he noticed this and complained about it, saying that such a device would predispose the audience to see the sequence as quasi-fictional. He was right; yet in the end, I decided not to change it. This fictive cut, done first as a bit of a joke, seemed to serve as a point of reference for the other, more disjunctive ones: to draw attention to the fact that all juxtaposition entails selection and construction, the construction of spatiotemporal narrativities being only a special case of this. In other words, I wished to disclaim that innocence on which purists are sometimes inclined to congratulate themselves.

In any case, the construction of spatiotemporal continuities— the "classic realist" form, where the action defines time and space rather than simply inhabiting them—does not of itself prohibit a documentary reading. We may understand the constituents of a continuity as recurrent events—in which case an action cut will

take on the grammatical status of a frequentative—or as having been enacted for the purpose of demonstration. It is true, however, that such usages create a bias toward the fictional; and they do so, paradoxically, because of what they seem to tell us about the pro-filmic. To read a film as fiction is to perceive all its elements as contributing to its statement, as existing *only for* that statement. Everything, including the pointing of the brickwork and the hue of the sunset, is subsumed into discourse. There is no residue of the intractable. And this implies that everything, as in verbal fiction, is subject to authorial control. Conversely, then, anything which bespeaks undue authorial intervention in the pro-filmic (as judged by the individual viewer) may prompt the selection of the fictional mode of response. But the control is not a *component* of the fiction, which positions it as already forgotten.

XIII

Twenty-five years ago, in an article on Robert Flaherty, I quoted from the commentary of *Industrial Britain* the words "So these industrial towns are not quite so drab as they seem, for behind all the smoke beautiful things are being made," and observed: "But we know perfectly well that 'these industrial towns' are a good deal *more* drab than they seem to a cameraman with a good eye for composition."

I was never happy with this formulation; and it has continued to nag at my mind long after the remainder of the article has evaporated from my memory. The difficulty is that it seems to suggest there is a *correct* balance to be found—hence somewhere a common calibration—between the qualities of photography and the qualities of lives. Obviously there is not. Yet the moment

we say this, we are struck by the suspicion that we may be deny-
ing the legitimacy of film expression altogether. It is easy enough,
when opposing a view we think false (picturesque, sentimen-
tal . . .), to offer such a criticism as the above; but how are we to
behave if we are *making* a film, and cannot escape the connota-
tory potencies of our imagery? Do we wish to spend all our lives
deconstructing dominant (i.e., other people's) codings? We may,
of course, relegate the pictures to the role of testimony to a ver-
bally correct analysis; but this amounts to a refusal to soil our
hands with the material in which we have chosen to work.

Most of us do, however undesirable we may think it, read pho-
tography as offering something more than bald, factual informa-
tion about what is represented: as revealing—rather than merely
superimposing—something we might vaguely designate "qual-
ity," or at least "atmosphere." As we watched the rushes of a
Mongolian carpet factory, which had been shot in hypnotic
close-up on hands, faces, and the richly coloured wools, the
sound recordist remarked that he remembered this factory as a
bleak, raw, comfortless place. With his comments in mind, I tried
to find ways of setting these shots "in quotes," as projections of a
cultivated national self-image in the manner of a poster. But we
cannot put everything in quotes. Sooner or later we must make
the decision whether a certain quality of image is or is not ap-
propriate to the matter recorded. Was the close-up shooting of
the carpet weavers a proper portrayal of the intensity of their
concentration and perhaps also of some level of satisfaction in
their work? Again, adjudication presupposes a nonexistent scale
of equivalence.

The problem is compounded by the fact that some of photog-
raphy's expressivity is borrowed almost unaltered from its ob-

jects. Not all; and never simply. Indeed, there is an irony under-
lying my opening example in that the images assumed to connote
drabness in 1933 were read by myself, in 1959, as having been en-
nobled by the camerawork (and perhaps, at an intertextual level,
by association with Lowry's paintings and the roofscapes of the
Coronation Street titles). Nevertheless, we do all see the width of
a pavement, the weight of a portico, even the slant of sunlight on
an allotment shed made of old doors, as communicating some-
thing of the lives lived in their ambience. No doubt this too is
questionable. An old man is digging his front garden. Does he
stand for contentment? Perhaps he hates gardening, risks a heart
attack with the exertion, and is doing it only because the neigh-
bours have complained about his weeds spreading into their
plots. Look closely enough, and we shall begin to doubt whether
any quality may be attributed to any environment or any life. Yet
if we deny that the quality of life can vary according to circum-
stances, we are left with no reason for wishing to change things.
Which is absurd.

It is our constant practice to attribute meanings to expe-
riences we do not share—in a word, to "sympathise"—and, con-
versely, externalise our own emotions by investing them in the
contingencies of our surroundings. It is doubtful whether film
could serve the needs of fiction without recourse to the com-
munity of such representations—i.e., as a system whose con-
notatory complexities were built up purely by overlays of self-
reference and intertextual echo. But in fiction it does not matter
if we are "wrong." With documentary, this question—like oth-
ers we have touched upon—brings us up against the implacable
central mystery: that of the relation of the constructions we place
upon imagery to the world on which these supposedly comment,

yet which does not exist for us *except* as defined in the operations of the text to which that imagery has contributed.

Again and again we tread the same ground, seeking that slight unevenness which may help us map the buried truth. One more example. In a film I was cutting about a mercurial character, much given to hesitation and digression, rarely finishing a sentence before starting another, I came into severe conflict with the director over the extent to which the speech patterns, in voice-over, should be tidied up for the sake of clarity. The director's position, I think, was that this was not a *vérité* exercise, that we were composing a portrait with filmic materials, that no one portrait could be inherently more valid than another, and that to grant priority to the accidentals of the rushes was perverse. My own position—more difficult to define, for I was certainly not arguing for total nonintervention—was that we were progressively discarding those very elements which made the subject an engaging, quirky, and likable personality. Toward the end of the schedule, however, the subject visited the cutting room. I became aware that what I had perceived as "mercurial" carried with it something darker, more unmanageable, almost entropic; and I began to see in the director's compulsion to curb this personality a fear of disorganisation, of loss of control, of the dissolution of that filmic coherence which director and editor alike are inevitably seeking. Leaving aside the question whether, in this instance, the director had not confused a threat to his authorial control with a threat to the inner logic of the text, we are left with the fact that the personality to which I felt responsibility, and which I hoped to reconstruct in the film, was not that of the subject as directly encountered but that which I had inferred from a reading of the rushes. And this, moreover, cannot be dismissed as

error or misfortune: for it replicates precisely, and quite properly, the situation of a viewer faced with the completed work.

XIV

What exactly is the pro-filmic? Fiction does not need to ask, since its only interest in the pro-filmic is to eradicate it. The documentary impulse resides in the wish that the distinctive relation of the photograph to its material prerequisites should hold for the film text vis-à-vis its anterior world. This is impossible; and documentary has consisted in ways of concealing this impossibility from itself. These ways have meandered between two primal strategies. One has been to establish, between the world and its representation, a purgatorial realm of the putative: of that which might have happened, or that which nearly did. (In classical documentary, this would have been scripted in advance of shooting; in post-*vérité*, it is discovered in the course of refining the material. In neither event is it to be read as a fiction, since— for one thing—the participants are not enacting it as having happened to people other than themselves.) The other has been to vest the claim to actuality entirely in the relation of the *elements* to the pro-filmic, and to leave the totality to take care of itself.

But again, what *is* the pro-filmic? Obviously it is the people and objects and places filmed. Yet even this may require some qualification if we are to avoid the tautology: Here is a photograph of someone of whom this is a photograph. Assuming the subjects are not already public figures, known from other sources, they must be identified from the viewers' standpoint as "people to whom the operations performed by the text are pertinent."

And when we move from people and objects to events and actions, the question becomes more complicated. Must the profilmic—as that to which the viewer is to see the film as referring, and from whose referential traces the film will be built—be held to embrace such circumstances as the participants' awareness/ unawareness of the fact of filming, or the motivations which might (or might not) lead them to modify their behaviour for the camera? Where does responsibility end?

Despite the formulations I have attempted, I still find difficulty with the idea of a film being "about" subjects who are ultimately defined for us only through the text of that film. Nobody would be interested in the Turin shroud if the question were simply whether its imprint was truly that of a crucified man. And I am not here discussing the banalities of "labelling" our material. To believers, I suspect, the shroud takes on holiness from its own testimony; and the consequent irrelevance of scientific proof (*dis*proof would be another matter) serves to enhance the eloquence of its majestic linguistic solitude. The Turin shroud would not benefit from a lower-third caption.

Documentary, which to its makers is a window, is to its viewers a veil impressed with the features of the unknowable. The impressions, certainly, are information. We can scrutinise film imagery for details which the original makers overlooked; and we can rearrange shots so as to highlight these details and bring new themes into prominence. And these themes will bear upon the thing first photographed. Documentary, above all art forms, is not self-referential. It interacts directly—and not just through a presumptive unifying consciousness, whether of author or viewer —with other discourses of knowledge, supplementing and contradicting their data. Yet for all that, to construe a documentary

as meaningful is to consent to the total assimilation of the profilmic into its own signification ("its own" in at least the minimal sense that it is not signifying something other). My most revealing reaction, when meeting people who have appeared in films I have cut, is to be shocked that they should say and do things which did not occur in the rushes. The filmmaker says to the subjects as perceived by the viewer: "The limits of my language are the limits of your world."

XV

All knowledge of the world is a projection of our constructive faculty upon material signals—though these, while they may on the one hand be misleading, can never on the other hand be complete. Documentary is both materialist and voluntarist. Its cathexis is to be found in the conviction that "trusted" images of the world, no matter how these may be manipulated, will engage us on a level of direct relevance to this world. But implicit in this idea—of an engagement with the world in the process of constituting its image as meaningful—is the idea that the world's material is all we have of it, and that its spirit, or meaning, is our way of interrelating its material and of summoning it before the purposive gaze of consciousness.

Every documentary is a do-it-yourself reality kit.

The mountain is nonfictitious if the viewer deems it so. And to forget this is to lose sight of the essentials of our trade.

Rooting for Magoo
A Tentative Politics of the Zoom Lens

Seen from a high angle, a motor launch is approaching; and as it does so, we zoom back to reveal that it is entering the embrace of a small harbour. This image has been shot without sound; but the editor has laid against it two effects: a constant motor and a general harbour ambience. In the dubbing theatre, the mixer asks: "Do you want me to bring up the level of the motor, because the boat is coming closer, or take it down, because we are pulling away from it?"

If the dubbing theatre costs £240 per hour, you will be paying £1 for every fifteen seconds' reflection. The decision is likely to be made quickly and intuitively, according to what "feels" right. But this workaday intuition will be informed by a whole backlog of culturally conditioned assumptions about what a zoom lens is and does.

One of the earliest major examples of the zoom *effect* was not done with a zoom lens at all. This was the coverage of the men's

1,000 metres final in Riefenstahl's *Olympiad*. At the very start, there is a cut to a telephoto shot which holds the front runners for almost the entirety of their several laps. (I have timed this shot at 3 mins 40 secs. The time given for the winner is 3 mins 47.8 secs.) During the interwar period, German lenses were popularly regarded as the world's best; and it is difficult not to suppose that this bravura performance on the telephoto was seen in its day as a valorisation of National Socialist technology. The reason it resembles a zoom shot to today's eye is that it is taken from so far back that the difference in apparent size of the runners, as between the far and near parts of the circuit, is scarcely noticeable.

The effect of a zoom is easily described. Suppose we walk toward a house over which the moon is visible. The apparent size of the house will increase, because we are reducing the intervening distance by a significant proportion; but the moon's size will not seem to increase, because the proportion by which its distance is reduced is negligible. If, however, we zoom toward the scene, both house and moon will grow at the same rate. Hence the illusion of "flattening": as if we were moving toward something drawn on paper. True zoom shots are virtually unknown in professional cinematography of the '30s and '40s. This was due mainly to the technical inadequacy of the available lenses. But we may see how cinema was already buttressing itself ideologically against the spatial implications of the zoom if we consider what was happening where scenes actually *were* drawn on paper: namely, in animation. So worried were Disney by lack of the illusion of spatial depth that they introduced, in 1936, the Multiplane camera: a rostrum rig which enabled as many as eight

superimposed transparencies to be adjusted independently, so that discrepancies in relative movement, both axial and lateral, could be all but eliminated. Within the individual shot, the space defined by such a camera was that of the "superimposition of planes" familiar from the carved reliefs of Greece and Assyria; but in combination, these shots submitted to the disciplines of cross-matching and "suture" which characterise the dominant fictive space of the period.

Just how dominant this was may be gauged from the reactions which greeted the gradual intrusion, during the postwar decades, of the zoom in particular and of long-focus lenses in general. As late as 1964, Charles G. Clarke is writing: ". . . too long a focal length will likewise create a type of distortion. We see a great deal of the latter in television, where a zoom lens is used to vary the picture size from medium shot to extreme close-up. In the last case the face is flattened together and the ears appear at the same plane as the tip of the nose." (It must be some while since any viewer has been troubled by this phenomenon.) And later, of telephoto shots: "They have such a shallow depth of focus as to render an optical or unnatural effect to the scene."* The appeal to what is "natural" in the defence of what is conventional is, of course, very familiar.

With the zoom now so commonplace, we must resort to memory in assessing the connotations of its early use. In Georges Clouzot's *The Wages of Fear* (1952), there are at least two zoom shots. One occurs after an explosion on the road ahead: a slow

* Charles G. Clarke, *Professional Cinematography*, American Society of Cinematographers, Hollywood, 1964.

movement as the smoke and dust roll toward us. The other is from a low angle as a truck nearly backs over a cliff. In both cases, the effect—which might well be lost on today's viewer—was to invest the moments with a sense of unease or of threat. The zoom shot, because it was strange to the fiction film context, was being recruited as a *signifier* of strangeness. In *Vertigo* (1958), Hitchcock sought to signify (or perhaps mimic—or even induce) the eponymous experience by shooting "down" a stairwell (in fact it was done on the horizontal, with a mock-up), and tracking in whilst zooming back, so as to maintain the same framing whilst widening the angle of the lens. This was almost a Méliès response to a new technical option.

One early use of the zoom lens is so striking as to deserve closer attention. It occurs in Robert Aldrich's *Apache* (1954). A young brave has decided, as a result of prior plot developments, to embark upon a solo war against the whites. His wife tries to accompany him as he sets off into the rocky wilderness; but he roughs her up, throws away her moccasins, and departs alone. Several dissolves later, we pick up the young man in mid-shot moving right-to-left. He halts, reacting to something off-screen. We continue the pan left, losing him and revealing the edge of a downward slope, perhaps a precipice, then zoom in to frame his wife clawing her way up the rocks toward him. One thing to be noted about this moment is that it is, in diegetic terms, nonsensical. Unless we assume that the brave was lost and walking in circles—an interpretation ruled out by the stereotypes of the genre—there is no way that the young woman, without footwear and left behind almost unconscious, could have arrived here before him. *Apache* is a film replete with

tracking shots, often over pretty unpromising terrain; and there is no practical reason—so far as one can see—why the shot in question should not have been done with a track. The zoom introduces a spatial oddity which marks the spatial impossibility of the narrative, yet which at the same time partly conceals it, since we may be inclined to attribute the almost supernatural cast of this incident purely to the intrusion of a visual construction out of kilter with the remainder of the film. It is also worth observing that the encounter on the rock is the pivotal point of the story, since the young man's acceptance of the woman leads to his acceptance of a settled, agricultural life. To that extent, too, the emphasis given by recourse to an unusual lens is appropriate.

Since the quality of the "unusual" is defined in *Apache* against the spatial grammar of the whole, the force of the zoom does not rely solely upon its novelty. However, it was not until the early '60s that zoom shots could be comfortably accommodated into the spatial economy of the fiction film. In Rosi's *Salvatore Giuliano* (1961), zooms accompany gunfire to supply topographic links over exterior distances, and also to emphasise the concealed subjectivity of the gunman by—paradoxically—closing in upon the object of his gaze. It is such usages, among others, which have led people to describe this film, retrospectively, as "documentary" in style. But this is not a case of fiction's appropriating the identifying usages of documentary, since documentary was itself only just beginning to explore them.

Up until 1960 or so, the main use of the zoom lens—other than by amateurs—had been in sports coverage and live television. And here again, the reactions of professionals and theorists

testify to the hold which received language exerted. Spottis-woode, in 1951, tells us:

> The least satisfactory kind of zoom is frequently to be seen
> in newsreels, when the frame embraces a whole football field,
> let us say, as seen from high up in the stands, and then quickly
> zooms down to a small group of players. In spite of the great
> change of magnification, the effect is not that of travelling
> through space; it is little more than that of dissolving from
> an ordinary long shot to a close up. Let us suppose, however,
> that at almost maximum magnification, our zoom lens is
> framing the same small group of players. The camera pans
> up to the stands just behind, a simultaneous slow zoom using
> the remaining magnification giving the impression that the
> camera is moving in on a few spectators to watch their re-
> action. Then, at slightly greater speed, the zoom control is
> pulled back, and the camera is simultaneously panned and
> tilted upwards. If these movements are skillfully coördinated,
> it will seem as if the camera itself were moving upwards and
> sideways through empty space above the field, in order to
> get a full general view of the stands and the game.*

The emphasis on the importance of having it seem that the cam-era is floating through empty space may seem bizarre today—"unnatural," in fact; but it is important to recognise that the zoom did not automatically assume the significance which we now generally attach to it, that of variation in focus of attention from a fixed viewpoint. The difficulty of learning to "read" a zoom shot may be confirmed by two more quotations. In 1964,

* Raymond Spottiswoode, *Film and Its Techniques*, University of California Press and Cambridge University Press, 1951.

Clarke (himself a cameraman) writes: "It [i.e., the zoom] gives the effect of a rapid dolly shot, except that the object moves to the eye rather than the eye moving to the object, which latter effect is the illusion created when we concentrate with the eye."* In 1969, an unnamed writer comes closer, yet still not quite, to the way we would now describe it: "The use of variable magnification makes the camera seem to advance towards or recede from its subject at any desired speed."**

One of the first documentaries to make substantial use of the zoom was Richard Leacock's (and others') *Primary*, a record of the 1960 face-off in Wisconsin between John F. Kennedy and Hubert Humphrey for the Democratic presidential candidacy. To see *Primary* today it is to be surprised at how much of it is couched in the idiom of earlier documentary. There are sequences using music over mute shots, a jokey montage of people's feet in polling booths, and so forth. But it is the parts which were not in this idiom which we remember today, being those which attracted most notice at the time. For much of the film, the camera is milling around with the senatorial retinues; and just as, in *Salvatore Giuliano*, the elision of the zoom with gunfire serves to emphasise the subjectivity behind the "shots," so here the frequent use of the zoom is meshed with other signifiers of the operator's presence: the handheld camera jostled by the crowd, focus changes and aperture adjustments conscientiously included in the final film. . . . Indeed, even in its relatively traditional passages, *Primary* is edited with a shoddiness which seems to mark

* Clarke, *Professional Cinematography.*
** *The Focal Encyclopaedia of Film and Television Techniques,* Focal Press, London, 1969.

it as a denial of received codings. Its aesthetic kinship is perhaps with the chillingly nonjudgmental collages of Robert Rauschenberg. We learn little of the campaign issues or of the political context. Hermetic, narcissistic, self-reflexive: *Primary* is about little but having been where the action was. Thus the ethos of the whole reinforces the specifics, and is reinvested in them. Perhaps it is for this reason that the "we-were-thereness" of the zoom in *Primary* became, for the following decade, its predominant connotation in documentaries made in the shadow of this hugely influential film.

A secondary factor, providing a further connotatory nuance, is that until very recently all zoom lenses have been imperfect, being usually a little soft at certain settings and at no point as sharp as a corresponding prime lens. For this reason, directors and operators in the sway of a particular tradition—realism as maximisation of detail—have preferred to avoid them. For those who have not, there has always been a suggestion of "to hell with the aesthetics, we're here to get a story": in a word, of gung ho journalism.

With time, however, the novelty value of such filmmaking began to wane, and with it the identification of the zoom with the conviction of presence: not least because the parallel effects which had sustained it in this meaning—the nervy hunting for framing and focus—began to look like plain incompetence once the best operators had learnt to frame and focus in a split second. And, perhaps on account of its residual coding as "subjectivity," the use of the zoom—except to find framings for static shots— came to seem almost ill-mannered. Yet there remain things for which the zoom shot is almost indispensable. To pick an example from a film I once edited: the Bakhtiari, on their annual migra-

tion to their summer pastures, are climbing with all their flocks and herds up an immense rock face. If you frame for the people, you get no idea of the size of the mountain; if you frame for the mountain, you can no longer see the people. A slow pull back links the two. In an instance such as this, the zoom takes on the grammatical function of a preposition.

To recapitulate: a piece of hardware, designed simply to enable certain things to be recorded on film which otherwise could not be, takes on a succession of connotations: valorisation of national technology; strangeness; conjuring; spatial dislocation bordering on the supernatural; subjectivity; journalistic endeavour; bad manners; prepositional linkage. But there remains the question of geometry.

If the zoom has lent itself to the articulation of subjectivity—the experience of the camera operator being notionally "shared" by the viewer—it is because the two-dimensional flatness of our viewing screen may be mapped onto the ground-glass "screen" of the viewfinder, our vision elided with the camera's. In the mid-1950s, U.P.A. brought out the *Mr. Magoo* cartoons, the first to break with Disney orthodoxy by abandoning the quest for three-dimensionality and allowing the drawings to look just like drawings. And these were greeted with an enthusiasm difficult to credit today: as if they were not merely a welcome change from what we were used to, but somehow iconoclastic and, above all, politically correct. We must surely conclude that they were answering to the same need as was the introduction of the zoom into documentary.

Barry Salt, having analysed 200 fiction films spanning the period from the 1920s to the "present day" (i.e., 1977), discovered that, from the 1930s onward, the majority conformed to a pat-

tern whereby 30 to 40 percent of cuts were based on eyeline
matching or point of view.* Given that many of the other cuts
must have consisted of location changes, such a percentage is am-
ply sufficient to define the familiar, non-Euclidean, fictive space,
where a circle comprises something like 300 degrees. This sutur-
ing of the sector(s) occupied by the camera, when combined with
a preference for "natural" setups (i.e., those suggesting an ob-
server) enacts, and arguably posits, knowledge in the absence of
a knowing subject. At this point, film language begins to assume
what are arguably theological implications.

A zoom lens, even if the movement is not used while the cam-
era is running, serves to define a "zoom space" very much at vari-
ance with that of most fiction. Even without the souped-up sub-
jectivity of the '60s, the use of the zoom lens, in conjunction with
such other signifiers as the handheld track, serves to define docu-

* Thus Barry Salt, "Film Style and Technology in the Forties," *Film Quarterly*,
Fall 1977, as quoted by Stephen Heath in "Notes on Suture," *Screen* vol. 18 no. 4,
Winter 1977–78. Here the term "angle–reverse angle" is used to designate "all
cuts which change the camera angle from a direction which is within 45 degrees
of the eyeline of a person appearing in a shot through a sufficient angle to fall
within 45 degrees from the eyeline in the other direction." However, in what
is presumably a reworking of the same material in *Film Style and Technology: His-
tory and Analysis* (Starword, London 1983), Salt has modified his definition of
"reverse-angle cutting" to mean anything which changes angle by more than
90 degrees, and seems to offer a wider statistical spread than that suggested by
Heath. But these considerations of "shot/reverse-shot" may in any case be, be-
yond a certain point, misleading. What really matters is not the reversal of angles
but the *displacement* of the camera position from the eyeline(s) of the character(s):
and once this is established, its implied geometry may be understood as being
sustained by other elements in the *mise-en-scène*—the oblique movement of a
track, for example.

mentary—where the camera's is the only subjectivity on offer—
as a first-person narrative. And there is a certain propriety in this.

A short while ago, however, I saw a construction not untypi-
cal of current affairs television. A young couple, facing each other
across a restaurant table, were discussing their mortgage difficul-
ties; and from a wide shot, we cut into a medium-close shot from
what was clearly the same position. (Zoom aside, in classical fic-
tion it was considered "wrong" to cut in along line of sight. A
change of distance ought, one was told, always to be accompa-
nied by an angle change of not less than 30 and not more than
90 degrees.) Yet it was equally clear that the couple were speak-
ing rehearsed dialogue; and it is hard not to believe, in such an
instance, that recourse to zoom space is intended as a signifier of
the scene's spontaneity. Signifier it may be; but guarantee it is
not. After *Primary*, documentary was able to redefine its mission
as the entrainment of the unrehearsed into the process of signifi-
cation; and from that point, the markers of spontaneity began to
be understood as the markers of documentary per se. But docu-
mentary consists in the viewer's attribution of relevance to the
anterior event. Practices which confuse this should be treated
with considerable caution.

Competing with Reality
(Sketch for a Lecture)

I've been invited to talk about film and reality. It's a pretty intractable subject, not least because we don't always mean the same thing by "reality," and we may be very conscious of the dangers of using the word glibly, of taking it at face value, and even more conscious of the likelihood of being pounced on by academics for using it at all. But for the sake of having a starting position, let's say that we'll use "reality" in a simple, colloquial sense: as meaning whatever's out there, whatever isn't the construction of the film, but had to be there for the film to be constructed. Of course, this can lead to all sorts of questions as to who's experiencing this stuff out there, and how; but those are precisely the questions I'm trying to sidestep in order to get started.

A few weeks ago, I heard a quote from Fellini which seemed to offer a route into this. It was in a television programme about *La dolce vita;* and it was to do with the fact that Fellini preferred to mock up the Via Veneto in the studio rather than shoot it on location; and what he'd said was—and I'm quoting from mem-

ory, but this was the essence of it—"I'd rather reconstruct reality than compete with it."

Now on the face of things, this is a very odd way of putting it. I mean, shouldn't it be the other way round? Wouldn't it be more natural to suggest that shooting the Via Veneto on location, then assembling the material in the cutting room, was "reconstructing" it, whereas rebuilding all those shopfront cafés in the studio was an attempt to "compete" with it?

But Fellini is acknowledging a far more subtle point, which is that if you shoot a sequence on location—especially, perhaps, a familiar public location—the sheer fact of presenting a photographic record of this piece of geography will show up the presence of the actors on it as a falsity, a fiction; or, to look at it from the opposite angle, that the fiction will not manage completely to digest this intrusion of "reality": that the two will be experienced as somehow peeling apart.

It's worth bearing in mind here that Fellini isn't in the normal sense a studio director—someone like Lang or von Sternberg, who prefers the studio precisely for its ability to create a world, if not necessarily quite a fairy-tale world, at least insulated from the grit and grime "out there." (Sternberg said of one of his own films that he'd made a mistake by including a real shot of the sea in it, because it broke the illusion; and that he ought to have shot it in a studio tank. I haven't seen the film in question, but I can well imagine what he meant.) No, Fellini's films, at least up to and including *La dolce vita*, are sufficiently committed to the experienced environment—and I mean the experienced environment as *subject matter*—to require a great deal of shooting in locations that couldn't possibly be replicated in the studio: long shots of housing developments, beach scenes, and what-have-you.

This, of course, can be seen in an historical context as deriving from the tradition of Italian neorealism, which in turn has its origins in at least two factors (and I couldn't even attempt to go into the literary influences): one, the sense of urgency in the closing days of the war which led young filmmakers to grab a camera and shoot when and how they could, often with scavenged film stock; the other, a sense that political truth demanded realism, and that realism meant a break with the glossy, cocooned world of the studio, where there was at least the option—to put it no more strongly than that—of triviality and irrelevance. (A whole school of Italian films of the '30s and '40s had attracted the sobriquet *telefono bianco*.)

Such a view wasn't confined to Italy at that time. In Britain, the war had opened up a space for feature-length documentaries on general release in cinemas. (It had done that in Italy too. The Italian ones tended to be somewhat less bellicose, and to deal with subjects like hospital ships, or the rescue of men trapped in a submarine.) And likewise, at the end of the war, there was a feeling that getting out into the streets and factories was something that commercial film should go on doing. At least, there was that feeling on the left. There was this idea that to shoot on location was politically progressive: so much so, that we were all mildly traumatised by Lindsay Anderson's review of *On the Waterfront*,* which he castigated—quite rightly—as being a politically pernicious film. How could it be politically pernicious when it was shot in "real" places?

* Lindsay Anderson, "The Last Sequence of *On the Waterfront*," *Sight and Sound* vol. 24 no. 3, January–March 1955 (p. 127).

There might be an interesting study to be done on what underlay that assumption about the inherent political merit of real locations—and of nonprofessional actors too, because that was part of it. In my own case, I think there was an ancestry leading back via Eisenstein to Engels's *Dialectics of Nature*, though I'm not sure Engels would have recognised himself in it. What seems certain is that there was an untheorised attempt to graft the materialism of documentary onto the stem of fiction; and the question is what you get from that graft, and whether there's any merit in it. Realism as such doesn't demand it. After all, Pabst had made the highly realist *Kameradschaft* entirely in the studio—though admittedly most of the action took place down a coal mine, which made it more easy to simulate than a waterfront, and which pretty well ruled out any other option, with the lighting technology of those days, in view of the danger of gas or dust ignition.

But to return to postwar Italy: they achieved what we in Britain failed to achieve, which was a politically radical—I won't get into the micropolitics, but broadly—a politically radical fiction cinema to which elements of documentary materialism were perceived as relevant. And when I speak of documentary "materialism," I mean precisely that property of the image which Fellini mistrusted and saw as competitive: the fact of having been taken at a particular place at a particular time, or of recording the face of a person whose background and struggle and sufferings had been those of that person and not another. In *Bicycle Thieves*, and to an even greater extent in a film such as *Rome, Open City*, it was felt that the actuality of the places where the events might have occurred, and of the people to whom they might have occurred,

had, as it were, its own rights to which respect was due, and that only that conditional "might have" stood—flimsily, as it were—between fiction and the world: a celluloid-thin distinction.

Although I still love these films dearly, I'm more inclined now to share what I take to be Fellini's view: that record and invention are an unstable mix. Fellini himself was never a neorealist. For one thing, so far as I know, he never used nonprofessional actors in major roles, and certainly never made a principle of it. There's a moment in *La dolce vita* which can easily slip by unnoticed. It's in a chaotic scene where Anita Ekberg is being interviewed by the press. She plays an American star who doesn't speak Italian; so there's a constant cross-talk of translation. One of the questions is "Is Italian neorealism alive or dead?"—and an off-camera voice is heard to say, in English, "Say 'alive.'" I think we can safely take it that this is meant as a joke.

All the same, there's one area where the very instability of the "mix," as I called it, may be turned to advantage; and that's the area of factual drama. (It's usually called drama-documentary; but in my view that's a plain contradiction in terms.) Almost at the same time as Fellini was making *La dolce vita*, Francesco Rosi was making *Salvatore Giuliano*, a film about the Sicilian bandit, on the actual terrain where he'd operated until his death ten years before. And here, the significance of the actual locations is very different from what it is in purely invented fiction: the conditional is removed: it's not a question of "here's where something like this might happen," but of "here's where something like this *did*." And I think it's fair to say that the very tendency to "peel apart," as I put it earlier, of the action from its location, may actually reinforce the uncertainty which accompanies any attempt

at historical inquiry: *something* like this happened; but can we ever be quite sure just how "like this" it was?

I think it's clear that what I've been talking about all this time is the ontological status which we attribute to a cinematographic record when it's introduced into various forms of discourse: because every shot is a record of something—even, if you want to push it that far, the sequence of still drawings which constitutes an animated cartoon. But just in case I haven't made myself entirely clear, let me return one more time to *La dolce vita*.

When this film was recently shown on television, it was preceded by a documentary on the making of it; and this documentary included an extract from what seemed to be a promotional film, made at the time, which included a sequence on the shooting of the famous scene of Anita Ekberg and Marcello Mastroianni slopping about in the Trevi fountain. As with all such examples, there was a distinct frisson in seeing the documentary and the fictive representation of the same thing within a short time of one another. The most obvious difference, apart from the presence of Fellini's crew and lights in the documentary, was the presence of huge numbers of casual spectators—sightseers—in what was presented, in the fiction, as a piazza empty but for the two protagonists. It was difficult to believe they were the same location: and that's because, in a sense, they weren't.

We read a documentary as constituting some sort of trace of things that happened in a particular place at a particular time. What leads us to give it this documentary reading? Well, in our particular instance, it is the fact that Fellini's cameras are in shot and the fact that we are told—in a way external to the material itself—that that is what it is. But I can't actually swear,

in retrospect, that those massed spectators were ever seen in the same shot as Ekberg and Mastroianni. Suppose they weren't. And suppose, to go one step further, that they weren't even there at the time of filming: that the whole thing was a con constructed in the editing room, and that, except for the film crew — or rather, the *two* film crews — Ekberg and Mastroianni really were alone in the piazza?

Would that mean that the documentary was really a fiction? No, I don't believe it would. What defines a documentary as such is the way we approach it: the fact that we look to its images as records of the specific, not as envisionings of the possible. The film would remain a documentary; but it would be a dishonest one, a mendacious one. Documentary, after all, can tell lies; and it can tell lies because it lays claim to a form of veracity which fiction doesn't. (Factual drama lays claim to veracity, but in a different sense — what you could call a legalistic or even a documentational sense, without ceasing to be, in film terminology, fiction.) Of course, once you *knew* the thing was phoney, you might then wish to avail yourself of the fiction option. That would be up to you.

So everything's wrapped up neatly. Except that I have a niggle of doubt. Because it seems to me — and you may not agree with this, and I wish I didn't, but it does seem to me — that if we were to *know* that those sightseers had not been present during the filming at the fountains, this knowledge would considerably lower the level of frisson in the comparison between the "two" locations, the documentary and the fictional. And yet it shouldn't. It shouldn't make any difference at all. Fiction inhabits its own world. Doesn't it?

Salvatore Giuliano
A Feature Film by Francesco Rosi

Consider the last two shots of *Salvatore Giuliano*. Introduced by
the title "1960"—i.e., ten years after the main action of the film,
and only two years before its release—the former is a long shot
on the outskirts of a small town on what may be market day.
There is a lack of obvious focus. We are not sure why we are
looking at this, or where to look. Suddenly there is gunfire; peo-
ple scatter; and we cut to an overhead full shot of a man lying
dead, facedown in the dust.

This two-picture sequence is both brutal and economical, put
together as if in a newsreel, as if saying no more than: "That hap-
pened." Yet the final image, both in the posture of the corpse and
in the use of high angle, is a perfect echo of the opening shot
of the film: the prostrate body of Giuliano himself. Thus an ap-
parent offhandedness of manner coexists with, and to some ex-
tent masks, a highly disciplined handling of film form. The for-
mal symmetry serves here to stress the endlessness of the cycle of

Sicilian violence; and it does so in a way that has none of the banality of such a verbal formulation.

Salvatore Giuliano was a figure of my youth, his exploits widely reported in the British press. At the age of fourteen or so, I would cut his photograph out of the papers. They said he was a fearless bandit who robbed the rich and gave to the poor—which seemed to me a good idea. This sentiment has its place in the film. Two of the journalists who have gathered at the news of Giuliano's death, frustrated at their inability to pick up anything beyond the laconic official statements of the carabinieri, approach a soft-drinks vendor in a square white with sun. They ask him what he thinks about Giuliano, and are told, "He robbed the rich and gave to the poor." For their physical thirst, a lemonade; for their intellectual thirst, the myth. Such recourse to outright symbolism is, however, uncharacteristic of the film.

Salvatore Giuliano appeared in 1962; and, having worked on the subtitling for its British release, I remembered it for many years as a film in which one was never entirely sure what was supposed to have happened. But this is not strictly true. Each scene is quite explicit; and a clear enough interpretation is offered—should we wish to believe it—of the events leading to the bandit's death. My reaction, though, was clearly not an isolated one. A number of critics have described this film as offering differing versions of the same events. And that is not true either. Yet somehow or another *Salvatore Giuliano* manages to come across not just as a film about betrayal but as a film about doubt: a film where the interpretation offered seems only one of many possibilities. How can this be, when film deals so resolutely in the concrete, in the bald presence of what is shown?

.

White-on-black titles give the credits followed by a brief para-
graph on the eponymous bandit, the main function of which is to
establish that he was a real person and to tell us that he was found
dead in the courtyard of a house in Castelvetrano.

The first image we see is a high shot into the courtyard. Sur-
rounding Giuliano's body are a number of people—some in uni-
form, some not, some standing, some seated.

As we cut to ground level, we begin to understand what is go-
ing on. A voice, which we might initially have taken for an im-
personal commentary describing the scene, turns out to be that
of a man whom we may assume to be a plainclothes police officer
reading out his report on the position and state of the body. The
most important-looking figure in the courtyard—an elderly,
seated man in a straw hat—seems to be nodding off, and only be-
stirs himself once to correct the grammar.

We are now very close to the body; and the contents of the
pockets are being checked off. At the line, ". . . a photograph of
someone not yet identified," we cut with a squealing of brakes to
the street outside, where a high-ranking officer of the carabinieri
is arriving amid milling pressmen to shouts of "No photographs,
please!"

We revert to the high angle of the courtyard as most of those
present are asked politely to leave. Our suspicion is confirmed
that the foregoing procedure was not being taken very seriously
by the people who really matter. Now the carabiniere and the el-
derly man confer quietly together, gesturing toward the corpse.
The fact that we can no longer hear what they are saying makes
us suddenly aware of ourselves as occupying a spatial position in

relation to them: as looking from above; as being eavesdroppers. And we are immediately given, for the first time, two low-angle shots of people looking silently down from windows and roofs.

For me, this is a crucial and almost shocking moment in the development of the film. Up to this point, we have taken it for granted that the shots we were seeing, from which the action was constructed, were a straightforward visual narration—equivalent to the use of an omniscient narrator in literature. Of course, it is perfectly normal for a film to incorporate a point-of-view shot (the equivalent of writing, "She watched him load the gun . . .") in such a narration; but the way the watchers are introduced in this courtyard scene is such as to make us reevaluate its images right back to the opening shot. It is as if we were being told: "Don't forget that every point of view is *somebody's* point of view. All knowledge is imperfect. You've been tricked once. Now be more careful."

The top brass leave the courtyard, and permission is given for the press to enter. As we again look closely at the body, someone says, "His singlet's covered with blood, but there's none on the ground"; and someone else replies, "It'll be underneath . . ." Is it? We try to see. If there is no blood on the ground, it must mean that the body has been moved here after death. But just as this doubt is raised, we cut to the elderly gentleman agreeing that the courtyard should be cleared after "just a few photographs"; and we think we have an inkling of why.

Again the high angle. And as one of the officials clears the courtyard he looks up, for the first time acknowledging the watchers, and shouts, "Close the shutters up there!" Like the press, we are to be given short measure. The privileged viewpoint from

which the film has seemed to be constructed is being refused. From now on, we may suppose, all will be conjectural.

What follows "Close the shutters!" is a sequence opening in the least conjectural idiom imaginable. Complete with superimposed caption "PALERMO 1945" and accompanied by a voice which really is that of a disembodied commentator, it is an account of political developments in Sicily toward the end of World War II. For a moment we suspect that this may be genuine archival material; but then the camera pans up to some men on a balcony, and we cut inside to a discussion among the leaders of the Sicilian separatist party at which they decide to enlist the aid of the bandits. There is nothing unusual about simulating a newsreel effect in a fiction film; and the device would be unremarkable did it not follow, quite dramatically, a moment where the status of the filmic narrative has been called into question and has been exposed as *partial* in at least two senses of that word: as incomplete, and as therefore necessarily biased.

We now come to a cluster of sequences serving to "introduce" the main character.

First seen in a high shot from the bandits' stronghold, two or three cars approach. An old man addressed as "Senator" alights and is accompanied on foot up the hillside. The newsreel-style commentary resumes to tell us that Giuliano is being offered the rank of colonel in the separatist forces, with the promise of rehabilitation when independence has been achieved. This comes across as factual information established by history. But the way the information is communicated visually is somewhat different. The senator goes into the house where Giuliano is waiting; but

we remain outside. Normally a film, unless clearly identifying with a particular protagonist, will feel free to present its action in the manner of the aforesaid omniscient narrator. Here, however, we are being excluded as a journalist might be excluded, not privy to the crucial negotiations. Are we then to view this scene as a simulation of newsreel coverage? Is the film saying to us, "We shall confine ourselves to the sort of truth a news crew might have captured"? Part of what we are doing as we watch the opening sequences of any film is to try and fathom the rules within which it is working. In this case, we may prefer not to assume that we shall be confined to events at which a news crew might credibly have been present, since such a constraint would probably make the story untellable; but we may perhaps assume that the narrative will confine itself to images a news camera might have picked up if it *had* been there. In either event, the treatment here has the effect of distancing the visual narration from the post facto certainties of the commentary.

The next sequence opens with a close shot of a Giuliano proclamation posted on a wall, then pans round to the street. (Interestingly, the poster glimpsed here is one which demanded not exactly independence for Sicily but its annexation as the forty-ninth state of the United States; but we do not have time to register this unless we are familiar with the poster from other sources.) There follows a shot up another street, hot and empty, held long enough to induce unease before a number of men, one by one, enter from the foreground and move purposefully away from us. Now we see a doorway, the insignia of the carabinieri above it, in the left foreground. Someone enters the building as the group of men, unseen by him, approach cautiously up a street on the right. (Could a news camera, we wonder, really have caught this mo-

ment?) Next it is night. Clusters of men are disposed about the square, waiting, to the nervy twang of a Jew's harp. Behind them a light comes on in an archway and a figure appears. He is in extreme long shot; but he is silhouetted, and others turn to register his presence. Cut to the reverse angle: foreground left, an arm raises a submachine gun; background right, the door opens to let someone out. A shrill whistle. Blackness and gunfire.

For all its simplicity, and for all its being carried on the film's prevailing current of realism, there is an extraordinary formality about these two night shots, with a lit opening in the right background providing the focus of significance in both. We believe that we have now seen Giuliano. But how did he know that his victim was about to emerge, arriving and aiming his gun just at the right time when his men had been waiting half the day? Are we to assume some rational or superstitious explanation; or are we to see the narrative as having shifted into a different register? Perhaps we just shelve the problem for now.

Daylight; open country. We are in the thick of the bandits as they converge upon a blockhouse with a military vehicle outside. One figure stands out, because he is wearing a long white coat and is clearly giving the orders. This *must* be Giuliano. But we become aware of something strange in the way he is shown. When he runs toward us, the camera holds on his legs rather than tilting up to his face. He is seen in close-up only from behind. We begin to suspect that a strategy of avoidance is being adopted. Yet it is an avoidance so insistent and so pointed as almost to amount to an alternative mode of representation; and, in retrospect, the quasi-operatic night scene in the square takes its place as an instance of this.

To end this cluster of sequences: a close shot of four carabinieri in a jeep; a high shot, panning with it. Abruptly a gun comes

into frame. (Thus again we discover we are sharing someone's viewpoint.) A quick zoom in—a rarity in those days—as the gun fires and the jeep swerves and one man falls out. (The zoom, in addition to adding dramatic force to the gunshots, emphasises further the subjectivity of vision—the eye behind the viewfinder or the sight.) And we cut to a coffin being loaded onto a hearse, panning with it past uniformed foreground figures. On first viewing, most people will surely take this to be the coffin of the carabiniere we have just seen killed. Only the next shot makes it clear that we are back in the "present." They are removing the body of Giuliano from the courtyard.

By now, we may feel we have grasped the ground rules of this film's grammar. But perhaps we feel we ought to move on a little, just to make sure we are not mistaking incidentals for essentials.

The journalists quickly realise that the story they are getting from the carabinieri is both inherently unconvincing and contradicted by such testimony as they can glean elsewhere. The dispenser of lemonade says nothing until asked, then:

"He stole from the rich and gave to the poor."

"Is that all?"

"Yes, sir, that's all. [*Pause.*] Where are you from?"

"From Rome."

"What can you understand about Sicily?"

We see the journalist from Rome peer through the glass doors of the hotel restaurant where carabinieri and civic dignitaries are enjoying a banquet, then go to the phone to file his copy, beginning, "The only certain thing is that he's dead . . ." and ending, "*continua, continua . . .*" We cut to a pan across the landscape surrounding Montelepre; and, almost as if continuing the journal-

ist's dispatch, the commentary brings us up to 1946. We pan and tilt up the cliffside until the words "the king of Montelepre" cue the appearance of the man in the white coat: confirmation that he is indeed Giuliano. Cut to a front shot of Giuliano, his face obscured by cap and binoculars. A zip-pan, prompted by his movement, reveals an army convoy approaching along the road we have just been looking at. What we took to be a neutral, travelogue-style image, illustrative of the commentary, proves to have been seen through the searching lenses of the outlaws. . . .

Well and good.

I think there are three structuring principles which deserve to be considered.

Firstly there is the way in which transitions between the time bands—"past" and "present"—are made. Transitions to the past have been brusque and businesslike: the use of the caption "PALERMO 1945" and the cue of the journalist's "*continua, continua . . . ,*" in both cases picked up by impersonal commentary. But the first return from past to present is marked by a linkage of ideas—from the shooting of the carabiniere to the coffin— almost as confusing as it is eloquent; and indeed, something similar will occur at the next reversion to the present, when the arrival of Giuliano's mother in deep mourning, to identify her son's body, will follow upon a flurry of wailing women in black protesting against the mass arrests of the Montelepre menfolk. It must, in fact, have been difficult to find a way of signalling these transitions, since the time bands are too close to afford significant differences in dress or townscape, or to justify any contrast in photographic style. We shall learn to look for semantic parallelisms as signals of a shift in filmic tense. But the upshot of this device is to create a sense not of sharp separation but of overlap

between past and present, as if it were hard to say that they could clearly be differentiated. There are other points in the film, moreover, where a similar temporary confusion is encouraged. When a soldier says of the bandits' stronghold, "We'd need an aeroplane to attack that," we hear a sound which we think is that of an aeroplane; but it is a dispatch rider on a motorcycle bringing the order to retreat. A consequence of these devices is to keep us always on our toes: to maintain us in an attitude of scepticism toward all we shall see and hear. It is as if a projectionist had somehow suddenly sharpened the film's intellectual focus.

Secondly there is the attempt—granted a little licence here and there—to remain within the camera constraints of newsreel or on-the-spot documentary. Far from allowing this to pass as a stylistic mannerism adopted simply for its connotation of "realism," the film forces it upon our attention at several points where it obliges us to reconsider the subjectivity of the view are have just shared; and at the symbolic level, such awareness is emphasised by the recurrent images of shutters being closed, of visual information being withheld. Now, there is no absolute moral reason why a fictive film should confine itself visually to what could be captured by a handheld camera during an unrehearsed event. Indeed, most feature films make a point of doing—and of being seen to be doing—the opposite. Why, then, this insistence? One explanation might be that it is a token of good faith to the viewer, a way of saying, "We haven't gone beyond the facts of the case as we know them." But I think there is a stronger way of looking at it. If the purpose is to make a film about events which were shrouded in "a conspiracy of silence and terror," and which even today leave many questions unanswered, then there is really *no point* in adopting a cinematic language grounded in

the idea of narrative omniscience. To do so, you would have either: to decide on the right answer and simply show that; to identify the narrative "voice" with one (or more) quasi-ignorant character(s), thus severely restricting its scope; or to be prepared to drop your omniscience at various arbitrary moments.

This, however, brings us to the third point. The casual, grabbed, reportage-like character of the imagery seems at odds with the studious avoidance of the figure of Giuliano himself. Yet could it have been otherwise? Giuliano is, and must be, the absence at the heart of this film. To show his face would have been to endow him with the beginnings of motivation, the beginnings of a character, the beginnings of meaning. It is very well to construct a film from images which might have been obtained by someone present at the time; but the cardinal truth is that no camera *was* present at these times: and since Giuliano is the film's subject, it is he whose absence must acknowledge the conjectural nature of the "record." The contradiction here is one from which the film does not shrink. As the story progresses, the representation of Giuliano will become if anything more formalised, more abstract, more disjoined from everything else. The scene where Giuliano's henchman, Pisciotta, hearing whistled warnings from afar, alerts Giuliano, and the two escape Montelepre together as a military convoy drives in, is of a sort which, on today's television, would be supertitled "Reconstruction." And that, clearly, is all that any account of Giuliano can be.

To have cottoned on to the principles of a film's operation, whether intuitively or with more explicit analysis, is, usually, to have equipped ourselves to understand the remainder of it. With *Salvatore Giuliano*, that is not quite the case. It is not that these

principles are abandoned or contradicted as the action progresses; but they are certainly submitted to development, to mutation, in a way that leads us constantly to reconsider our position in relation to them.

When Sicily is granted autonomy, and amnesty offered to those who have fought for independence, some of Giuliano's men approach a lawyer in an attempt to claim their rehabilitation. The scene in his office is handled in classic fashion, with eye-matching cuts across dialogue; and this treatment, so much the norm in our experience of cinema, here strikes a strange and slightly ironical note: as if the use of such classic grammar were a comment on the supposed normalisation of politics and the restoration of properly constituted order.

As the bandits turn to robbery and ransom, there follows a major sequence of mass arrests in Montelepre; and this is built up from some of the most complex and highly choreographed shots in the movie. But there is a comment worth making about these. While we, as people with a special interest in the medium, may be filled with admiration and astonishment at the directorial skills they reveal, they do not—unlike, say, the complicated opening shots of Welles's *Touch of Evil* or Visconti's *La terra trema*—insist upon the recognition of these skills as a prime component of our response: as signalling, that is, a flamboyant or virtuoso visual delivery. It is rather that the skills have been employed to simulate the results achievable by a highly responsive documentary operator with luck on his side: the unfolding of an intricate action in front of the camera.

Something very different begins to happen, however, the next time we revert to the "past tense" narrative. Over a seemingly neutral shot of a goatherd on a mountainside, we are told in com-

mentary that the people's bloc have won the first Sicilian elections and that the peasants are demanding land reform. The goatherd then encounters two bandits, who tell him that Giuliano wants to see him. This exchange, albeit brief, employs the matching cuts across dialogue which we have hitherto seen only in the context of establishment inertia; and it is followed by a dissolve —the only one in the film—which finds the goatherd waiting with others outside Giuliano's HQ; and this scene is accompanied, for the first time since the titles—that is to say, for the first time since the action began—by background music.

What are we to make of all this? We may wonder whether the dissolve formally signals a change in moral stance toward Giuliano as, presumably at the behest of the Mafia, he leads his recruits to fire upon a workers' and peasants' demonstration at Portella della Ginestra. Or we may begin to wonder whether we have been wrong in our interpretation, and indeed whether we may not have overestimated the formal rigour of the film. Perhaps it is, after all, a purely opportunist text, availing itself of whatever devices come to hand from moment to moment. In the demonstration itself, we have a close track past the crowd followed by a tilt up to the mountain just in time for the gunfire: a little too good to be true. Only when we cut to the interrogation of the goatherd by the police—a cut accompanied by the abrupt cessation of the music—do we realise that what we have been given is a conventionally structured account of this one man's evidence: not, to be sure, in the literal sense that every shot is from his point of view—a restriction which cinema scarcely ever embraces—but that it remains broadly within the ambit of his experience and certainly does not identify with the viewpoint of anyone else. Once again, though in a fresh manner, the question

of whose knowledge we share has been retrospectively answered, and its relevance again stressed.

From the goatherd thrown into a cell, sobbing and shouting, "Catch Giuliano, not people like us," we pass, with fades out and in, to a photograph of Giuliano—a real one, one I remember clipping out of a newspaper—affixed to his tomb. As his mother pays her respects and leaves the cemetery, the commentary cues us into the events leading to the capture of Pisciotta, the last of the bandits still at large. I have always found this a decidedly awkward transition. Obviously we are in the "present" time band, having passed beyond Giuliano's burial so that his full facial image—the public one, the mythological one—can now be exposed. Yet the use of commentary has hitherto signalled the "past." Furthermore, two cars pass Giuliano's mother as she is leaving the cemetery, and two cars pull up outside the house where Pisciotta is hiding. Are these the same two cars, or is this one of those transitions-by-resemblance? That is to say, was Pisciotta captured before or after the moment at the graveside? In itself, this makes little difference; but it will make a great deal of difference—and lead us into considerable confusion—if we assume the capture to have occurred, like all previous "past tense" scenes, before Giuliano's death. (It has to be said, too, that there is a further source of potential confusion for those of us unfamiliar with the Italian legal system. At one point the President of the Court will refer to a letter received, during the trial, from Giuliano, thus implying that the trial had already begun before Giuliano's death. And that is in fact how it did happen, Pisciotta simply being added to the defendants after his capture.) Essentially we have reached the point when the past, the explanatory, catches up with the present flow. There will be further scenes filling in

the interval between the massacre at the demonstration and the arrest of Pisciotta; but these will be of a slightly different order, consisting of flashbacks enclosed by the trial. It may be that such minutiae are of interest only to grammarians; but it does seem to me that this is the moment where the film's risky strategy for the handling of time transitions nearly comes to grief. The slightest inattention here will leave us muddled over the chronology of what is to follow.

Pisciotta and his associates are in the dock, charged with participation in the massacre. This is a long, sustained sequence—in effect three sequences run together—showing successive stages in the trial. It is composed primarily of the sort of material familiar from newsreel coverage: telephoto shots, shots over people's heads, shots from prescribed positions from which characters are not always easily recognisable. The exception is the treatment of Pisciotta, particularly during two climaxes, one where he claims the bandits were hand in glove with the police and the other where he threatens to reveal not only perpetrators but the instigators of the crime. Here the camera cranes and dollies in on him and cuts dramatically to different angles as he is speaking: operations which conspicuously could *not* have been performed during actual legal proceedings.

I find myself able to believe, on no other evidence than the film's stylistic scrupulousness, that the words we are hearing are taken verbatim from the trial transcripts. If Pisciotta is at this point treated in a fictive manner, it can only be to signal that *what he says* is to be considered conjectural; and it is significant that such treatment accompanies his most contentious statements. It is as if the stylistic disjuncture which has marked Giuliano as an

uncertainty, as a flaw in the text, were now spreading to embrace his lieutenant. (It may be worth noting that a ground bass to these disjunctions is provided by the imperfect postsynchronisation characteristic of European filmmaking at this period, particularly in Italy. The effect of this, even though we know the technicians would have been striving to get it spot-on, is to stress the distinctness of *function* between words and images. There have been losses as well as gains to cinema from the attainment of accurate lip synch.)

Now let us face up to a difficulty which may be troubling some people. A danger in the close reading of a film is that one may begin to attach excessive and unwarranted importance to detail. (It is necessary, from time to time, to check one's perspective by running the thing through without halting.) Not everything that happens in a film need be regarded as of major consequence. But how do we set about distinguishing the structural from the trivial or fortuitous?

Critics of a certain stamp are inclined to treat this as a question of what the *auteur* had in mind. But the arts do not require us to be mind readers. If we were to ask a director what she or he had meant by this or that, we might justifiably be given the reply: "What I wanted to say, I said in the film; and if you don't know how to read a film, that's your problem"; or, more realistically, "Damned if I remember!"

Is there a way, then, that the validity of an interpretation may be tested without the introduction of some presumptive—and ultimately unhelpful—idea of authorial purpose? Can criteria be found for deciding between the incidental and the essential, or between a perverse and a reasonable reading? Our understanding of a film begins at an intuitive level, where things "come to-

gether" or assume significance for us; and this significance becomes a touchstone for our deepening experience of the work. What this depends upon is an ability to distinguish signal from noise such as human beings display in all manner of contexts; and the principles governing this process are those which, should we be motivated to do so, we may extend into a more reflective study.

It seems to me that there are two criteria to be applied to our reading of any part of a film. The first is gravity. How much difference would it make if it were differently done? Does it matter? The second is consistency. Does this detail reinforce or undermine our overall view of the way meaning is being generated? I would consider a good reading one which accounted for most of the salient features of a film and as many of the minor ones as possible, whilst at the same time making sense in terms of the world outside the cinema (for an attribution of meaning, however tentative, will always engage our concerns in that respect).

Suppose, then, that I am accused of "making too much" of the handling of Pisciotta's big speeches. What are the alternatives? Well, it might be argued that what matters here is the verbal content of the speech, and that the way it is presented visually is relatively unimportant; but this is a position which no film worker would be happy to adopt. Another view might be that the shots are used for their inherent dramatic impact, and that it is unnecessary to try and relate them to some overall stylistic pattern. But this seems incompatible with our primary experience of the film. Very many commentators have described *Salvatore Giuliano* as being made in "a documentary style"; and what they mean by this is that much of it is shot as if the action anteceded the fact of shooting. Yet there are demonstrable departures from this style;

and it has been my argument that these have both a logic and a development to them. With Pisciotta's speech we are confronted with a new form of this departure. My explanation may not be the best one; but not to explain it at all would be to consign it to the status of a lapse: in intentionalist terms, a lapse of directorial judgment; in ours, a lapse of internal coherence.

The scenes in the courtroom, with their succession of named witnesses some of whom we have not previously met, may make us wonder whether this film does not rely heavily upon a prior knowledge which the audiences of its time might have been presumed to possess. To some extent, indeed, this question may be asked of many of the action sequences as well. There is a clear allusion, albeit in précis, to the hoisting of the separatist flag over Monte d'Oro; and it is possible that the attack on the blockhouse, mentioned earlier, is meant to stand for Giuliano's attacks on the barracks at Bellolampo, which it resembles in being isolated amid barren terrain. Certainly there may have been some advantage for an audience in being already familiar with such personalities as police Inspector Verdiani, with whom Giuliano is said to have been in lengthy negotiation, or Colonel Ugo Luca, who had headed the Force for the Repression of Banditry in Sicily and whose public status is emphasised by the use of newspaper headlines to announce his appearance before the tribunal. Yet it is arguable that such prior knowledge would not really get us much further, but would simply shift the focus of confusion back into the world of daily news whose function is little more than to offer us the illusion of comprehension; and that the film's seeming reliance upon "what is publicly known" serves mainly to rub in the fact of our befuddlement. And clearly it must have been

obvious, when the film was made, that any seeming clarification supplied by the public context would be eroded to insignificance within a fairly short time.

In conventional film practice, the courtroom scenes might have been interspersed with flashbacks representing the testimony of individual witnesses, the cueing of such flashbacks serving to imply their subjective nature. Here that is not done, perhaps because such a treatment, attributing each account to an individual whose motivations might at least be guessed at, would have sacrificed the *audience's* engagement with the uncertainty—equivalent to that of a researcher whose perspective on the whole is being constantly altered. Instead, after the main bulk of the court sequence, we move into a continuous series of minisequences, initiated by commentary, which take us up to the killing of Giuliano and the placing of his body in the courtyard.

These sequences are presented in more or less the standard fictional manner. Music and cross-matching of shots are employed freely. New characters are introduced and identified through dialogue as we see Don Nunzio, evidently a small-time mafioso, pressured by the authorities into turning in several of the remaining bandits and, finally, managing to persuade Pisciotta that Giuliano is about to betray him. Unless we are to assume that the film has simply given up on its carefully laid stylistic groundwork, we must surely see these sequences, pre-echoed by the quasi-fictive treatment of Pisciotta in the courtroom, as representing some sort of distillation from the witnesses' testimony and deserving whatever level of credence we wish to give to that. There are no actual contradictions in it; and perhaps it is simply the best sense that the court can make of the evidence. We

are not sure. Many of these sequences, in contrast to what has gone before, show clandestine interchanges between as few as two people. Clearly it would be an absurdity to have used a newsreel idiom to represent backroom deals struck with the Mafia. Looked at in this light, it may seem that the film's formal sophistications have been dedicated to rendering both newsreel and fictional modes semi-opaque: in their different ways inadequate as carriers of truth. Support for this view may be found in the strangely fragmentary nature of the minisequences composing this passage of the film. They convey only the scantiest information, and connections between them are somewhat elliptical. Most strikingly, the moment when Pisciotta is persuaded of the truth of Don Nunzio's accusations consists only of a brief glimpse, through a half-open shutter, of some men entering the building below. We do not know where we are; and the men are not anyone we recognise. The evidence is seemingly enough to convince Pisciotta of Giuliano's treachery; but the sheer wilfulness of the film's refusal to make it convincing to us, the audience, must surely be seen as casting doubt on the adequacy—to put it no more strongly—of this portion of the narration. Furthermore, as we are now firmly in the "fiction" mode, in which the portrayal of Giuliano himself might be thought to be permissible, it is noteworthy that the avoidance of him is more marked than ever. In his final confrontation with Pisciotta, in a darkened room, he is not seen at all; and we cut away to exteriors before the fatal shots are fired.

We return to the courtroom for just long enough to learn that there is still a mystery about who was behind Giuliano, and that Pisciotta claims to have the key to it. When the sentences are

read out—life for himself and some others—Pisciotta flies into a rage and vows to tell all he knows at the inquest into Giuliano's death. We assume from this that he has trusted some deal bargaining his silence for a promise of acquittal—or that he wishes the court to believe he has.

In prison, Pisciotta takes a spoonful of medicine followed by his morning coffee. A moment later, screams from his cell signal the start of his death throes. A couple of the bandits come to help carry him to the hospital wing, and he tells them that either his medicine or the coffee was poisoned. At this, we pan with one of them to the cell cupboard. He removes the medicine and puts it in his pocket. Why? Is he hoping to trace the culprit? Is he implicated in the killing and concealing the evidence? Or does he simply think that, whoever was responsible, it is no business of the authorities? We never find out.

Thus at the very last moment—as if saying, "Did you think it was coming out tidily after all?"—the film draws visual attention to an action fraught with ambiguity, a moment for which no certain explanation is to be found, and, in so doing, teases us with the representation of something supposedly witnessed by no one.

.

Although, as I have remarked, the word "documentary" persistently crops up in discussion of *Salvatore Giuliano*, Rosi firmly— almost vehemently—rejects any suggestion that his work is of a documentary character. Even when discussing his decision to shoot scenes in the places where the original events occurred, he stresses only the value of this in putting the performers—themselves mostly local people—in the right frame of mind. Yet whilst it is clear that we do not respond to *Salvatore Giuliano* in a truly

documentary sense, it is hard not to feel that the ghost of actuality which haunts any fiction film is of particular potency here, where the landscape and dwellings in which the story is shot played such an intimate role in the events fictively portrayed. I have tried to show how the extremes of manner, ranging from the rawness of newsreel to a fictional treatment verging on the symbolic, provided Rosi with a stylistic gamut for the articulation of many shades of doubt. When it comes to the use of documentary idiom, one comparison will suffice to demonstrate the control with which conventions are handled. In the lead-up to the killings at Portella della Ginestra—which, though we do not know it at the time, will turn out to have embodied the testimony of the goatherd—a long track behind the crowd arrives at a framing of the mountaintop just in time for the gunfire to be heard: an essentially fictional coincidence. However, when a crowd drawing water during a break in the military curfew is startled by the sound of gunfire from the hilltop above Montelepre, the pan up to the hill is prompted by the sound, exactly as it would be in a documentary. This is not a scene whose truths are in any way contested; and the film is here speaking, as nearly as it can ever be said to do, without displacement—in its own voice.

Documentary is by no means limited to a simpleminded, denotative address—an address which would in any case, we know, be very difficult to achieve. Documentaries can be subtle and complex in the means they offer us for articulating our vision of the world through their imagery. But are their subtleties and complexities of the same kind as those found in *Salvatore Giuliano*? I believe not. To represent a scene as having not necessarily taken place, or not necessarily taken place as represented, could be done in documentary only under the rubric of "reenact-

ment"; but in fiction film everything is reenactment—or at any rate enactment. Fiction film—especially perhaps fact-based fiction film—is free to exploit a slippery ontological gradient within the common fictive status of things shown. With documentary, where the actual circumstances of filming are granted priority, such gradients are likely to be perceived as epistemological: i.e., to be referred back to such questions as how far the camera may have modified the behaviour of the subjects, and how we might tell if it had.

In this connection, it is worth asking how the systematic visual avoidance of the central character would "read" in a documentary. In the more formal instances—as has already been suggested—it might very well be understood as the "reconstruction" of an event which it had not been possible to film: a meaning unavailable in the fiction. In the more casual scenes, such as the attack on the blockhouse, it would be more likely to provoke the reaction: "They had the cameras on him, so why did they fail to get a proper shot of his face? Was he refusing to cooperate, perhaps hoping to evade identification?" The level at which we negotiate such options may well, in the last analysis, be the level at which we choose between the documentary or fiction modality in response.

Leonardo Sciascia once suggested that Rosi had, by the device of never allowing Giuliano to be properly seen, endowed him with mythic or heroic stature; and Rosi seems reluctantly to have conceded the point. It may indeed be true that the film can be seen in this way; but it is surely the case that what we have here is the convergence of two requirements toward a similar result. For the mythic hero, avoidance is both a dramatic stratagem—as, for example, with the long wait before we get a good look at

Hitler in *Triumph of the Will*—and a constant stripping away of the contingent in favour of the ideal. With Giuliano it is different. Since he is posited as the unknown—rather, as "he about whom the truth cannot be known"—the representative conventions must bend as they approach him to become more formalistic, less substantial. There are, of course, many other characters about whom the truth is not known; but they, at least, are encountered in the public space of the narrative; and even for them, the unknownness of Giuliano, represented by his nonrepresentability, exercises its gravitational pull. I believe we would take the evidence of Pisciotta and others more "seriously"—that is, would assume we were meant to accord it greater credence as having been shown to us in good faith—if the handling of Giuliano in the context of this superficially realist film had been more of a piece with it.

Interviewed at Cannes in 1972, Rosi said that he sought in his films to provoke "an uninterrupted dialectical rapport between the individual and reality." Rosi disclaims Marxism; and it is of interest to ask what he means by "dialectical." The constant reinterrogation of our assumptions about the nature of the narrative, to which I found myself urged in the above reading of *Salvatore Giuliano*, would certainly seem to fit this description. It is no easy matter to create a structure which is both logically consistent *and* demanding of a constant revision of our stance toward it. Perhaps the handling of the "reconstructions" of the trial evidence is of particular interest here. Had this been done in the normal way, with flashbacks from the testimony of each person who spoke, the option for reading each as potentially untruthful would still have been present. But the potential untruth would in each case have been bracketed, within the narrative, as a feature of the

character of the individual in question: as reflecting upon that person's individual traits of honesty or mendacity. The way it is actually done in *Salvatore Giuliano* allows us to treat the text itself, analogously with the public record, as riddled with doubt. Lies—if they are lies—are allowed no sanctuary in psychology.

It is up to us, as individual viewers, whether we take the narrative strategies of this film as being dictated by the peculiarly Sicilian conditions of *omertà* or as reflecting upon the problems of knowledge and certainty at a more general level.

· · · · ·

The harsh black-and-white world of *Salvatore Giuliano*, a world of sun-dried bloodstains and heavily retouched photographs and uninterrupted mourning, seems a generation away from our image of Danilo Dolci, whose "strikes in reverse" and free schools for impoverished children seem imbued with the anarchic, anti-authoritarian spirit of the late '60s and early '70s. Yet Dolci arrived in Trapetto—a fishing village close to Partinico—in 1952, only two years after Giuliano's death; and the first of the strikes in reverse occurred as early as February 1956, when he organised a group of the unemployed to undertake repair work on a public highway. (The response of the authorities was to imprison them for malicious trespass.) His *Banditi a Partinico*—published in English with a collection of other texts as *Outlaws of Partinico* (MacGibbon & Kee, 1960)—was evidently researched during the period of 1953–54, and he must have been working on it at the same time as Gavin Maxwell was in Montelepre researching his life of Giuliano, *God Protect Me from My Friends* (Readers Union, Longmans, Green, 1957). And Rosi is said to have consulted with Dolci while planning his film.

All the same, the sense of having stepped into another universe is not entirely a trick of memory and iconography, of the difference between black-and-white and colour stock. Dolci's book, which covers exactly the same region of western Sicily as Maxwell's, contains scarcely a single identifiable reference to associates and relatives of Giuliano, though these cannot fail to be anonymously present in the tables listing bandits against age, occupation, hectares owned (mostly nil), educational standard, criminal convictions, and so forth. One secondhand allusion to "Turiddu" is not even footnoted by the English translator as referring to Giuliano, though it clearly does; and there is one impatient diary entry upon the death of Pisciotta—which occurred in 1954, rather later than you would imagine from the film—in which Dolci rails at the obsession of the Italian press with such trivia as the clothes he was wearing in his coffin. These omissions cannot be accidental. Neither, I think, are they the simple consequence of Dolci's focus of interest, which is overwhelmingly upon social conditions. What is happening here is that Dolci, in order to force social conditions to the top of his agenda so as to raise the question of their being changed, has been obliged quite systematically to suppress an entire area of discourse: namely, that where conspiracies and mendacities breed. It is perhaps a little shocking at first to recognise this suppression for what it is; but Dolci's message—and it is a rejoinder to *Salvatore Giuliano* of which I am confident Rosi would have approved—is that progress can only be made in such a corrupt polity when we treat questions of guilt and innocence as irrelevant distractions and say simply, "Such-and-such conditions lead to such-and-such consequences. Now let us ask how the conditions may be changed without appeal to those whose discourse it itself corrupt."

From Today,
Cinema Is Dead

The invention of photography was hailed by Paul Delaroche with the declaration "From today, painting is dead." The centuries-long search for two-dimensional equivalents of furs, clouds, distances, the intricate patterning of textiles and the multifarious details of foliage was at an end. What had been difficult was now easy. The photograph could guarantee likeness.

Delaroche is best known in England for his *Execution of Lady Jane Grey;* and anyone familiar with this work—which, in black-and white reproduction, could easily pass for a film frame from the first decade of this century—will understand his reaction. But still, it can hardly be denied that the agenda of art was radically altered. Painters now had to define their work in relation to the new technical option. Impressionism, the first major response to photography, challenged it on its own ground by questioning, if only implicitly, its claim to having the last word on the world's appearance. The impressionist project, whatever value

we may set upon Chevreul's theories of the composition of colour, was antiphotographic in a way that Leonardo, with his optometric approach to visual experience, would not have understood.

But if the photograph seemed to guarantee likeness, how did it do so? Even leaving colour and binocular vision out of it, we know we do not perceive the world exactly according to the laws of perspective; neither do we, except for a flickering instant, hold to one plane of focus. There is more to sight than meets the eye. Besides, the idiom of the photograph is itself not wholly immutable. We can usually distinguish—"stylistically," as it were—between a daguerreotype and a calotype, even in a relatively poor reproduction. No, the point of photography is not that it mimics definitively the experience of seeing an object, but that its relation to that object is a necessary rather than a contingent one. More tellingly: the object is necessary to the photograph. These necessities find their complement in a specific manner of *trust*. The visual idiom of the photograph reassures us not only that it is a nonarbitrary transformation of the thing represented but, more fundamentally, that an object of which this is a representation must have existed in the first place.

The realism we attribute to photography is our apprehension of its twin necessities. This is not always well understood. A cliché frequently encountered in art films is the juxtaposition of a painting with a photograph, albeit a moving photograph, of the same thing. The suggestion—though no one would be so crass as to put it in so many words—is that this is what Mont Sainte-Victoire or the garden at Giverny "really" look like: with the implication that Cézanne or Monet didn't get it quite right, or were perhaps, in the perverse way of artists, looking for some-

thing other than resemblance. Yet although, as we have suggested, the "likeness" guaranteed by photography is more ontological than iconic—being mediated through a process which is not the only one conceivable, and is certainly not quite that of the human senses—it may nevertheless be regarded as a sort of surrogate vision. Thus the nude in *Le déjeuner sur l'herbe* is shocking not just because her companions are in modern dress but because she is rendered in a photographic manner—that of a snapshot, casually sunlit.

It is likely that, had photography not been invented, the idea of travelling into and through a visual image might have seemed a morbid, Edgar Allan Poe–like conception. Be that as it may, the sense of photography as surrogate vision took on great force at the beginnings of cinema, when visitors to the first Lumière show marvelled at the rendering of such transient effects as the brick dust billowing from a demolished wall or the leaves rustling as the baby is fed. Such sense of shared vision was, however, understood to be fugitive. As early as 1903, a review of a series of films made by Charles Urban in Borneo contained the comment "It was full of 'actuality,' as people were fond of saying *a few years ago* . . . [my italics]" This "actuality" was—and is—the subjective conviction on the part of the viewer of that prior and independent existence of the represented world which is specific to the photograph.

Attempts to reinvigorate the "actuality" effect have been ceaseless throughout cinema's history, consisting first in the exploration of ever-new subject areas, then in such dubious gimmicks as hand-tinting and toning, and eventually in the development of fresh forms of cinematic articulation. Thus at a point when General Interest films (travelogues and the like) had lost all bite

and immediacy, the Grierson movement set about using every-day imagery to generate an urgent civic propaganda. By the time British Documentary had begun to smell stale and governmental, new portable professional equipment was beginning to throw emphasis upon the uniqueness of the moment as captured by those holding the gear.

The evangelical function of cinema, as witness borne to the having-been, is one that has claimed passionate loyalty from many practitioners. They have seen in it the promise of a language purged of authoritarian impositions by its being grounded in the free consent of the viewer to reading it in this light. The extent to which the authorities in the field of television recognise this as a threat may be judged from the efforts they make to contain it: the constant insistence that documentary material should be explained, identified, captioned, signposted, even musically accompanied — in short, made subordinate to extraneous schemata. It is a species of stylistic censorship far more insidious than the occasional banning of a current affairs programme which provides a *cause célèbre*. (Throughout my career as a film editor, I have seldom shepherded anything worthwhile onto the screen without a feeling of guilty triumph — of having "got away with it.") Of course, there is no denying that a *vérité*-style film has been edited into a statement, and may indeed have been dishonestly edited; but even where this is the case, there remains a residuum of choice, of enfranchisement of the viewer. In seeking to curtail the power of the photographed image to direct us toward the autonomy of the prior event, the authorities have received flanking if unintended support from people who, in blind deference to semiological axiom, have made a point of denying that there is any distinction to be found between documentary and fiction. A

sign is a sign, and that is that. But are those who insist that "the camera *can* lie" seriously telling us that they have never granted the photograph a different form of credence from that which we accord to a painting, or the film clip a different form of credence from that which we accord a written dispatch?

· · · · ·

On 21 October 1990, the *Independent on Sunday* carried an account by William Leith of a meeting with David Hockney. Scarcely had Leith arrived when Hockney began photographing him, in segments, with a camera which recorded its images digitally onto a floppy disk. He then fed the disk into a computer, adjusted the colour, enhanced the outline, and laser-printed the result onto paper. In a phrase eerily echoing that of Delaroche 150 years earlier, he described this as heralding "the end of chemical photography." It was at this point that I began keeping an eye open for relevant items in the popular and trade press. Not long afterward, a piece appeared in *The Guardian* explaining how advanced computer graphics could now be programmed to offer the viewer of an archaeological series a "walk" through a long-demolished building. With Hockney, an image obtained "photographically" had been only the starting point for a process of modification. Now something was to be experienced as a photographic image which was not one.

The memory capacity of digital systems has increased unabated, allowing ever-more-subtle effects—reflected colour from adjacent objects, for example—to be mathematically preprogrammed. At the same time, ultrahigh-definition video systems are being developed which will approximate to photochemical standards of image resolution. In day-to-day television,

electronic manipulation of imagery has proliferated, and has long escaped the confines of commercials and title sequences to infect the tissue of programmes themselves: first news, then current affairs, science, sport, and even gardening. Already I have once or twice been uncertain whether I was looking at a genuine shot or a simulation. Meanwhile, there has been controversy over the "colorization" of old black-and-white movies. Those who oppose this do so on the grounds that we ought not to mess about with the classics. But there, at least, all that is involved is the adding of a further fictional element to what is already fictitious. To colorize old newsreel footage for use in a newly shot drama is a different matter: it is to negate the value of those codings, derived from the technology of the original registration, whereby we customarily identify the level of recognition an image demands.

The problems of categorisation have become steadily more teasing. Snell & Wilcox have developed a system, for eliminating the ratchetting effect of slow-motion action replays, whereby a computer calculates the appropriate intermediate position between two frames for every pixel in the field. Each of these intermediate frames, if held, would represent a photograph *which was never taken*. Less dramatically, but with similar implications, Panasonic advertise a video camera for the amateur market which will eliminate the effects of wobble by centring each frame to match the previous one. And in the realm of stills, we have seen accounts of the "Ageit" computer system, designed to help the police in tracing children who have been missing for a long time, which, if fed with the photograph of a child of known age, can print out an accurate image of how that child will look a given number of years later. Here the one-to-one correspondence of a

photograph to its subject is coupled with invariant formulae for the relative rates of growth of different parts of the human face. Is the result a photograph or isn't it?

Developments of this sort have, of course, been debated widely. But such discussion, insofar as it has touched upon the question of photography as evidence, has tended quickly to shift from "evidence" in the sense of "the state of being made manifest" to "evidence" in its more limited, forensic meaning: to whether the photograph can still be treated as the bearer of truth. From here, it is a natural step to point out that photography (and, *a fortiori*, film) was never trustworthy in any absolute sense; that we have always judged photographic texts with more than half an eye to the credibility of their sources; and that therefore, all things considered, the new technologies have changed nothing much.

Certainly the option for manipulation of the image has always been present in photography. Mostly these manipulations have been designedly blatant, whether in the political collages of Heartfield and Bayer or in Frank Hurley's apocalyptic multiple exposures from the battlefields of World War I—for which, even then, he incurred the wrath of the purists. But there have been exceptions. Peach Robinson's prints from multiple negatives—of which the best known is *Fading Away*—are distinguishable from straight photographs only by an unease, a certain surreal frisson, which they provoke. (Here, one must stress, it is not simply a question of misidentification of a photograph's subject—which is usually all that is at issue in arguments about the camera's untrustworthiness. *Fading Away* is a "photograph" of four people in a room together who were *not* in that room together. We do not even know if such a room existed.) More sinister and widespread

was the success of Stalin's agents in eradicating from the photographic record people who had been eradicated from life. Such practices, however, whilst perhaps putting us on our guard in certain cultural areas, were never so predominant as to call into question our underlying assumptions about the relation of the photograph to a prior world. Indeed, just as Heartfield's photomontages rely for their force upon our recognition of them as *impossible* photographs—an oxymoronic and hence self-mocking category—so were the airbrush exercises of the NKVD parasitic upon that very "trust" which is photography's signature. There is no point in tampering with the facts unless people are going to assume—in spite of all their well-founded suspicions—that you haven't.

So what *has* changed? In one sense, nothing. That is to say that none of the developments I have mentioned, singly or together, logically changes the relation of a photograph—or the possible relations of a photograph—to its object. But it is not altogether a matter of logic; rather of how much weight our cultural assumptions will bear. I am inviting you to consider the moment when what has been said already will have ceased to be the case.

•　•　•　•　•

Let me make it clear that I am not concerned here with mendacity. I am not concerned with the possibility that people may be misled by a doctored picture. What concerns me is that we shall wake up one day and find that the assumption of a privileged relation between a photograph and its object, an assumption which has held good for 150 years and on which ciné-actuality is founded, will have ceased to be operative. And when that hap-

pens, it will not be because some thesis has been refuted but because the accumulation of countervailing experiences—of the simulation of the photographic idiom, of the electronic recombination of photographic elements, of "photographic" processes where intervention between the registration and reproduction of the image is not only easy but inescapable—have rendered null that "trust" for which the idiom has simply been our warranty. And once we have lost it, we shall never get it back.

What we are faced with, if we entertain the suspicion that "from today, cinema is dead," is not a gradual decline into the moribund but something closer to the catastrophe model, where a seemingly innocuous curve takes a sudden nosedive, an irreversible switch into another state. Of course, a photographic idiom will continue to exist, and will perhaps for a long time retain a residual connotation of photochemical process. Scientists and the agencies of surveillance will continue to use photography, knowing—as with infrared and other exotic data—precisely the nature of the information it encodes. But for most people, and in most cultural contexts, a kind of fog, a flux, will have intruded between the image and our assumptions about its origins.

It is happening already. In a straightforward educational programme, an interviewee is seated in what appears to be an ordinary room until, *apropos* of nothing, it mutates into somewhere completely different. Are we meant to receive this as a conjuring trick in the spirit of Méliès or of *Zelig*, and marvel at its defiance of the norms? I doubt it. Such techniques are themselves becoming norms. But, to the extent that they do so, to the extent that we abandon any assumption that the background of a shot represents the location where the action took place, we are abandon-

ing the founding assumption of a photograph's relation to a prior occurrence. In 1991, the BBC *Arena* programme "The Human Face" contained a brief passage showing the metamorphosis of presenter Laurie Anderson into a baboon. I assumed this to be a bit of electronic jiggery-pokery—of the sort, now commonplace and known as "morphing," which has allowed people on various commercials to mutate into other people while not ceasing to address us directly from the screen—until I read in the *Radio Times* that for this sequence Anderson had had to spend fourteen hours in makeup, unable to eat, drink, or scratch her nose. There was a time—not so long ago—when the implications of this, in terms of discomfort and endurance, would have remained present for us in the sequence; now they did not. A sense of the effort and impediment of the represented world is one thing lost when we cease to see that world as necessary to its representation. This is the price we pay for *Terminator II*.

It seems likely, moreover, that such an effect may feed back into our responses to individual photographs. Hitherto we have felt that a portrait by Nadar, say, of Baudelaire or Rossini, differed in some qualitative way from the works even of those artists whose representations could most convincingly persuade us—as do Holbein's drawings—of the presence of the sitter. But will this continue to be so? Will the very idea of immanence—of the intuition of presence in representation—be lost to us? What I am arguing is that the way we have viewed films for the past century, and photographs for the past century-and-a-half, may be on the point of becoming a forgotten state of cognition, which future generations will be able to recover, if at all, only with great speculative effort, approaching it gingerly with whatever tools future historiography may make available. (Odd as it may seem,

a perusal of the past twenty years' academic film writing will offer them little reason to suppose that such a state of cognition ever existed.)

· · · · ·

At this point, someone will probably say: "Very well, it's possible that the cultural underpinning of documentary may be about to disintegrate; but that will not affect fiction, since fiction film consists precisely in presenting things as *other* than what was actually photographed." But I am not so sure. After all, as I have said, misidentification is not the issue here; and fiction film may make its own demands upon photographic "trust." Think, for example, how often a return to realism has meant the adoption of documentary manners: such practices as the use of nonstudio locations in the hope that their "reality" will somehow rub off onto the narrative, or the slowing down of pace so that details of locale or of human behaviour may be scrutinised as if casual and unplanned. And, aside from any thought of realism, is it not some sense of old-fashioned actuality which must account for that extraordinarily compelling quality we find in certain technically unsophisticated fictions: the original version of *Cat People*, perhaps, or Cocteau's *Orphée*, or Kubrick's *Killer's Kiss*? Let me ask my fiction colleagues bluntly: Would you really be content to think your films differed from animated cartoons only in the degree of their verisimilitude? Has there not been, for all of us, more to it than that?

To rephrase the question: suppose that *Fading Away*, with its subversion of "trust" in the camera, had become the paradigm for nineteenth-century photography; can we then imagine that the cinematograph would have come to exercise the popular com-

pulsion it did? That is to say, can we believe that the history of our medium would have been no different if the condition we now face had preceded its invention?

If I am right, then documentary is the taproot of cinema, even of those forms most remote from it; and if this were allowed to die, all else would wither. It is more than possible that the cause is already lost, along with that of social progress with which photography and documentary have throughout their existence been strongly identified—perhaps out of nothing more theoretically defensible than a gut feeling that if people were allowed to see freely they would see truly, perceiving their world as open to scrutiny and evaluation, as being malleable in the way film is malleable. In spite of constant attempts to accommodate or recruit it, cinema has always represented an impediment to the word of authority by virtue of its ultimate appeal to something prior to that word. It is surely not fortuitous that the age of the chemical photograph has broadly coincided with that of mass democratic challenges to entrenched power.

A Light Not Its Own

> If you can speak of a thing, it is past. . . . Speaking makes
> it glow with a light that is not its own.

Any self-respecting '50s-style linguistic philosopher could prob-
ably demonstrate that the above was meaningless. For a start,
what would we understand by an assurance that the light with
which a spoken thing glowed *was* its own?

Yet the words carry conviction. It is difficult not to believe
that an important truth has been articulated. And it is the sense
of this truth, rather than a meaning extracted from the words
with forceps and scalpel, that I wish to think around. As someone
who has devoted most of his life to documentary cinema, I am
concerned with trying to clarify the documentary project and its
relation to other forms of expression. After all, if anything may
have been supposed to make things glow with their own light,
documentary was surely it.

The quotation is taken from *Interim*, the fifth of Dorothy Rich-
ardson's series of novels, *Pilgrimage* (p. 317 in the Virago edition,

London [1979]). Perhaps significantly, it is one of the very, very few formulations that can be isolated from the flow of that work.

Dorothy Richardson is the Claude Monet of literature. Those who enjoy the parlour game of trying to pinpoint the onset of modernism could do worse than cite the moment when Cézanne said Monet was "only an eye." It was not true, of course; but it marked that decisive shift of attention from the signified to the signifier which characterises the modern movement. Despite her account of herself as writing in "the modern manner," Richardson seems to me to antecede that shift: to be engaged in an heroic attempt to fix the instantaneous receptivity of the mind. On superficial acquaintance, each passage resembles a *plein air* study done rapidly while the light lasts. Areas of the canvas remain blank. The hierarchies imposed by forethought are not evident. A casual walk through the streets will be rendered in detail, whilst a cycling accident in which the central character is seriously injured will be alluded to only fleetingly and in retrospect. Yet it is not exactly a matter of the reduction of experience to sense data, even if we may suspect that to have been the aim. Each "brushstroke" is a compound of sense datum with associative, interpretative resonance. Jenny Joseph once observed that Richardson, more than any other writer, captures what it feels like to think. Indeed, she captures what it feels like to *be:* to the extent that I, who am not of the Edwardian period, am not a woman, am not upper middle class, find that she, more than any other writer, seems to describe my own experience.

Richardson's narratives do indeed glow with a strange, redemptive light which is a light of recognition: of past experienced as if it were present, or of present experienced as if it were past. In one vertiginous episode, lasting several paragraphs, we

are given a conversation between two people entirely in terms of the shimmer of feelings and emotions it engenders, as if it were the shimmer of light on foliage, and are told nothing of what was said. This *tour de force* of omission, which the reader cannot fail to relish as such, raises the question: if the purpose is to be true to the fabric of the moment, how much exhaustiveness is appropriate? To put it another way: how much luggage will the moment hold, not in the putative original experience (assuming there to have been one), but in the form of its representation? A painting by Monet reveals considerably less detail than an academic work of the nineteenth century; but even such detail as it does contain could have been registered only by the sustained attention of the artist, for all its attempt to render the experience as instantaneous.

Detail is oddly elusive. At a certain distance, we can recognise a face; and at a certain distance, too, we can recognise its photograph. But go closer to the photograph, and we see only the pattern of the grain; and closer still, only the fibres of the paper. Go closer to the face, and we see the pores of the skin; and closer still—with the necessary equipment—its individual cells. Degrees of magnification seem to be distinct, each level calling forth a different level of recognition; and these perhaps correspond to levels of organisation (alternating with chaos) in the thing under scrutiny. But the object and its representation part company as both recede from the scale of everyday experience. And much the same goes for a rendering of chronological sequence.

If every recognition has its own level of magnification, then there is a limit to how far realism can be enhanced—spatially or temporally—by increment. When a more recent writer, Nathalie Sarraute, opens up the moment to accommodate ever-greater

196 / *A Light Not Its Own*

tracts of explication, we are left unsure whether the characters' experience is being truly analysed or rather elaborated: whether what we are seeing is truly structure or rather filigree. Realism of a certain sort breaks down at the point where we recognise that the grain of the photograph is not the pores of the skin, and that any proposed equivalences must henceforth concern themselves as much with the former as with the latter: as much with the matter of representation as with the matter represented. Richardson was Monet to Joyce's Picasso.

"Speaking makes a thing glow with a light that is not its own . . ." This thought may well be the key to Richardson's insistence upon calling her work a novel rather than a biography. (It is also, less creditably, what lies behind glib statements to the effect that all history is really fiction.) I do not believe—though I have no evidence for this—that Richardson manufactured a single incident in *Pilgrimage*. What she was saying, I suspect, was something like: "No truth is absolute (though an untruth may be). This book, insofar as it recounts my own life, is partial. But the book will have legitimacy provided that it is perceived as a self-contained entity, as proposing an 'as-if' world. What I do not wish is that readers should look to my life—i.e., to other representations of it—to fill in the 'gaps' in my account, since the whole point of my literary endeavour is to indicate that such gaps acknowledge the limits of the possibility of saying." In some degree I think most of us do read *Pilgrimage* as autobiography, even though we may have the decency not to try and supplement it from other sources—i.e., not to imagine that information culled from other sources could be understood as enhancing or clarifying it. Heirs to modernism, we know and accept the

sense in which the light will be "not its own." But we do not see this as necessarily rendering meaningless the distinction between genres.

For me these questions have a personal relevance. Once in a while, I write a story based so firmly on my own experience that I can honestly claim to have invented none of it. Yet I see such stories as utterly different from the autobiographical essays which I have also occasionally written. And I have difficulty in understanding why. It is certainly not because I doubt that the latter are equally artifacts, or that their events glow equally with a light not their own. But by labelling a piece a story I am asking the reader to use it in a way that does not depend at all on whether the events recounted are true: to treat them, that is, as "let's pretend" constructions. Conversely, by labelling a piece an essay, I am saying not simply, "This actually happened"—a statement which might itself be fictive, not to say mendacious—but, "Please read this as if it *mattered* whether it were true or not."

It may be argued that what I am describing as alternatives are no more than subjective halations in the mind of the writer, and that the distinction vanishes as we pass through the looking glass into the reader's world where signs—visual or verbal—do not bear certificates of their provenance. Nonetheless, most of us feel it would make some difference to our life-view if it were to be established that, for example, Beethoven had not been deaf, Hitler had not known about the Holocaust, or Christ had recanted rather than face execution. In accepting this perhaps philistine position, we as writers take on the weight of a certain responsibility: that the facts recounted in an "essay" should, give or take a modicum of poetic license, be accurate. At the end of *The Last Enemy*, Richard Hillary tells of an encounter with a dying woman

in an air raid whose last words are "I see they got you too." The suggestion that this anecdote was a concoction is as troubling as the suggestion that Capa's famous photograph does not record the actual moment of a republican soldier's death. In both cases, we want to know just how far from fact we have been taken. We are not comfortable with the assurance that Hillary's little fib is true to the way he felt about things at the time, and feel that his fictions—*if* they are fictions—should have been clearly disjoined from his factual narrative, perhaps by a difference of typeface. It is not that fiction cannot tell The Truth, but rather that fiction cannot lie. (How would you set about telling a lie in a fiction?) Our puritan conscience demands a mode in which untruth is a hazard, just as science demands that a statement be open to disproof; otherwise, life is no more than a warm bath of solipsism.

The puritan conscience informs documentary; and mention of Capa's dying republican raises precisely that distinction between photographs and words (or any other nonphotographic mode of representation) on which documentary is founded. Every photograph—like consciousness itself in Sartre's ontology—is a photograph *of* something. If the republican is not dying, he is at least losing his footing. If he is not a republican, he is at least a man dressed up as one. Unlike words or paint, the photograph cannot conjure a thing out of fancy. The documentary conscience demands not that a statement be true, since a photograph can never in itself be untrue, but that an image represent what, within its given context, it may reasonably be taken as representing.

Documentary may best be defined as the attempt at a materialist reading of film. Film: because the problems engendered by the articulation of cinema as a language are present only embry-

onically in our encounter with the still photograph. Materialist: because in documentary the photographic image is held to signify that which was a material prerequisite of its formation. Reading: because no instruction, external or implicit in the mode of address, can guarantee beyond doubt that the film will be construed as intended, and intention is therefore of marginal relevance. Attempt: because the viewer can never be certain, authorial assurances notwithstanding, that she or he has interpreted the images correctly.

To define documentary as a reading implies, obviously, an element of viewer's discretion. Any film can, albeit with some strain, be approached in this manner. (Karl Koch—about whom I know nothing else—noted in the 1930s that "entertainment films are merely monstrous documentaries of actors at work.") This being so, however, must we not grant an equal element of viewer's discretion to the reading of a film as fiction? In principle, yes. But there is a heavy imbalance here, in that every single nonphotographic medium has accustomed us to the fictive construction: "fictive" in a sense which, in this context, encompasses the use of language for factual communication, since words have no documental character—except, perhaps, as symptoms of neural conditions in the speech centres of the brain. To this extent, then, it seems to me that documentary engages our freedom in a way that other forms of communication do not.

Of greater consequence, however, is the element of uncertainty acknowledged in the word "attempt." How do I, as an ordinary member of the public, see the contentious Capa photograph? Well, I happen to have heard somewhere the legend that he took a number of shots "blind" over the lip of the trench, and did not know till the contacts were printed exactly what was on

them. In that case, he cannot himself have been 100 percent certain what he had captured, though he could well have known that the man had been killed at about the time of these exposures. On the other hand, I suspect that if someone had tried deliberately to fake such an incident, she or he would have produced something more "obvious," more in tune with our preconceptions: dying as actors die in Shakespeare, perhaps. Thus with the mixture of internal and external evidence which anyone might find for it, and pending some more definite resolution, I trust it as an image with a high probability of showing what it was alleged to show. And probabilities, in most walks of life, are as good as we can expect to get.*

It has become something of a cliché to say that a photograph conveys no information except as an adjunct to a verbal text. After a viewing of *The Battle of the Somme*, someone commented to me that you would not even have known it *was* the battle of the Somme if the film's title had not told you so. This is true so far as it goes. But you could see from the uniforms that the soldiers were British and of 1914–18 vintage, and from the desultoriness of the behaviour that it was actuality, not acting. You could see the sort of countryside they were encamped in, and the time of year and the state of the weather; and for many of the audience the insignia of rank and regiment would have been meaningful. Why not begin from all that? It is at least arguable that to label the film "The Battle of the Somme" was to ensure its assimilation

* Fresh information has now been unearthed which, I gather, tips this particular probability in the other direction: just one more twist in the skein of our perceived world.

into a preexistent discourse, to dull its freshness and even in some degree to diminish it.

To say that documentary ingests the significance of what it records is not to say that it should be subordinated to some verbal description of it. Such descriptions, in any case, are never above question. There is some well-known newsreel (and stills) footage which shows German soldiers distributing bread to the defeated population of Warsaw in September 1939. Well, yes, they did. They did it exclusively in the presence of the news cameras; the bread had been impounded from Polish bakeries; and the cost of the exercise was charged to the Polish Red Cross. Of course, the filmmaker who knows this will be cautious in using the material; but nobody knows everything, even about yesterday's rushes, and it is possible to pursue the ideal of archival authenticity to the point where an image is allowed to communicate nothing beyond the knowledge required for its own validation. More important: from the viewer's standpoint, how much background data is required to fulfil the demand that documentary be true to the materiality of its images' making? If we are not careful, we will find ourselves drawn into an infinity of clarification which, as with the photographic grain or the deep exploration of the narrated moment, entails a magnification far beyond the "plane of recognition" appropriate to the particular image. Just as the essay demands only to be read as if the truth of its assertions mattered, rather than making an absolute claim for their truth, so documentary demands that the provenance of its imagery never be considered irrelevant, not that all aspects of this provenance be at all times taken into account. I would be content with a documentary practice in which the audiovisual elements of a sequence

were left free to assume a metaphoric dimension by being allowed primacy over their verbal identification—particularly since such identification always risks endorsing the dominant meanings of any society and shrinking the world to the measure of official certainties.

It is difficult to imagine how cinema would have developed if it had pre-dated the advent of modernism, from whose aesthetic it seems inseparable. Would it have been used primarily for its pictorial qualities, as in *Koyaanisquatsi*? Would it have held to the continuous, one-shot narrative of Hitchcock's *Rope* or Jean Rouch's episode in *Paris vu par*? Or would it have adopted the direct-to-the-audience tableaux manner of *Pirosmani* or *The Colour of Pomegranates*? I suspect it would have evolved no storytelling capabilities at all.

Implicit in the practice of both Richardson and Monet is a recognition that there can be no seamless, one-to-one equivalence between the world and its representation: that we cannot, under the banner of truth, go on for ever filling the gaps between signs with more signs. (Richardson, in particular, seems to have accepted that fullness in certain areas must be paid for with omission in others, precision be paid for in puzzlement.) Though neither adopted the modernist approach whereby the sign achieves parity as an object of scrutiny, both clearly knew that realism has nothing to do with totality but involves, on the part of the recipient, a sparking of understanding across gaps in the text; such creative response, such active construction of meaning by the recipient, lying at the heart of aesthetic pleasure.

Film has a built-in modernism, since the irreducible materiality of its signs is a given. This is true even where the film does

not, as it does in documentary, place special priority upon the pre-filmic. It is no mere coincidence that Eisenstein was adducing the Chinese ideogram as protomontage at just the time when Ezra Pound was drawing avant-garde, *imagiste* conclusions from Fenollosa's *The Chinese Written Character as a Medium for Poetry*.

The illusion of continuous movement in films is usually ascribed to the phenomenon of "persistence of vision," the brief retention of an image on the retina. But this does not explain it. If retinal retention were all that was involved, we would expect to perceive a rapid succession of static images linked by brief dissolves. It must surely have more to do with the way the human brain handles time. Oliver Sacks describes—I think it must be in the BBC film version of *Awakenings*, as I have failed to find it in the book—how some of his patients recovered consciousness after years of sleep. At first, they registered only arrested images— snapshots—of their surroundings. These then became more frequent; but only when their occurrence began significantly to exceed ten per second was the experience of life's continuity restored. Silent cinema settled on a nominal sixteen frames per second as the projection speed necessary for the rendering of movement; and this is precisely the frequency at which a succession of sound impulses ceases to be heard as a rhythm and is heard as a pitch. In each case there has been a shift to a seemingly discrete level of recognition. Whether or not continuity is—as Zeno teasingly hinted—always an illusion, it may well be that the brain's sixteen-per-second threshold is what enables consciousness to experience time at all, instead of slithering into an infinite subdivision of microseconds, picoseconds, nanoseconds. . . . Richardson poked gentle fun at those who could "persuade themselves of the possibility of comparing consciousness to a stream."

Probably all realisms encounter a barrier beyond which they disintegrate. Monet's impressionism threatens to become *expressionism* at the point where the canvas becomes a battleground of impasto because it is recognised that nothing that is said can ever be adequate, that paint is not light, that language (and its materials) stands always between us and the represented world. You see this starting to happen as you follow the series of the west front of Chartres cathedral. But Monet backed away from it to the higher magnification of water lilies. For Richardson, the recognition seems to have been that, however much detail you try to include, you always end up with juxtaposition because there are always gaps: a montage of episodes, a montage of phrases, a montage of words—and words which, because they are *not* the objects they describe, are inescapably freighted with metaphor. "We all live under a metaphorocracy," she concedes almost at the end of *Pilgrimage*, at a point where it has come full circle and her surrogate self has already embarked on the writing of the book we have just read.

It is arguable that all communication partakes of two components: on the one hand, the mimetic and analogical, to which prose aspires, where the relation of description to thing described is that of a vector diagram to a distribution of forces; on the other hand, the ideogrammatic, characteristic of poetry, which Eisenstein identified with the Marxian dialectic and which relies on juxtaposition, association, and the play of ambiguities.

There is a sense in which to be human is not to be concerned with the continuous, whether in the aesthetic, emotional, spiritual, or any other realm. Ask yourself the grotesque question: At what degree of magnification is my loved one, or his or her pho-

tograph, most attractive to me? I once possessed a book of human anatomy for painters and sculptors. Though full of images of the human body, it was in no way titillating. The title page, however, was embellished with fragments of photographs of a female nude; and this achieved an erotic eloquence such as none of the complete photographs possessed. There seemed no other explanation than that the eroticism was a function of the work which my brain was performing in integrating the collage. And the same phenomenon must surely account for the enhanced "presence" we find in those postwar European films shot on location with post-synch sound never matching quite perfectly. These imply a recognition that words and visuals remain separate components of a film text—in the sense that there is no necessary correlation between what characters are saying and how they are framed. Even the "self," as known to introspection and memory, is no more than a congregation of fragments. The light with which the spoken glows can only be the light of the hearer's understanding.

Even film, however, does have, at a certain level of recognition, a continuous, analogical relation with a prior event: the sort of relation which, in the more popular usages, almost defines the "realistic." Indeed, the recognition of this, usually accompanied by a profound subjective sense of "actuality," supplies one basis for the materialist reading whereby documentary is constituted. Attempts to reinvigorate documentary have always been attempts to recover an actuality whose conviction seemed on the wane; and in the early 1960s, one such attempt centred on the idea of uninterrupted action before the camera, or "real time." The locus for this concern was the use of film in anthropology.

The idea that a film record could be the equivalent of raw data,

or of field notes, or of something between the two, had been abandoned by such pioneers as Jean Rouch almost before the '50s were out; yet as late as the mid-'70s you could hear anthropologist-filmmakers urging—for example—the use of split screen so that both sides of a transaction might be shown without recourse to editing, and dreaming of the ideal of a panoramic, 360-degree screen on which the real world could unroll itself untouched, as it were, by human hand—or judgment. Such thinking, such yearnings for totality, represented the zany extremes of a movement which produced some excellent cinema and set new standards of rigour in documentary ethics, but whose relation to anthropology as a science—if conceived in Popperian terms of thesis, observation, falsification, and modification of thesis—is at best slender.

The development of lightweight cameras and tape recorders made possible the continuous, handheld, synchronous filming of events without prior planning or direction; and this happened just at the time—the early 1960s—when artists in various fields were seeking to overthrow established grammars which had begun to seem complicit with political oppression. The word "democracy" was much in vogue, being used in ways that had not been heard before and have not been heard since. Serial music was held to be more "democratic" than tonal music, not because more people could enjoy it but because it eliminated any hierarchy between notes. The aleatory principle was embraced with enthusiasm. Even so conscientious a craftsperson as B. S. Johnson produced a book-in-a-box whose chapters were to be shuffled before being read. Umberto Eco, whose essays of this period have been translated under the title *The Open Work*, speaks of plurivo-

cality, of the situating of aesthetic pleasure "less in the final recognition of a form than in the apprehension of the continuously open process": which is another way of describing the artist's attempt to abjure privilege.

It is here that we find the true link with anthropology, a study which seeks to avoid superimposing our own conceptual systems willy-nilly upon others' experience: which seeks to sidestep ethnocentricity for reasons either of academic principle or of anticolonialist conviction. By embracing the aesthetic of the '60s, it seems, anthropology became host to a benevolent parasite.

In 1964, Mark Boyle and Joan Hills set up an "event" for which we assembled in a vacant lot and were led through dingy passageways into a room where we took our seats in front of a proscenium curtain. When the curtain was drawn aside, we discovered that we were in an abandoned shopfront looking out through the window: and whatever happened in the street would be the "performance." The gap between signifier and signified had been reduced to the thickness of plate glass. But the import of this observational theatre was not that we can (or cannot) distance ourselves from the subjects "represented." It was rather that all observations are fundamentally of equal legitimacy. Thus there seems, or seemed at that time, to be some deep alliance between the aesthetic of continuity and the ethic of tolerance: the withholding of creative or moral censure.

And again, for all her broken surfaces, we find Richardson foreshadowing the spirit of the '60s in the way she managed to suggest that what she was giving us was a purely arbitrary selection from life's bounty, and that she might equally well have shown us something other. Everything is equally important; or,

at any rate, equally remarkable. Yet any inference of neutrality is surely unfounded. Before all other considerations, the mere act of framing something alters our view of it. Look at the street through a proscenium, and that too will glow with a light that is not its own. Nothing can rid the perceived of the act of perception; and in the act of perception lies, already, the germ of language.

INDEX

actualities, 60; renewal of effort to make, 205–7

advertisement: defined, 125; photographs as, 124–26

Aldrich, Robert, 140

Anderson, Lindsay, 150

angle–reverse angle cuts, 146n

Apache, 140–41

audience reaction: to early films, 1–2, 2–3, 4–5, 6; to kinetoscope, 4; to Mitchell style, 15. *See also* viewers

authenticity, 85–86

available light, filming in, 14, 16, 19, 65

Awakenings, 203

Banditi a Partinico (Dolci), 179

The Battle of the Somme, 200

The Battleship Potemkin, 79–80, 114

Bayer, Herbert, 187

BBC: on particular / general relationship, 15–16; *Principles and Practice in Documentary Programmes*, 10–12

Beauvoir, Simone de, 54

Berlin Olympics, 91–100; fascist viewpoint of, 109–10; marathon in, 102–5, 109; medal winners in, 108–9; pole vault in, 91–92, 93–94, 98–99, 109; slow motion in, 91, 93–95, 96–97, 98–99, 100; social meanings in, 97–100; spectators in, 92

Bicycle Thieves, 151

Bikela, Abebe, 105, 107, 108

A Boat Leaving Harbour: audience reaction to, 2–3, 6; spontaneity as central in, 5–6, 8; summary of action in, 3

Boyle, Mark, 207

Burden of Dreams, 125

Camera at War, 87

Capa, Robert, 198–200

Cassavetes, John, 114
Cat People, 191
cement joiner, 13, 16
Cézanne, Paul, 182, 194
cinéma vérité: BBC ethical guidelines on filming of, 10–11; general connotations made from specifics of, 119–21; omissions as related to accuracy of, 118–19; technicians and mike booms visible in, 19–20; truth and, 9–10, 23; unsteady camera as characteristic of, 120. *See also* objective style
Clarke, Charles G., 139, 143
"classical" documentary, 31; accepted conventions of, 67; *Hôtel des Invalides* as, 31–41, 51–52
Clouzot, Georges, 127, 139
Cocteau, Jean, 191
colorization, 186
colour, photographic trust and, 127
The Colour of Pomegranates, 202
Congress of Photographic Societies at Neuville-sur-Saône, 2
Coronation Street, 132
Cowell, Adrian, 31. See also *The Tribe That Hides from Man*
Crown Film Unit, 87
culture: conventions of, and editing, 69–74; ethnocentricity of, and significance of events, 117; meaning as influenced by, 114–16; significance of sport and, 97–100

The Damned, 47, 49
Delaroche, Paul, 181

De Sica, Vittorio, 86
documentary: "classical" vs. "modern," 31; defined, 58, 66, 84–85, 87, 198–99; erosion of photographic trust and, 191–92; horror in, 116–17, 118; as like poetry, 80–83; as mode of response, 58–60, 66; narrowing of gap between fiction film and, 64–66; reality and, 51, 87–89; stylistic characteristics of, 63; technical developments enabling television's association with, 12–14; as truth vs. fabrication, 29–30; zoom effect first used in, 143–44
Dolci, Danilo, 179–80
domestic realm, 55–56, 66
drama-documentary. *See* factual drama

Eclair 16mm camera, 13
Eco, Umberto, 206–7
Edison, Thomas Alva, 4
editing: film shot in snow, 111–12; future methods of, 75; "horizontal" and "vertical" structures in, 61–62; as how things are put together, 119; meaning with shots juxtaposed in, 67–69; minimal, and truth, 57; social meaning introduced in, 69–74; tape joiner's effect on, 13; viewers' misreading of conventions of, 76
Eisenstein, Sergei, 203
Ekberg, Anita, 152, 153
ethnographic filmmaking: concern for authenticity of, 85–86; debate over significance of

events in, 117
Execution of Lady Jane Grey, 181

fabrication, documentary as, 29–30
factual drama, 152, 154
Fading Away, 187, 191
Family, sequence of shots in, 22
Fellini, Federico, 148–49, 152
fiction film: author's disappointment with, 113–14; colorization of, 186; erosion of photographic trust and, 191; fictitious events vs. fictitious objects in, 119; horror in, 116, 117–18; incorporated into observational cinema, 78–80; narration in past tense in, 44; narrowing of gap between documentary and, 64–66; stylistic characteristics of, 63; vs. filmed fiction, 6–8
film: "actuality" effect of, 183–85; early, audience reaction to, 1–2, 2–3, 4–5; electronic manipulation of, 185–86; erosion of photographic trust and, 188–91; as incomplete representation of reality, 130–34, 205–7; modernism of, 202–3; as record or as language, 55, 79; spontaneous movement captured by, 4–5, 6–8; whole/part relationship to meaning of, 112–13, 119–21. *See also* documentary; fiction film
film emulsion, for shooting in available light, 14, 16, 19, 65
film fiction: defined, 85–86; vs. literary fiction, 128–30
Fitzcarraldo, 125

Flaherty, Robert, 57, 60, 128, 130
Flanders, Michael, 42
Franju, Georges, 30. See also *Hôtel des Invalides*

Godard, Jean-Luc, 17
God Protect Me from My Friends (Maxwell), 179
Graef, Roger, 9. See also *Space between Words* series
Grierson style, 12, 15, 16, 184

Heartfield, John, 187, 188
Herzog, Werner, 125
Hillary, Richard, 197–98
Hills, Joan, 207
Histoire générale du cinéma (Sadoul), 4–5
Hitchcock, Alfred, 140, 202
Hockney, David, 185
Hôtel des Invalides, 31–42, 51–52; commentary by guides' voices in, 31, 37–38; mineral/flesh antithesis throughout, 32–33, 38, 51; "mood" of, 31, 40–41, 42; newsreel footage in, 32, 33, 35–37, 41
Hurley, Frank, 187

Ichikawa, Kon, 17, 90, 100. See also *Tokyo Olympics*
impressionism, 181–82, 204
Industrial Britain, 130
Interim (Richardson), 193

Johnson, B. S., 206
joining technology, innovation in, 13
Joseph, Jenny, 194

Kameradschaft, 151
Killer's Kiss, 191
kinetoscope, audience reaction to, 4
Koch, Karl, 199
Koyaanisqatsi, 202
Kubrick, Stanley, 191

La dolce vita, 149, 152; documentary on, 148, 153–54
Lang, Fritz, 149
L'Arroseur arrosé, 6–7
The Last Enemy (Hillary), 197–98
La terra trema, 166
Laurel and Hardy, 84, 87
Leacock, Richard, 143
Le Déjeuner de bébé, 5
Leith, William, 185
Les Annales politiques et littéraires (Parville), 4
literature, fiction in, vs. film fiction, 128–30
location: creation of fictional, 111–12; shooting on, and reality, 148–54
Lorang's Way, 77
Losey, Joseph, 47
Lumière brothers films, 1–8. *See also specific film titles*
Lyme, Harry, 49

MacDougall, David, 77
MacDougall, Judith, 77
magnetic sound, 13, 118
Marey, E. J., 1
Mastroianni, Marcello, 153
materialism, 151–52
Maxwell, Gavin, 179
Méliès, Georges, 4–5, 60, 61
Mitchell, Denis, 13

Mitchell style: expression of attitude in, 14; as poetic, 23; public distrust of, 15; technical developments underlying, 12–14
modernism, 194, 202
Mohr, Jean, 123
Monet, Claude, 182, 194–96, 202, 204
movement, in film vs. theatre, 4–5
Mr. Magoo cartoons, 145
Multiplane camera, 138–39
Muybridge, Eadweard, 1

Nagra tape recorder, 13
newsreels: colorization of, 186; in *Hôtel des Invalides*, 32, 33, 35–37, 41; incorporated into documentaries, 86–87; *Salvatore Giuliano*'s simulation of, 159, 164–65; zoom effect in, 142

objective style: decisions influencing truthfulness of, 20–21; limitations on, 20–21; open-endedness in films of, 24–26; technical developments underlying, 16–17. *See also cinéma vérité; Space between Words* series
observational cinema, 55; meaning with shot juxtaposition in, 67–69; minimal editing in, 57
Olmi, Ermanno, 114
Olympiad, 138
Olympische Spiele. See *Berlin Olympics*
On the Waterfront, 150
The Open Work (Eco), 206
Orphée, 191
Outlaws of Partinico (Dolci), 179

Pabst, Georg Wilhelm, 86, 151
Packer, Ann, 101
painting, invention of photography and, 181–82
Paris vu par, 202
participants: assurances given, before filming *Space between Words* series, 17–18; included in shaping of film, 28
Parville, Henri de, 4
"persistence of vision," 203
photographic trust, 182–83, 188–91; erosion of, and film, 191–92; film technical developments and, 127; as foundation of film, 126
photographs, 58, 59; as adjuncts to verbal text, 200–202; computer-created, 186–87; electronic modification of, 185; history of manipulation of, 187–88; painting's response to invention of, 181–82; recognition of objects represented in, 195; as representations of reality, 121–22, 198, 204–5; as witness vs. advertisement, 122–26
Pilgrimage (Richardson), 193–94, 196, 204
Pirosmani, 202
portable equipment, 27; domestic realm opened up by, 56; film as record or as language and, 55; invention of, 13–14, 30; as narrowing gap between fiction film and documentary, 65
Potemkin. See The Battleship Potemkin
Pound, Ezra, 203
Primary, 143–44, 147

Principles and Practice in Documentary Programmes (BBC), 10–11; assumptions contained in, 11–12
The Private Life of Henry VIII, 129
pro-filmic: defined, 134–36; distortion or influence within, 56–57

Read, John, 13
reality: documentary and, 51, 87–89; documentary, viewer as element of, 87, 88, 136, 199; editing required for film representative of, 21–23; film as incomplete representation of, 130–34, 205–7; gap between representation and, 202–4; photographs as representations of, 121–22, 198, 204–5; recognition of representations of, 195–96; shooting on location and, 148–54
Reed, Stanley, 2, 5
Reynaud, Charles Émile, 1
Richardson, Dorothy, 193–96, 202, 203, 204, 207
Riefenstahl, Leni, 56, 90, 138. See also *Berlin Olympics*
Robinson, Henry Peach, 187
Robinson Crusoe, 49
Rome, Open City, 151
Rope, 202
Rosi, Francesco, 141, 152, 175, 177, 178, 179. See also *Salvatore Giuliano*
Rouch, Jean, 202, 206

Sacks, Oliver, 203
Sadoul, Georges, 4–5
Salt, Barry, 145–46, 146n

Salvatore Giuliano, 155–80; bandit portrayed in, 156, 179–80; documentary style of, 171, 175–79; doubt as subject of, 156, 158, 179; fictional minisequences in, 173–74; introduction of main character in, 159–62; location of, 152–53; newsreel simulation in, 159, 164–65; opening/closing shot in, 155–56; Pisciotta's speech in, 169–72; poisoning scene in, 175; presumed prior knowledge of viewers of, 172–73; structuring principles of, 163–65; time transitions in, 166–69; zoom shots in, 141, 143, 162

Sarraute, Nathalie, 195

School film: alternative endings for, 22; sound recording in, 20; open-endedness in, 26

Sciascia, Leonardo, 177

script, as obsolescent, 14

Shaw, George Bernard, 76

Six Million Dollar Man TV series, slow motion in, 96, 100

slow motion: in *Berlin Olympics*, 91, 93–95, 96–97, 98–99, 100; digital manipulation of, 186; documentary use of, 95–96; meaning signified by, 96; in *Six Million Dollar Man* TV series, 96, 100; in *Tokyo Olympics*, 94, 95, 100, 101–2, 105, 106, 107–8

snow, editing film shot in, 111–12

Snow White, 116

social meanings. *See* culture

Son, Kitei, 102–3, 104, 105

Space between Words series: assurances given to participants in,

17–18; *cinéma vérité*/truth relationship and, 9–10, 23; decision making in production of, 23–25; editing of, 21–23; *Family*, 22; indifference to camera in, 18–19; objective style of, 17; open-endedness of, 24–26; *School*, 20, 22, 26; as style for future television, 26–28; titles of films in, 9n; *Work*, 25

spontaneity: in *A Boat Leaving Harbour*, 5–6, 8; in early film, 4–5, 6–8; film's portrayal of, 4–5

Spottiswoode, Raymond, 142

Sternberg, Joseph von, 149

Tabu, 128–29

tape joiner, introduction of, 13

technical developments: allowing for "democratic" films, 206–7; in electronic manipulation of imagery, 185–86; as narrowing gap between fiction film and documentary, 64–66; photographic trust and, 127; underlying Mitchell style, 12–14; underlying objective style, 16–17

telephoto shots, 139

television: electronic manipulation of images on, 185–86; objective style in future of, 26–28; technical developments enabling documentary's association with, 12–14

The Third Man, 49

Three Days in Szczecin, 129

Tokyo Olympics, 100–109, 110; bicycle race in, 106–7; marathon in, 102, 105–6, 107–8; medal

winners in, 108–9; pole vault in,
92–93; slow motion in, 94, 95,
100, 101–2, 105, 106, 107–8;
spectators in, 91–92
Tokyo Orinpikku. See *Tokyo
Olympics*
Touch of Evil, 166
Tree of Wooden Clogs, 114
The Tribe That Hides from Man,
42–51, 52–53; "attack" se-
quence of, 45–46; hunting se-
quence of, 46–49; stance toward
reality of, 43–44; voice-over in,
43, 44, 45, 46, 52–53
Triumph of the Will, 109, 178
trust. *See* photographic trust
truth: *cinéma vérité* and, 9–10, 23;
documentary as, 29–30; mini-
mal editing and, 57
2001, 49

Urban, Charles, 183

Verne, Jules, 42, 50
Vertigo, 140
viewers: editing conventions
misread by, 76; as element in
construction of documentary
reality, 87, 88, 136, 199; as nec-
essary for meaning of documen-
tary, 58–59, 74, 78, 84–85; shot
juxtaposition interpreted by,

68–69; variation in meaning
constructed by, 113. *See also* au-
dience reaction
Villas Boas, Claudio, 42–51
Visconti, Luchino, 166
voice-over technique, introduction
of, 13

The Wages of Fear, 127, 139–40
Warhol, Andy, 21
Watt, Harry, 120
Welles, Orson, 49, 166
"wobblyscope," 120
Work, criticism of open-endedness
of, 25
*Workers Leaving the Lumière Fac-
tory*, 2

zoom effect, 138; achieved without
zoom lens, 137–38; connota-
tions of, 145; as distortion, 139;
early uses of, 139–41; first used
in documentaries, 143–44; per-
ceived as from floating camera,
142–43; in *Salvatore Giuliano*,
141, 143, 162
zoom lenses, 137–47; dubbing
film shot with, 137; imperfec-
tion of, 144; indispensability of,
144–45; photographic trust and,
127; zoom space defined by,
146–47

Lightning Source UK Ltd.
Milton Keynes UK
UKOW041811010313

207015UK00001B/68/A